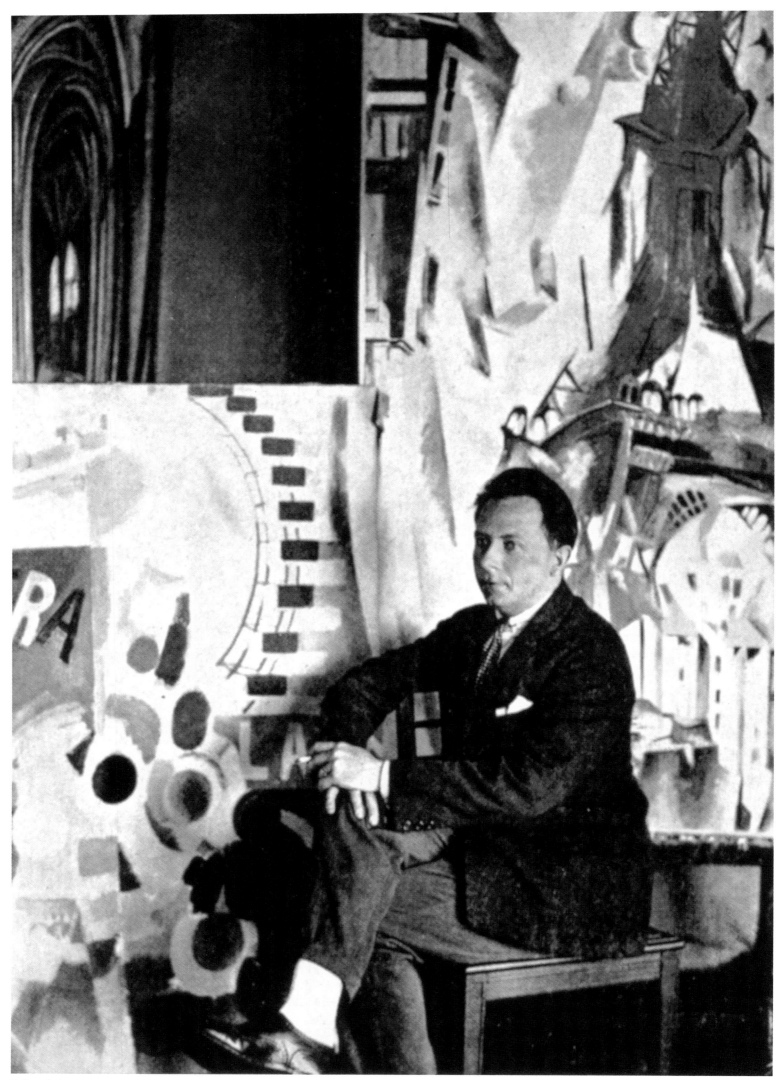

Robert Delaunay at the age of twenty-five, ca. 1910

Visions of Paris
Robert Delaunay's Series

G U G G E N H E I M M U S E U M

Visions of Paris: Robert Delaunay's Series
Organized by Mark Rosenthal

Deutsche Guggenheim Berlin
November 7, 1997–January 4, 1998

Solomon R. Guggenheim Museum
January 16–April 25, 1998

This exhibition originated at Deutsche
Guggenheim Berlin as part of the ongoing
collaboration between Deutsche Bank and the
Solomon R. Guggenheim Foundation.

ISBN 0-8109-6906-8 (hardcover)
ISBN 0-89207-196-6 (softcover)

Guggenheim Museum Publications
1071 Fifth Avenue
New York, New York 10128

Hardcover edition distributed by
Harry N. Abrams, Inc.
100 Fifth Avenue
New York, New York 10011

Front cover: *Tour Eiffel* (*Eiffel Tower*), 1911
(cat. no. 27).

Back cover: *Fenêtre sur la ville* (*Window on the City*),
1914 (cat. no. 59).

Designed by Michelle Martino Lapedota

Printed in Italy by Mariogros

Unless otherwise noted, all works are by Robert
Delaunay. In the captions, titles are given in the
original language followed by the English. Years
in brackets correspond to those discussed by
Matthew Drutt in his essay, "Simultaneous
Expressions: Robert Delaunay's Early Series,"
and indicate dating that is at variance with the
date given to the work by its owner or with which
it has been previously published.

Table of Contents

Foreword

An exhibition of Robert Delaunay's series is an idea full of resonance for the Guggenheim Museum. Thanks to the foresight of the founders of the Solomon R. Guggenheim Foundation and the Peggy Guggenheim Collection, we are particularly rich in the holdings of this pioneering artist of Modernism. Indeed, with one example from the *Saint-Séverin* series, two from *The City*, three from *The Eiffel Tower*, and two from *The Windows*, we were able to approach our colleagues and private collectors during the planning stages of this exhibition with the firm knowledge that a thorough examination of the subject would be mounted.

Delaunay's achievements have always been related to those of his Cubist colleagues, but this exhibition should help to individualize his contributions. He not only added a coloristic dimension to the structural innovations of Cubism, but he also produced imaginative views of the modern city of Paris conveyed in a modern art style. In contrast to most of his fellow Cubist painters, he willingly accepted the ramifications of Cubism by exploring pure abstraction. Delaunay's advances were eagerly applauded and followed by artists in Germany, who then carried forth the mission of abstraction. Thus, Delaunay was not simply a member of the Cubist orbit, but a highly accomplished artist who created new directions during a time when many competing tendencies abounded.

Visions of Paris: Robert Delaunay's Series has been ably curated by Mark Rosenthal, Curator of Twentieth-Century Art, whose idea it was, and who moved with calm alacrity to organize this project. The catalogue is enhanced by the insightful contribution of Associate Curator for Research Matthew Drutt, who has introduced a good deal of new insights on Delaunay's art.

We are deeply indebted to Jean-Louis Delaunay, the artist's grandson, for encouraging our efforts and for providing much help to our curators. Our gratitude extends most profoundly, as always, to the lenders, whose kindness and generosity have allowed for this beautiful and richly revealing exhibition to occur in all its glory.

Thomas Krens
Director, The Solomon R. Guggenheim Foundation

Acknowledgments

The realization of every exhibition seems like a miracle, and this one is no exception. The inaugural exhibition of Deutsche Guggenheim Berlin, *Visions of Paris: Robert Delaunay's Series* will also be presented at the Guggenheim Museum in New York. Our deepest gratitude is therefore extended to the individuals and institutions who have generously lent works to the exhibition, for it is only due to them that such a large public has the possibility of enjoying these great works. In particular, I wish to thank Katharina Schmidt, Director, Kunstmuseum Basel; James Wood, Director, Jeremy Strick, Curator of Twentieth-Century Art, Douglas Druick, Curator of Prints and Drawings, and Suzanne Folds McCullagh, Curator of Earlier Prints and Drawings, The Art Institute of Chicago; Armin Zweite, Director, and Volkmar Essers, Curator, Kunstsammlung Nordrhein-Westfalen, Düsseldorf; Georg W. Költzsch, Director, Folkwang Museum, Essen; Uwe Schneede, Director, and Helmut R. Leppien, Curator, Hamburger Kunsthalle; Nicholas Serota, Director, and Jeremy Lewinson, Curator, Tate Gallery, London; Evan Maurer, Director, The Minneapolis Institute of Arts; Helmut Friedel, Director, Städtische Galerie im Lenbachhaus, Munich; Glenn Lowry, Director, Kirk Varnedoe, Curator of Painting and Sculpture, Margit Rowell, Curator of Prints and Drawings, and Cora Rosever, Associate Curator of Painting and Sculpture, The Museum of Modern Art, New York; Werner Spies, Director, Museé National d'Art Moderne, Centre Georges Pompidou, Paris; Anne d'Harnoncourt, Director, Ann Temkin, Curator of Twentieth-Century Art, Michael Taylor, Assistant Curator of Twentieth-Century Art, and Suzanne Penn, Conservator, Philadelphia Museum of Art; Philip Rylands, Deputy Director, Peggy Guggenheim Collection, Venice; Dieter Schwarz, Director, Kunstmuseum Winterthur; Hubert Neumann, representing the Morton G. Neumann Family Collection; and a group of private collectors who prefer to remain anonymous. The support of Christian Klemm, Deputy Director, and Tobias Bezzola, Curator, Kunsthaus Zurich, is also highly appreciated.

Chief among the gallerists who kindly provided extensive help were Krystyna Gmurzynska and Mathias Rastorfer, Galerie Gmurzynska, Cologne. I wish also to acknowledge the assistance of Marc Blondeau, Paris, Renate Danese, New York, and Roberta Entwistle, London.

Nicole Bregergère, Documentation et Manuscrits, and Brigitte Vincens, Documentation, Photothèque, Museé National d'Art Moderne, Centre Georges Pompidou, Paris; Florence Callu, Département des Manuscrits, and Thierry Collin, Département des Reproductions, Bibliothèque Nationale de France, all provided invaluable assistance by granting access to manuscripts and photographs belonging to the Fonds Delaunay. Matthew Affron, Assistant Professor of Fine Arts, University of Virginia, Charlottesville, and Kenneth Silver, Associate Professor of Fine Arts, New York University, generously offered insight and advice.

I have greatly enjoyed the comradery and contributions of my colleagues, especially Matthew Drutt, Associate Curator for Research, whose essay in this catalogue represents an important contribution to Delaunay scholarship, and Claudia Schmuckli, Curatorial Assistant, whose tireless and diligent assistance is greatly appreciated. I am most grateful for the personal support of Thomas Krens, Director, and Lisa Dennison, Deputy Director and Chief Curator, who played crucial roles in the negotiation of loans.

Special thanks go to Paul Schwartzbaum, Chief Conservator, Guggenheim Museums/Technical Director, International Projects; and Suzanne Quigley, Head Registrar for Collections and Exhibitions. Their personal involvement was instrumental in the realization of this exhibition. Marion Kahan, the registrar for this project, skillfully handled the complex transportation and insurance matters between Berlin and New York. I am most grateful to Gillian McMillan, Senior Conservator, for her expertise. Karen Meyerhoff, Director of Exhibition and Collection Management and Design, and Peter Read, Production Services Manager/ Exhibition Design Coordinator, provided counsel on many design and installation issues. Donna Moll, Senior Designer, and Marcia Fardella, Graphic Designer, also provided invaluable design help. The exhibition profited from the professionalism and the talent of the installation team: Richard Gombar, Museum Technician; Scott Wixon, Manager of Art Services and Preparations; Mary Ann Hoag, Lighting Designer; James Cullinane, Senior Exhibition Technician; and Barry Hylton, Art Handler. I would also like to thank David Saik at Richard Gluckman Architects for his constructive advice concerning the newly built Berlin facilities.

I am grateful to Max Hollein, Executive Assistant to the Director, and Paul Pincus, Project Director, Planning and Operations, who successfully coordinated the activities between New York and Berlin. George McNeely, Director of Corporate and Foundation Giving; Melanie Forman, Director of Individual Giving and Membership, and Stacy Bolton, former Development Coordinator, secured the funding for the exhibition. Wesley Jessup, Senior Financial Analyst, and Ruth Taylor, Director of Budget and Planning, assembled the budget. I am highly appreciative also of the contributions of Ben Hartley, Director of Communications; Judith Cox, General Counsel and Deputy Director; Rosemarie Garipoli, Deputy Director for External Affairs; Marilyn Goodman, Director of Education; Scott Gutterman, Director of Public Affairs; Julia Caldwell, Public Affairs Coordinator; and Sally Ritts, Assistant Photographer and Photography and Permissions Manager. Finally, I wish to

thank curatorial interns Uta Husmeier and Sabine Prenn for
their enthusiasm and help.

This catalogue could not have been realized without the
skillful management of Anthony Calnek, Director of
Publications, and the members of the Publications depart-
ment. My gratitude goes to Edward Weisberger, Editor, who
adeptly coordinated and oversaw the book's editorial aspects,
and to Carol Fitzgerald, Assistant Editor, and Domenick
Ammirati, Editorial Assistant. The production lay in the
expert hands of Elizabeth Levy, Managing Editor/Manager
of Foreign Editions, and Melissa Secondino, Production
Assistant. I especially thank Michelle Martino Lapedota, who
designed the catalogue with great sensitivity and skill.

I am most grateful to Dr. Ariane Grigoteit and Friedhelm
Hütte at Deutsche Bank, and Svenja Simon at Deutsche
Guggenheim Berlin, whose cooperation and trust have made
this exhibition possible.

M. R.

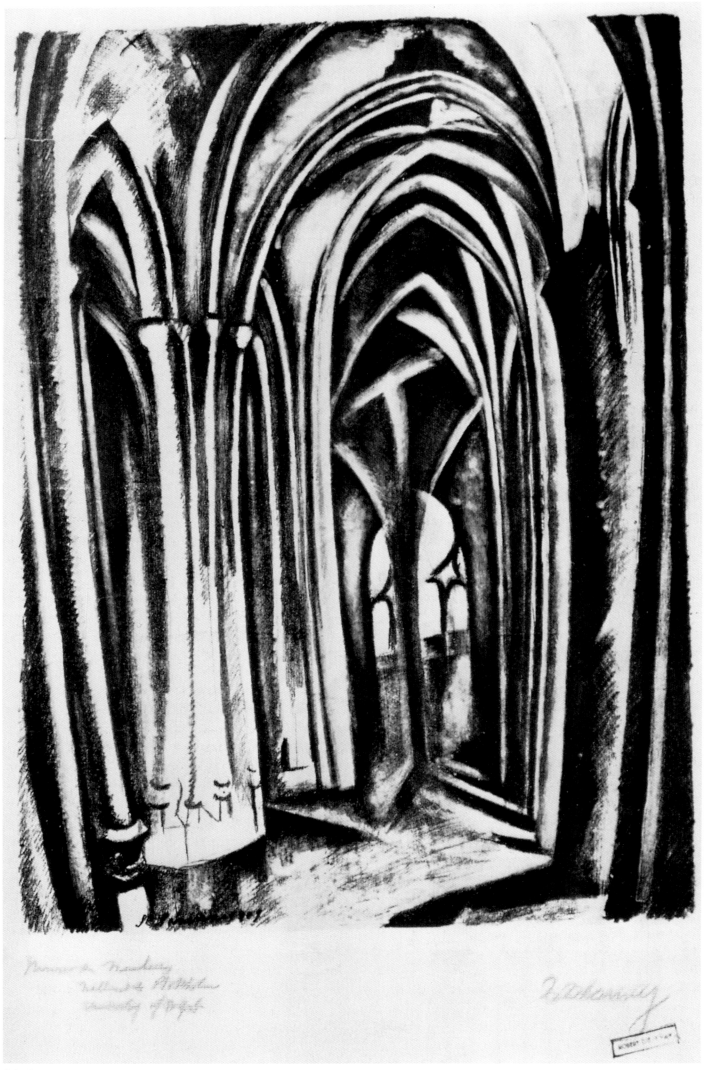

Saint-Séverin, 1909/1927. Lithograph on paper, 56.8 x 43.2 cm (22 ⅛ x 17 inches).
The Museum of Modern Art, New York, Abby Aldrich Rockefeller Fund

Introduction

Mark Rosenthal

In an inspired five-year burst of activity, from 1909 to 1914, Robert Delaunay successively synthesized the Impressionist model of series paintings, the contemporary language of Cubism, and the high-wire allure of pure abstraction. At the heart of Delaunay's series *Saint-Séverin* (1909–10), *The City* (1909–11), *The Eiffel Tower* (1909–12), and *The Windows* (1912–14) is the Eiffel Tower itself, the signature Parisian manifestation of modernity. Delaunay effectively replaced the pastoral landscape of the Impressionists with a modern paean of French glory.

With his transformation of the recognizable world into patterns of interlocking fragments, Delaunay is rightfully included within the Cubist sphere. For instance, as if a Cubist, he described the *Saint-Séverin* and *Eiffel Tower* series as his "destructive" period, by which he meant that the subject of the work was fractured and then reassembled according to pictorial concerns. From the start, however, his interests were distinct from the Cubist pioneers Georges Braque and Pablo Picasso. The very fact that Delaunay chose not humble still-life motifs but dramatic architectural themes separated him from his contemporaries. As opposed to the Cubists, who used the subject as a mere departure point, Delaunay gave full reign to the physical and even iconic impact of his architectural themes. For him, Cubism was a language he applied to larger issues. Delaunay's friend Guillaume Apollinaire, poet, art critic, and major interpreter of Cubism, considered the *Windows* series to be an extension of Cubism, and termed it Orphism: a form of Cubism purer in character and primarily concerned with the effects of light. Indeed, with *The Windows*, Delaunay declared that he had evolved from the "destructive" to the "constructive" phase of his career.

In an article written in the third person entitled "Three Notes on the Differences between Delaunay's Art and Impressionism and Expressionism" (1920s?), Delaunay reflected on the precedents for his art with a specific note of appreciation for the series of Paul Cézanne and Claude Monet.[1] Monet's series, with the exception of *Gare Saint-Lazare* (1877), which is contemporary and urban in character, speak either of another era or another milieu. For example, the *Rouen Cathedral* series (1892–94) depicts the architectural façade of a building that evokes French religiosity and architectural innovation during the Gothic period.[2] Monet's *Grainstacks* (1888–91), *Poplars* (1891), and *Water Lilies* (1899–1920)—along with Cézanne's *Mont Sainte-Victoire* paintings (first series, 1882–ca. 1890; second series, ca. 1902–06)—emphasize the beauty of the rural French landscape at a time when the agrarian life was thought to be threatened.[3] Monet's series were shown extensively, including an exhibition of forty-eight of the *Water Lilies* at Galerie Durand-Ruel in 1909, in the very year when Delaunay himself first turned to the subject of Saint-Séverin. Perhaps not unnoticed by Delaunay,

too, the *Grainstacks* series was the start of Monet's considerable financial success, which distinguished him from most of his Impressionist colleagues.

Effectively mimicking Picasso's metamorphosis of the bather genre into the convulsive *Les Demoiselles d'Avignon* (1907), Delaunay similarly modernized or leapfrogged the Impressionists' example. Although he shared with them a concentration on the majestic beauty of specifically French locales, Delaunay—with his focus on the city of Paris and its structures—emphasized an urban dimension to French achievement. Whereas Monet was concerned with atmospheric effects, Delaunay stressed the physical structures of the interior of the church of Saint-Séverin and the Eiffel Tower. Monet's delineation of a locale and its colors started with plein-air observations and remained fundamentally naturalistic; Delaunay's portrayals were determined in his studio. Unlike Monet, who would generally vary his viewpoint of a subject, Delaunay remained more or less fixed in his position vis-à-vis a site. Every painting in a series by Monet or Cézanne is about the same size, but Delaunay altered his formats. When, like Monet, Delaunay focused his attention on the appearance of light in the *Windows* paintings, he atomized it within even, allover compositions.

As if in opposition to the natural splendors offered by the Impressionists, Delaunay decisively stayed indoors, investigating a deep architectural space in the *Saint-Séverin* paintings. In each view, the columns either bend, bow, expand, or dissolve in a highly expressive, even kaleidoscopic way. At this point in his career, Delaunay's work is only nominally Cubist, although it is unimaginable without that precedent. Rather, the blue- or purple-dominated interiors are rendered in a recognizable but dramatized fashion that would likewise be the case in the usually red-dominated *Eiffel Tower* series. Both subjects are always shown on vertical formats so as to emphasize their ascendant character.

The Eiffel Tower, through its repetition in at least nine paintings and many works on paper beginning late in 1909 and continuing through 1914, and several more occasions a decade later, has the role of a mantra in Delaunay's art. Hieratically centered as if at the end of an apse, it holds an iconic position in each work. Because it is shown from the vantage point of a window, the *Eiffel Tower* series combines exterior and interior spheres, and recalls a traditional, Romantic theme of the open window. In these works, Delaunay suggests that the interior represents a prosaic world of appearances, hence the window curtains, and subsequently the buildings that replace them as a framing, halolike device, are plastic and conventional. That plane of existence is juxtaposed with the imaginative exterior, wherein the tower's upper torso bends in unnatural ways or even leans toward the viewer. The tower is a giant colossus, dominating the streets

Claude Monet, *Cathédrale de Rouen, façade de l'ouest, soleil* (*Rouen Cathedral, West Façade, Sunlight*), 1894. Oil on canvas, 100.2 x 66 cm (39 7/16 x 26 inches). National Gallery of Art, Washington, D.C., Chester Dale Collection

Delaunay's obsessive concentration on the subject of each series served him well, but on occasion he synthesized motifs, as in *La Ville de Paris* (*The City of Paris*, 1910–12 [1912]; see fig. 39) and the *Cardiff Team* paintings (1912–13). Besides adding figurative elements, he sometimes conjoined a Ferris wheel to the Eiffel Tower. The wheel motif, which repeated Delaunay's earlier views of the sun in such paintings as *Paysage au disque solaire* (*Landscape with Sun Disk*, 1906–07; see fig. 2), metamorphised into a circle and became the basis for the *Circular Forms* paintings that he began in 1912, but with the exception of the great *Premier Disque* (*First Disk*, 1912 [1913]; see fig. 3), this group of works lacks the forceful, single-minded coherence of the other series.

Whereas the *Saint-Séverin* paintings were usually bathed in a blue aura, and the *Eiffel Towers* were usually red, yellow typically predominates in the *Windows* paintings. In *The Windows*, Delaunay moved away from vertically accentuated compositions to formats that were either modestly vertical, square, somewhat horizontal, or emphatically horizontal. The transition to *The Windows* is signaled by the series called *The City*; indeed, these latter works belong to the *Windows* genre, if not by color, then by their format, a sense of transparence and multiple views seen simultaneously, and the urban setting. In the *Windows* paintings, Delaunay created an overarching atmosphere of evenly distributed luminosity. Carried to the verge of pure abstraction, he left only an occasional triangle to recall the slope of the Eiffel Tower. Delaunay appears to have begun each composition with a gridwork of squares or rectangles, many of which are bisected by diagonals; the pattern of diagonals builds to form larger triangles. With *The Windows*, Delaunay entered his "constructive" phase, in which the exterior and interior worlds are sublimely merged on a flat surface of flickering color patches. Space, light, motif, and paint interpenetrate in these airy, allover compositions. His washes of paint, sometimes with little or no sense of a brushstroke, extend the Impressionist gesture to a new level of wispy evanescence. In evaluating the Impressionists in relation to himself, Delaunay wrote: "but how enriched is the picture that is no longer a simulacrum of natural colors but is 'color'."[4] Here is Delaunay's self-proclaimed demonstration of how Impressionism becomes abstraction, for what we witness in *The Windows* is not so much light as its fundamental basis in color.

While Delaunay was the first painter in France to carry on the Cubist pictorial revolution and embrace its obvious intimation of pure abstraction, his primary influence occurred elsewhere and with a slightly less extreme practice. In *The Windows*, Delaunay submerged a motif in a predetermined, gridlike structure, thereby setting forth an approach that was completely embraced by the Munich-based group known as the Blaue Reiter (Blue Rider)—which included

of Paris and our field of vision. Unlike Cézanne's favorite mountain, this human invention always seems near at hand, yet with its top unseen and clouds often present, the awesome size and heavenward orientation are emphasized.

Delaunay's *Eiffel Tower* series defiantly focused attention on the still-controversial structure, built for the Exposition Internationale de Paris of 1889, which epitomized French innovation, progress, and optimism. Cosmopolitan and modern, the Eiffel Tower demonstrated that French culture was flexible and forward-thinking. The tower's form, which slopes toward a triangular top in a manner echoing the cone-shaped crowns of Monet's *Grainstacks* suggested that French enterprise had found a new field of endeavor. In contrast to the Alfred Jarry–inspired, bohemian iconoclasm of the Cubists, whose themes originated indoors, in cafés, Delaunay went outdoors to admire the tall buildings and to evince a dreamy French patriotism.

Vasily Kandinsky, Paul Klee, August Macke, and Franz Marc—in the early 1910s. Delaunay's influence in Germany was yet more extensive if one compares his hallucinatory views of Saint-Séverin to some of Lyonel Feininger's architectural fantasies (see fig. 35), Ernst Ludwig Kirchner's street scenes with churches, and Robert Wiene's film *The Cabinet of Dr. Caligari* (1919; see fig. 17). Indeed, Delaunay's celebration of the Eiffel Tower could have served as an example in America, too, where John Marin glorified the Woolworth building in a 1913 series. Later came Vladimir Tatlin's *Monument to the Third International* (1920), which was a sculptural celebration of a modern building concept. In sum, Delaunay's achievement represents a microcosm of the new millenium and its shift toward urbanization.

1. Delaunay, "Three Notes on the Differences between Delaunay's Art and Impressionism and Expressionism" (1920s?), in Arthur A. Cohen, ed., *The New Art of Color: The Writings of Robert and Sonia Delaunay*, trans. David Shapiro and Cohen (New York: Viking Press, 1978), p. 58.
2. Paul Hayes Tucker, *Monet in the 90s: The Series Paintings* (Boston: Museum of Fine Arts; New Haven: Yale University Press, 1989), p. 153. I am indebted to Tucker's book for the dating of Monet's series.
3. Ibid., pp. 110ff.
4. Delaunay, "Three Notes," p. 58.

Simultaneous Expressions:
Robert Delaunay's Early Series

Matthew Drutt

Detail from a photograph of Robert Delaunay at the age of eighteen, ca. 1903

For most of Robert Delaunay's career, he worked outside of artistic circles or movements. While he absorbed such contemporary styles as Cubism along the way, his paintings retain a singular identity that confounds categorization. Between 1909 and 1914, Delaunay created *Saint-Séverin*, *The City*, *The Eiffel Tower*, and *The Windows*, the four series of paintings that are among the most iconic and renowned bodies of work in Modern art. Focusing on a highly restricted range of subject matter—the interior of the church of Saint-Séverin, the exterior of the Eiffel Tower, and a single, repeated view of the Paris skyline—he undertook a prolonged investigation of the properties of line and color in pictorial construction, seeking to find a new means of visual representation that would reflect the modern era. Determining the evolution of Delaunay's painterly experiments presents a number of challenges, many of which are posed by the artist's practice of working in an elliptical rather than a linear, or consecutive, fashion. He worked on paintings simultaneously, alternating between different canvases or interrupting a subject only to take it up again at a later date. Thus, the seamless flow of one version of a subject into the next occurs intermittently.

There are also problems with the dates inscribed on particular works. Dates were sometimes added or changed years after a painting had been created. In some instances, Delaunay may have wanted to inscribe the date he identified as being that of the series's original conception instead of the date of the individual painting's execution. With the passage of time, it is also possible that the artist became less certain of precise dates of conception or execution. Delaunay returned to these celebrated subjects later in his career with prints that commemorate the archetypal example within a series. While it is known when the prints themselves were executed, sometimes they have been dated in the image to a year when the artist thought the series had been first conceived.

The question of dating is further complicated by the inconsistency of documentary evidence. Many of the early publications in which these paintings appear give either conflicting dates for a single work or refer to a painting so generically that it is difficult to determine precisely which version of a given subject was exhibited. During 1914 to 1921, Delaunay and his wife, Sonia, lived in Spain and Portugal, and notebooks or letters from these years unfortunately do not contain substantial information that might shed light on key points of chronology. Finally, Delaunay's later notes and essays, as well as those of his wife are rife with conflicting dates and references.

Despite this overwhelming mountain of contradictory information, it is nonetheless possible to unravel many of the mysteries surrounding Delaunay's creative evolution. The current exhibition, which brings the artist's major series

together for the first time in a tightly focused fashion, provides us with a renewed opportunity to consider the problems inherent in the development of his art. In so doing, we reassert the importance that Delaunay holds for early twentieth-century painting, a status that was much heralded within his own lifetime but has gradually diminished over the fifty-odd years since his death.[1]

Early Years (1885–1908)

Robert Delaunay was born in Paris in 1885 to a family of secure financial means, providing him with the stability early in life to pursue a career in art unfettered by the usual concerns for income. His parents divorced in 1889, and his mother, Countess Berthe Felicie de Rose, often traveled abroad; he ended up essentially in the care of his maternal aunt, Marie, and her husband, Charles Damour, spending a great deal of his time in their country estate in La Roncière. At the age of seventeen, after demonstrating a persistent lack of academic ability, he undertook a two-year apprenticeship with a theater set painter, Ronsin, in Belleville. This was the extent of any formal training Delaunay might have received as an artist, and he shortly thereafter embarked on his own, teaching himself by painting from nature and imitating the prevailing trends shown in the annual salons and art galleries of Paris.

Delaunay's earliest known paintings, six of which were exhibited for the first time in Paris at the 1904 *Salon des Indépendants*, reveal the formative role Impressionism played in his development. While not particularly original, they nonetheless indicate a sensibility that emerged more distinctly in his later works. For instance, *Les Bords de la Yèvre* (*The Banks of the Yèvre*, 1903, fig. 1), a painting reminiscent of Camille

fig. 1. *Les Bords de la Yèvre* (*The Banks of the Yèvre*), 1903. Oil on canvas, 72.5 x 91.5 cm (28 9/16 x 36 inches). Musée National d'Art Moderne, Centre Georges Pompidou, Paris, Donation of Sonia and Charles Delaunay, 1963

fig. 2. *Paysage au disque solaire* (*Landscape with Sun Disk*), 1906–07. Oil on canvas, 55 x 46 cm (21 ¹¹/₁₆ x 18 ¹/₈ inches). Musée National d'Art Moderne, Centre Georges Pompidou, Paris, Donation of Sonia and Charles Delaunay, 1963

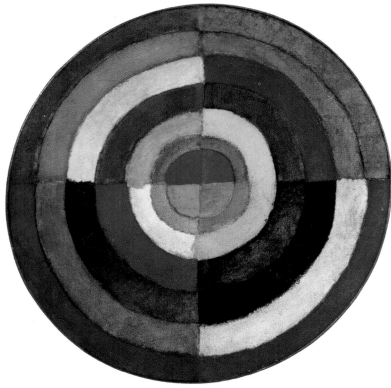

fig. 3. *Premier Disque* (*First Disk*), 1912 [1913]. Oil on canvas, 134.6 cm (53 inches) in diameter. Private collection, Switzerland

Pissarro's work, testifies to Delaunay's interest in the shifting color values of light and their effect on form. This concern became a focal point of his art scarcely a decade later, and though his tenure as an Impressionist was brief, years later he often cited its importance for the evolution of his art.[2]

Delaunay's transition away from Impressionism was swift, and over the next few years as he became proficient with a given technique he moved on from one style to the next. By 1905–06, amid the camaraderie of Jean Metzinger (whose 1912 essay "Cubism," written with Albert Gleizes, would define Cubist theory), Delaunay was exploring the painterly science of neo-Impressionism, a style characterized by Pointillism, a technique of applying clusters of harmoniously contrasting colors to create the impression of a single resulting color. Such experiments were fed by a revived interest in the nineteenth-century color theories of Michel Eugène Chevreul and Ogden N. Rood, about whom Delaunay and Metzinger apparently corresponded.[3] In particular, Chevreul's laws of simultaneous contrast of colors—proposing that two contrasting colors produce the impression of a third—provided a touchstone for Delaunay's own theories of light and color. Chevreul and Rood also played a key role in shaping the art of Georges Seurat, neo-Impressionism's most luminous of painters, whom Delaunay greatly admired.

Perhaps first impressed by the large Seurat retrospective at the 1905 *Salon d'Automne*, Delaunay later declared:

One of the great first theoreticians was Seurat. Seurat struggled against the exuberance of his time with the search for true constructive means. He goes back to nature as the source of reality: light. He had more restraint than his peers. He almost touched the great reality. His accidental death prevented him perhaps *from creating for us true Beauty.*[4]

Paysage au disque solaire (*Landscape with Sun Disk*, 1906–07, fig. 2) exemplifies Delaunay's neo-Impressionist efforts. Composed of broad strokes of vibrant color, it bears a distinctly mosaic-like design. The coarsely rendered landscape offers the clearest indication to date of the artist's fascination with the spectral radiance of natural light. The painting celebrates the sun as a kind of icon, abstracted into the form of a radiating disk (like a color wheel); it offers a clear source for Delaunay's pioneering *Disk* paintings of 1913 (for example, fig. 3),[5] the first nonobjective works created by a French artist. Delaunay's art from this period also bears a likeness to the neo-Impressionist paintings of Henri Edmond Cross, whose works probably became known to him through an important exhibition at Galerie Druet in 1905.

In 1906, Delaunay painted his "première vision de la peinture future,"[6] *Manège de Cochons* (*Carousel of Pigs*, fig. 4). He considered this dreamlike apparition of a carousel at a fairground to be a significant turning point, so much so that he revisited the subject again in 1913 and 1922.[7] The painting

fig. 4. *Manège de Cochons* (*Carousel of Pigs*) (fragment), 1906 (verso of *The Window on the City No. 3*, 1911–12). Oil on canvas, 113.7 x 130.8 cm (44 ¾ x 51 ½ inches). Solomon R. Guggenheim Museum, New York 47.878.2

from 1906 has remained largely unknown except through written descriptions, since Delaunay had supposedly destroyed it in frustration when the 1906 *Salon d'Automne* rejected it.[8] However, a large fragment from this painting was recently identified on the back of *La Fenêtre sur la ville n° 3* (*The Window on the City No. 3*, 1911–12, cat. no. 21).[9] Far from destroying the work, he apparently cut down the canvas, whitewashed the painted side, and started a new composition on the other side. We can be certain that this is the painting from 1906 for two reasons. First, it clearly depicts the subject as described by Delaunay in his notebooks:

Electric prism; dissonances and concordances of colors; an orchestrated movement striving for a great flash; inspired by a vision of a popular fair, striving for the sort of violent rhythm that African music achieves instinctively; cold and warm colors dissect each other, redissect each other violently, harmonics in comparison with traditional academic harmony.[10]

Second, the figures astride the carousel pigs are treated with broad strokes of garish color, as in a Fauve work, while the haloed globes of electric light bear a striking resemblance to the sun in *Landscape with Sun Disk*. Thus, the confluence of neo-Impressionist and Fauvist traits places this fragment exactly within the years when Delaunay's art was making a transition to Fauvism.

1906 was also the year that Delaunay first met Henri Rousseau, who became a close friend in the ensuing years. Indeed, after Rousseau's death in 1910, Delaunay took it upon himself to look after the artist's legacy, attempting to

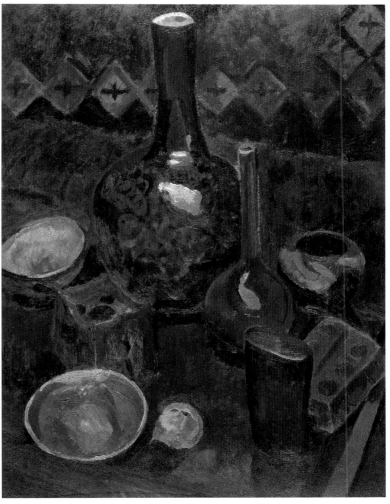

fig. 5. *Nature morte bleue* (*Blue Still Life*), 1907–08. Oil on canvas, 58 x 45 cm (22 ¹³⁄₁₆ x 17 ¾ inches). Musée National d'Art Moderne, Centre Georges Pompidou, Paris, Donation of Sonia and Charles Delaunay, 1963

publish a book on his work and promote his paintings through commercial galleries.[11] While Delaunay never adopted any stylistic devices from Rousseau, the latter's inclusion of the Eiffel Tower, airplanes, and dirigibles in his views of Paris may well have been the inspiration for Delaunay's own versions of such subjects, for example, *Dirigeable et la tour* (*Dirigible and the Tower*, 1909, fig. 8) and *Paysage de Paris* (*Landscape of Paris*, 1908–09, fig. 26).

Although the Fauve character of Delaunay's work continued to evolve through 1908–09, beginning in 1907—as a consequence of his first encounter with the work of Paul Cézanne—his approach to pictorial construction began to fundamentally change. Delaunay's writings are rich with references to Cézanne's historic role in reconceptualizing representation, stating for example that he "demolished all painting since its inception, that is to say, *chiaroscuro* adapted to a linear composition which predominates in all known schools."[12] Cézanne's influence can be plainly felt in a work like *Nature morte bleue* (*Blue Still Life*, 1907–08, fig. 5), in which the rendering of forms has become more simplified and the overall feeling less decorative or patternlike than in earlier

works. Even more notable is the Cézanneian treatment of space, where the background dissolves into the foreground and everything seems tilted and compressed toward the picture plane. Delaunay's dialogue with Cézanne's art resonated throughout his career, graduating swiftly from the imitative reverence of this still life and evolving into his own experiments with simplified volumes and fractured space.

After serving a year of military service in Laon—during which he spent much of his time in the library reading German philosophy—Delaunay returned in the fall of 1908 to a Paris that was experiencing the throes of Cubism's emergence. Daniel H. Kahnweiler had begun showing the works of such artists as Georges Braque, Juan Gris, and Pablo Picasso the year before. By 1908, knowledge of their works began to spread through gallery exhibitions and private salons. Delaunay's awareness of Cubism was nurtured by these exhibitions and through his inclusion in gatherings at both Gertrude Stein's and Wilhelm Uhde's homes. Uhde was an art dealer whose wife, Sonia Terk, would eventually marry Delaunay. Cubism's extension of the pictorial principles developed in Cézanne's art made a significant impression upon Delaunay, leading him toward the paintings that comprise his first mature works.

Saint-Séverin (1909–10)

Delaunay's absorption of the art of Cézanne and of Cubism is most successfully first expressed in the group of works depicting the church of Saint-Séverin in Paris. Widely regarded as the artist's first series, and certainly his first major body of work, the *Saint-Séverin* paintings represented for him "the passage from Cézanne to the confusion that followed and to the destructive patterns of this period."[13] It was, as he was fond of calling it, his "destructive" period, in which "the uncertainty of earlier methods" gave way to "the search for another aesthetic."[14] This rite of passage, in which Delaunay had to dismantle years of understanding representation according to conventional uses of line and perspective, propelled him from being an artist who followed trends into one who created them. For when these paintings were finally exhibited, beginning in 1910, Delaunay was embraced by artists and critics at home and abroad as a peer of great distinction.

The *Saint-Séverin* paintings are very Cézannesque in character, not only in their palette and brushwork but also in their structure of exaggerated arcs, which is reminiscent of the way in which Cézanne distorted forms to create a unified pictorial system in such works as *Les Grandes Baigneuses* (*The Large Bathers*, 1906, fig. 7). But whereas Cézanne, and Delaunay's Cubist peers, deliberated over subjects traditional to classical painting—landscapes, still lifes, nudes—Delaunay turned to an architectural monument from another era and subjected it to the language of the present. Located in the Latin Quarter,

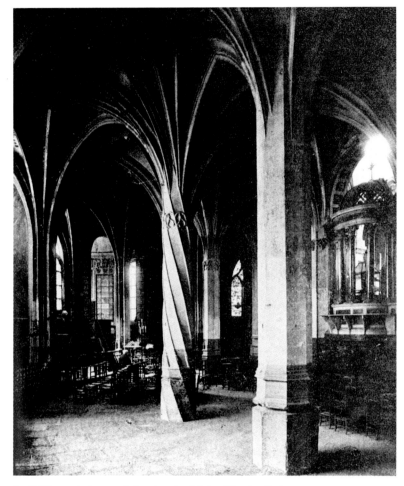

fig. 6. The ambulatory of the church of Saint-Séverin, Paris

not far from where the artist's studio was at the time, the church was originally built in the thirteenth century, although the view depicted by Delaunay shows a section rebuilt after a fire in the mid-fifteenth century.[15] The stained-glass windows, whose refracted light captured Delaunay's imagination, have been replaced since the paintings were done, though an early photograph (fig. 6) gives us a sense of what the church might have looked like at the time.

Consisting of seven paintings, at least eight sketches or finished drawings, one watercolor, and several lithographs executed later in the 1920s, all of the works in the *Saint-Séverin* series represent an identical view of the ambulatory of the church, looking northeast. In this regard, they have often merited comparison with Claude Monet's *Rouen Cathedral* series (1892–94; for example, see p. 12). Like Monet, Delaunay celebrated a French Gothic landmark[16] and made a protracted study of the effects of light at different times of day using a fixed subject. Indeed, though referring specifically to Monet's *Haystacks* (1888–91), Delaunay praised his "accidental" discovery of the "simultaneity of color" resulting from an identical subject viewed through a "succession of differently colored effects."[17]

However, not all of Monet's views of Rouen Cathedral

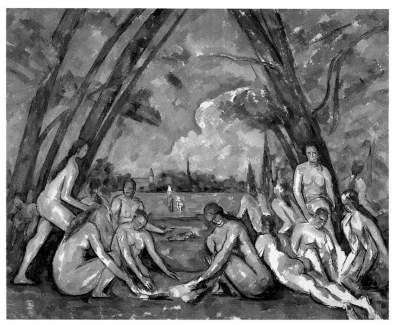

fig. 7. Paul Cézanne, *Les Grandes Baigneuses* (*The Large Bathers*), 1906. Oil on canvas, 208.3 x 251.5 cm (82 x 99 inches). Philadelphia Museum of Art, Purchased with the W. P. Wilstach Fund

fig. 8. *Dirigeable et la tour* (*Dirigible and the Tower*), 1909. Oil on cardboard, 34.8 x 26.8 cm (13 11/16 x 10 9/16 inches). Courtesy of Galerie Gmurzynska, Cologne

fig. 9. *Vue de Paris: Notre-Dame* (*View of Paris: Notre-Dame*) [*La Flèche de Notre-Dame* (*The Spire of Notre-Dame*)], 1908. Wax on canvas, 58 x 38 cm (22 7/8 x 15 inches). Öffentliche Kunstsammlungen Basel, Kunstmuseum, Donation of Marguerite Arp-Hagenbach, 1968

are identical; he occasionally cropped the façade differently or included people. What is remarkable about Delaunay's *Saint-Séverin* series is the absolute consistency of the view represented, with only color, scale, and slight formal modulations setting each painting apart. It is almost as if he had worked from a reproduction, such as a postcard or a photograph, a practice he had already become fond of, as with his earlier paintings *Dirigible and the Tower* (fig. 8) and *La Flèche de Notre-Dame* (*The Spire of Notre-Dame*, 1908, fig. 9).[18] However, unlike these well-documented cases, the existence of preparatory studies (all 1909, figs. 10–13, cat. no. 5) suggests that Delaunay recorded his impressions of Saint-Séverin on site and returned to his studio to work out the details. The studies contained in a sketchbook demonstrate a preoccupation with the form of the arches in the vaulted ceiling (figs. 10–13) and the way in which the pillars flow upward like a fountain (fig. 13; this impression, which strikes you as soon as you enter the church, is hard to get from looking at photographs). In one of the studies (fig. 11), Delaunay deliberated over the angularity of the arches and seems to be blocking out the basis of the composition's structure. It exemplifies his comment: "I have never in my life seen a straight line. . . . They look as if they were straight, but they never are straight."[19]

The *Saint-Séverin* series is generally thought to have originated in the spring or summer of 1909 and to have continued into 1910 (with one picture being reworked in 1915). However, while accepting that the studies were executed in the spring, Sherry Buckberrough dates the first paintings to the fall, based on their formal similarity to plant studies that Delaunay made during the summer, such as *Saint-Cloud. Etude*

de paysage (*Saint-Cloud. Study of Landscape*, fig. 14, which, although inscribed "1910," is probably from 1909).[20] Though most of the *Saint-Séverin* paintings have inscriptions dating them to 1909 or 1909–10 and numbering them one through seven, the confusion about the chronology of the works stems in part from Delaunay's own lapses regarding dates and from the stylistic variances between them. In one essay, he dated the inception of the *Saint-Séverin* series to 1907,[21] a date he also inscribed in the image of a *Saint-Séverin* lithograph executed in 1928 (fig. 15). The last painting, *Saint-Séverin n° 7* (*Saint-Séverin No. 7*, cat. no. 12), is inscribed "1908." As Angelica Zander Rudenstine points out, a date before 1909 is unthinkable, if not only for purely stylistic reasons, than also for the fact that the paintings were exhibited or published soon after completion with the date of 1909.[22] Furthermore, in 1912, Delaunay himself dated the series to 1909–10.[23] Delaunay's subsequent erroneous dates, which occurred almost twenty years later, might in part be ascribed to faulty memory or to his desire to date the works to the point at which he first conceived of the subject.

In examining the paintings, we see a variation of handling that obfuscates the chronology suggested by their numerical sequence. *Saint-Séverin n° 1* (*Saint-Séverin No. 1*, cat. no. 1), inscribed "R.D. 09," has a dark bluish cast, with highlights in yellow and green indicating where light falls on the pillars. Overall, it is a very detailed description of the space, with specific architectural features of the pillars fully drawn. The cropping of the pillars on either side of the foreground frames the view. The exaggeration of the arch's curvature, described in an early study for *Saint-Séverin* (probably 1909,

fig. 10. Study for *Saint-Séverin*, 1909. Pencil on paper, 17.5 x 10.5 cm (6 ⅞ x 4 ⅛ inches). Location unknown

fig. 11. Study for *Saint-Séverin*, 1909. Pencil on paper, 17.5 x 10.5 cm (6 ⅞ x 4 ⅛ inches). Location unknown

fig. 12. Study for *Saint-Séverin*, 1909. Pencil on paper, 17.5 x 10.5 cm (6 ⅞ x 4 ⅛ inches). Location unknown

fig. 13. Study for *Saint-Séverin*, 1909. Pencil on paper, 17.5 x 10.5 cm (6 ⅞ x 4 ⅛ inches). Location unknown

cat. no. 5), is subtle yet clear. A faint resonance of Cubism is present in the crystalline structure of the floor.

However, in what should be the next painting in the series, few of these features can be found. *Saint-Séverin nº 2* (*Saint-Séverin No. 2*, cat. no. 2), inscribed "1909" on the back, is smaller in size, and its monochromatic blue cast is slightly brighter in hue. Inscribed on the back as the second study of Saint-Séverin, it has the feeling of an oil sketch, in which the artist is thinking his way through the composition directly on the canvas. The painting is executed in a rougher fashion than *Saint-Séverin No. 1*, offering a more abbreviated description of form and space in keeping with a sketch. The rendering of the interior is more straightforward, with less of the expressive distortion found in the first painting. While perhaps more sober than any of the other paintings in the series, it was nonetheless the first to have been exhibited.[24]

Saint-Séverin nº 3 (*Saint-Séverin No. 3*, cat. no. 3) is not inscribed with a date, but Rudenstine convincingly assigns it to 1909–10, arguing that this version may not yet have been completed when *Saint-Séverin No. 2* was exhibited in March 1910 at the *Salon des Indépendants*.[25] The palette of the work is distinctly Cézanneian, with brown, green, and blue offset by blue highlights. It has many of the expressive qualities found in *Saint-Séverin No. 1*, but overall the forms are softer, especially the faceted planes of the floor, which are broader and more subtle. Of all of the paintings in the series, *Saint-Séverin No. 3* was apparently the one that Delaunay considered most representative; in almost every reference to the series in his letters and notebooks, Delaunay used this version as the example for the series. Two studies for *Saint-Séverin* (cat. nos. 5 and 6) are each inscribed "Musée de Mannheim," identifying them with *Saint-Séverin No. 3* (first purchased by Städtische Kunsthalle Mannheim in 1928), even though they bear little specific

resemblance to this painting. The finished character of one of the studies (cat. no. 6) suggests that it was made after the painting was completed, indicating that it probably dates from 1910. Also, a *Saint-Séverin* lithograph from the mid-1920s (see p. 10) carries the same Mannheim inscription and comes closer to representing the demeanor of the painting.

Saint-Séverin nº 4 (*Saint-Séverin No. 4*, cat. no. 4) is inscribed "1909" and is closer in scale and treatment to *Saint-Séverin No. 2*. The pillars and vaults are angled toward the left, but with less exaggeration than the first and third versions. While the palette is similar to *Saint-Séverin No. 2*, Delaunay began to introduce more variation with brighter contrasting colors, such as orange and emerald, which appear in the floor and vaulting. The drawing is also much more linear than in the second version. If we accept that *Saint-Séverin No. 3* was finished in 1910, it is hard to reconcile *Saint-Séverin No. 4* as being finished earlier, unless he worked on both paintings at the same time. Because an early, fully completed *Eiffel Tower* painting (cat. no. 23), probably dating to the fall of 1909, is on the verso of *Saint-Séverin No. 4*, a date of late 1909 to very early 1910 can be suggested for this fourth version.

The next two paintings are quite small, and at least formally very similar. Beautiful emerald greens and bright blues dominate *Saint-Séverin nº 5. L'Arc-en-ciel* (*Saint-Séverin No. 5. The Rainbow*, cat. no. 9). It is a composition filled with a glowing yellow sunlight and carries the curious subtitle of rainbow, perhaps identifying the spectral radiance of a rainbow with the refracted sunlight that passes through the stained-glass windows. Inscribed on the back "1909–10" and "époque du 'Saint-Séverin'," it was purchased by its present owner in 1918. The latter inscription suggests that Delaunay was using the dates 1909–10 to generically refer to the series. Given its style and numerical location in the series, however, the pre-

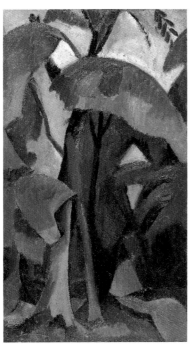

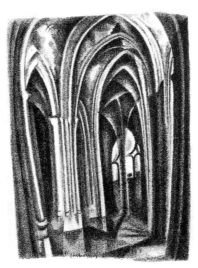

fig. 15. *Saint-Séverin*, 1928. Lithograph on paper, 65 x 51 cm (25 ⁹/₁₆ x 20 ¹/₁₆ inches). Collection of B. and J. Gheerbrandt, Paris

fig. 16. Otto Morach, *Betende Frau im Dom* (*Praying Woman in the Cathedral*), 1914–15 (verso of *Asphaltworkers*, 1916). Oil on canvas, 115 x 86 cm (45 ¹/₄ x 33 ⁷/₈ inches). Kunstmuseum Winterthur

fig. 17. Film still from Robert Wiene's *The Cabinet of Dr. Caligari* (1919)

fig. 14. *Saint-Cloud. Etude de paysage* (*Saint-Cloud. Study of Landscape*), 1910 [1909]. Oil on canvas, 61 x 50 cm (24 x 19 ¹¹/₁₆ inches). Musée National d'Art Moderne, Centre Georges Pompidou, Paris, Donation of Sonia and Charles Delaunay, 1963

sent work must date from 1910. Broad planes of color from the floor cut into the pillars at left, and along with the subsequent version, *Saint-Séverin n° 6* (*Saint-Séverin No. 6*, cat. no. 10), it is the most expressive and animated work in the series.

Although *Saint-Séverin No. 6* is not inscribed with a date, it is clear that by now Delaunay must have been working on the series in 1910. It is the smallest of any of the *Saint-Séverin* paintings and is further distinguished by the fact that it is painted on metal. Delaunay painted few works on metal, a practice that has a distinguished history in seventeenth-century painting as a medium for virtuoso expression. The surface of metal is slick and unforgiving, so that mistakes are very difficult to correct. Moreover, a metal support renders the color on its surface more luminous. Given Delaunay's interest in light and color, it is surprising that he did not attempt such works more often.

Saint-Séverin No. 7, the last and largest work in the series, presents a few problems. It is inscribed on the back "1908," but according to Guy Habasque's catalogue raisonné, Delaunay reworked the composition when he was in Portugal in 1915.[26] Its rainbowlike palette, especially the disk on the floor, resembles Delaunay's *Circular Forms* paintings, which he began in 1912. However, it contains less of the formal drama found in the fifth and sixth versions, but rather feels more linear as with the first and third versions. Thus the possibility exists that it could have been started along with those works dating to 1909 and left unfinished until 1915.

What we might conclude from this summary of the characteristics of the *Saint-Séverin* paintings is that Delaunay probably worked on more than one at a time, and may have even gone back and reworked certain compositions after progressing further in the series. Despite the date inscribed on *Saint-Séverin No. 7*, it seems highly unlikely that he could have begun the series in 1908. If we accept that the studies in his sketchbook are preparatory—and their tentative character certainly suggests that they are—then the series could not have begun until the spring of 1909 at the earliest, since the studies follow others in the same book made at an aerial exposition in Paris in spring 1909.[27]

In looking back on these works, Delaunay assessed his accomplishments critically:

In Saint-Séverin, one sees a will towards construction, but the form is traditional. The refractions [of light] appear timid. The light shatters the lines in the arches and across the floor. The color is chiaroscuro, [and] in spite of the decision made not to copy nature objectively, it still creates perspective. As with Cézanne, the contrasts are binary and non-simultaneous. The reactions of colors convey the line. The modulation is still classical expression in the sense of expressive craft. This picture well indicates the expressive desire of a new form, but it doesn't quite get there.[28]

Despite his own apparent disappointment with the series, the paintings gained attention when he began to exhibit them. When Guillaume Apollinaire first encountered *Saint-Séverin No. 2* in the 1910 *Salon des Indépendants*, he likened it to an earthquake.[29] In the preface to Delaunay's important exhibition at Galerie Barbazanges in 1912, which included *Saint-Séverin No. 1*, Maurice Princet remarked:

His reasonings are not a delicious acrobatics of ingenious paradoxes; his reflections lead neither to mathematical formulas nor to mystical symbols of the Cabal; they orient it simply and naturally towards pictorial realities, colors and lines. He expresses himself with mass and values.[30]

Moreover, the appearance of *Saint-Séverin No. 1* in Germany helped solidify Delaunay's reputation in that country. Certainly the painting's Gothic, mannered character found a welcome reception amid the climate of German Expressionism. Delaunay was invited by Vasily Kandinsky to participate in the first exhibition of the Blaue Reiter (Blue Rider) group, which was held December 1911–January 1912 at the Moderne Galerie Thannhauser in Munich. Among the five works Delaunay sent was *Saint-Séverin No. 1*, which was purchased from the exhibition by Adolf Erbslöh, a German painter who was a founding member of the Neue Künstlervereinigung München (New Artists' Society of Munich). In 1912, the painting was also reproduced in *The Blaue Reiter Almanac*, with an essay exploring Delaunay's method of pictorial construction by E. von Busse, in which he observed:

The artist intends to focus the viewer's attention on the center. He achieves this not by content or objects (objects moving to a particular point) but by an adequate dynamics of space. This is created by a proportionate distribution and correspondence of colors, as well as by curving lines corresponding to the motion.[31]

He went further, likening Delaunay's accomplishments to Eugène Delacroix.

By 1916, German critics regarded Delaunay as "the first known Expressionist,"[32] and as if in homage to that status, both Heinrich Davringhausen and Otto Morach produced paintings (for example, fig. 16) clearly indebted to the example of *Saint-Séverin*.[33] Finally, Delaunay repeatedly claimed that the *Saint-Séverin* series had influenced the sets for Robert Wiene's 1919 Expressionist film, *The Cabinet of Dr. Caligari* (fig. 17). This is certainly plausible, for the sets were conceived by artists affiliated with Herwarth Walden's Der Sturm gallery, where Delaunay began exhibiting in 1912, and the expressive arches that are the hallmark of the *Saint-Séverin* paintings abound in different scenes of the film.[34]

The City (1909–11)

At the same time as the *Saint-Séverin* series was evolving, another serial group of works, *The City*, was taking shape. However, unlike the former group, Delaunay's *City* paintings of 1909–11 follow a more logical chronology in terms of numerical identification and stylistic evolution. They are in both format and general conception the basis for the *Windows* series of 1912–14. However, since they are markedly different

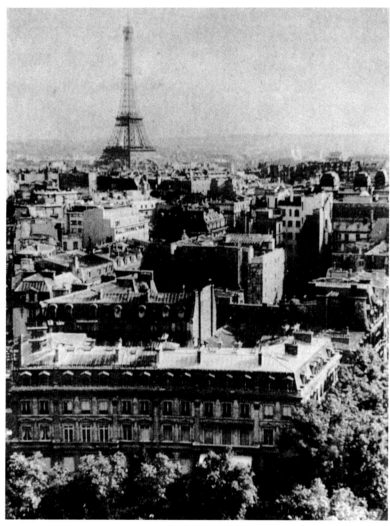

fig. 18. View toward the Eiffel Tower from l'Arc de Triomphe, Paris. Postcard collected by Robert Delaunay. Bibliothèque Nationale, Paris, Fonds Delaunay

in several respects, and since Delaunay himself treated them as a separate series, it seems prudent to isolate them. There are eight paintings and one watercolor, all of which essentially show the same view of Paris, looking toward the Eiffel Tower from the southwest. It has been shown that, in fact, this view was based upon a postcard in Delaunay's possession (fig. 18).[35] As in most postcard views of the time, the tower soars above the Parisian cityscape. Though Delaunay had included the tower as an element in such earlier works as *Dirigible and the Tower*, this is the first group of paintings in which it becomes a repeated, centralized motif that dominates the skyline of Paris.

The first painting in the *City* series, the study for *La Ville* (*The City*, 1909, cat. no. 13), is an unfinished sketchlike oil on the back of *Saint-Séverin No. 2*, which has been covered by a wax lining since 1952.[36] It represents the basic composition of buildings found in the postcard, except that it leaves out almost all the windows on the building in the foreground and includes a large Ferris wheel in the upper left, which used to be near the Eiffel Tower (see fig. 19). The upper third of the tower is cut off, and the foreground view is more constrained

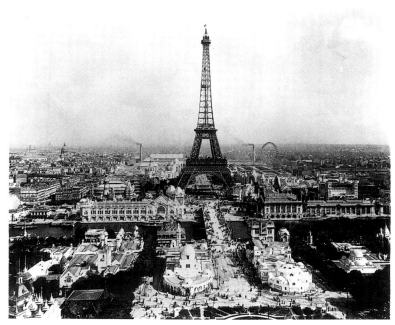

fig. 19. View of the Eiffel Tower and a Ferris wheel (right background) at the Exposition Internationale de Paris, 1878

than in later versions. Large areas are left unpainted, including the area at the upper right where the inscription for the painting on the front appears. However, part of the inscription appears to be painted over the composition, suggesting that the back was painted before the front. Furthermore, as this work is much closer stylistically to paintings done around the late summer of 1909—for example, *Usine à Chaville* (*Factory at Chaville*, fig. 20)—it begs the question as to whether or not this painting precedes his first *Saint-Séverin* paintings.

The *City* series is generally dated to early fall 1909,[37] but it is hard to reconcile it stylistically with the earliest *Saint-Séverin* paintings, which presumably date from the same period. Those paintings show a greater sophistication of handling and a more resolved conceptual structure. Moreover, in 1912, Delaunay placed *The City* before *Saint-Séverin*,[38] though subsequently he placed the series afterward (albeit dating *Saint-Séverin* to 1907–08).[39] Thus, the study for *The City* (cat. no. 13) could even precede the works created in Chaville in August 1909.

The next painting in the *City* series is the study for *La Ville* (*The City*, 1909, cat. no. 14), which is squarer in format (like the *Windows* paintings) and sketchier in conception. The same key elements of the previous composition are present, but they are described with fewer features. The Ferris wheel is a crescent-shaped line. The buildings are described in broad geometric planes of blue and white, differentiated from one another by subtle contrasts in shading. This painting also shows the beginnings of contorted architectural forms, a feature that will distinguish subsequent versions. Formally, the painting vaguely resembles the Cubist works

Braque and Picasso painted in summer 1909, which would be a reason to place this work later in 1909. Too much should not be made of the painting's style, however, since it still has the rough quality of a sketch, which it was clearly meant to be.

A more finished-looking version is *Ville. Première Etude* (*City. First Study*, probably 1909–10, cat. no. 15), which is distinguished both by its copious detail and for the fact that it excludes the upper half of the composition found in both the previous and subsequent versions. This latter feature, which gives it the horizontality of a landscape painting, has prompted speculation that it was cut in half at some point.[40] If this were the case, then the painting would have been among the largest Delaunay had painted to date (it is comparable in scale to the contemporaneous *Saint-Séverin No. 1* and *Saint-Séverin No. 3*). Less abstract than the studies for *The City* (cat. nos. 13 and 14), it does nonetheless have some of the distorted linearity found in *Saint-Séverin No. 3*, which suggests that this work should be dated to very late 1909 or early 1910. The fact that it is known as "first study" is a bit confusing, since the two other versions clearly precede it. However, this subtitle could suggest that *City. First Study* was the first *City* painting in which all of the desired elements were satisfactorily realized. Indeed, Rudenstine, who prefers a date of 1910, contends that it is a study for the following painting.[41]

La Ville n° 1 (*The City No. 1*, 1910, cat. no. 16) is the first fully completed version of the *City* series, but it is known only through a black-and-white reproduction.[42] The painter Alexei von Jawlensky purchased it when it was shown as no. 16 in the first Blue Rider exhibition of 1911–12,[43] but the painting has been missing since leaving his possession, perhaps during or after World War I. It most likely conformed to the same range of colors present in the preceding versions: gray-blue shifting to a darker blue with white highlights and occasional brown tones and green for foliage. This version shows another step in Delaunay's progression toward Cubism, with a greater simplification of the architectural forms offset by an exaggerated curvilinearity, and with the foliage at the bottom of the composition reduced to broad patches of stippled brushwork.

The painting thought to complete the first cycle of the *City* series is *La Fenêtre sur la ville* (*The Window on the City*, 1910/1914, cat. no. 17). While its composition is similar to the previous version, it contains significant differences: the Eiffel Tower has shifted location and the composition is more abbreviated. Begun in 1910, the painting was considerably reworked in 1914,[44] transforming it stylistically in such a manner that it belongs more to the *Windows* series, thus it is really a hybrid of two different periods in Delaunay's art, one formative, the other definitive.

The last three *City* paintings, *La Ville n° 2* (*The City No. 2*, 1910, cat. no. 19), *La Ville* (*The City*, 1911, cat. no. 20),[45] and

fig. 20. *Usine à Chaville* (*Factory at Chaville*), 1909. Oil on canvas, 60 x 30.5 cm (23 ⅝ x 12 inches). Location unknown

The Window on the City No. 3, 1911–12 (cat. no. 21), belong to another cycle of work on the subject. As Rudenstine points out, in both style and handling they seem to postdate Delaunay's *Eiffel Tower* paintings from the summer of 1910 (for example, cat. nos. 24 and 25).[46] In fact, it is likely that Delaunay was working not only on *Eiffel Tower* paintings at that time but also on the *Saint-Séverin* series, so that the *City* paintings evolved over a more expanded time frame.

When Delaunay returned to the *City* series, probably in late 1910, his treatment of the subject underwent a profound change. The watercolor *La Fenêtre sur la ville* (*The Window on the City*, 1910–11, cat. no. 18)[47] shows the beginnings of this change. Bathed in yellow, it seems preoccupied with light and rhythm. Billowing forms on either side of the composition

suggest curtains. The Eiffel Tower is now depicted as a rust-colored object, forming a bridge between the *Eiffel Tower* paintings of the summer and the next cycle of *City* paintings. In those *City* paintings, Delaunay applied a more angular, fragmentary, and abstract design to the compositions, by now fully reflecting a Cubist sensibility. The more refracted handling of color and form is offset by the inclusion of intermittent Pointillist brushwork (not seen in his paintings since 1908), which provides an effect like the glare of light on a window. Furthermore, the appearance of curtains at either side of the compositions, perhaps first applied in *The Window on the City* (cat. no. 17), reinforces the sense of a view through a window.[48] In the last work in the series, the word "window" appears in the title of a *City* painting for the first time; thus, *The Window on the City No. 3* provides the definitive link between the *City* and *Windows* paintings.

The City No. 2 is inscribed "1910," while the related *The City* (cat. no. 20) is inscribed "1911." Rudenstine, arguing that these two works are syntactically consistent with *The Window on the City No. 3*, which can be securely dated to December 1911–January 1912,[49] refutes the 1910 date of *The City No. 2*, locating all three works to the last six to nine months of 1911.[50] Certainly, *The Window on the City No. 3* grows out of the previous two paintings, but insisting that a longer hiatus between *The City* and *The Window on the City No. 3* could not have occurred is too limiting. Although its field of Pointillist brushwork indeed ties it to the other two paintings, *The Window on the City No. 3* fundamentally differs from them in several key respects.

While *The Window on the City No. 3* still represents the basic view we are by now familiar with, the Eiffel Tower has shifted toward the central axis. The palette has exploded into a new range of colors, including lavenders, greens, and yellows, and the composition is broken into a pattern of triangulated squares. The format is also horizontal, and more squared off, not vertical like *The City No. 2* and *The City*. *The Window on the City No. 3* has graduated firmly into the realm of the *Windows* paintings, which while clearly related to the *City* paintings, are formally and conceptually distinct. Thus, given the fact that Delaunay was working hard on the *Eiffel Tower* series and other individual works in 1910 and 1911, Virginia Spate is correct in concluding that *The City No. 2* was begun in late 1910 and *The City* in the middle of 1911.[51]

Like the *Saint-Séverin* series, the *City* series helped establish Delaunay's reputation as a leader among the emerging generation of artists in Europe. Apollinaire's remarks in 1910 likening Delaunay's paintings to earthquakes were probably as much in response to one of the *City* paintings—perhaps *The City No. 1*—as they were to *Saint-Séverin No. 2*.[52] At least one of the paintings in the series, perhaps two, appeared in the celebrated 1911 *Salon des Indépendants*.[53] This exhibition,

and gallery 41 in particular, was the public debut for Cubism as a movement, with works by such artists as Gleizes, Gris, Henri Le Fauconnier, Fernand Léger, and Metzinger announcing a new artistic vanguard. Amid the public outcry that these works provoked, it was again Apollinaire (who in this same year was to befriend Delaunay) who defended the new art, singling out Delaunay for praise:

Among the best gifted of these artists, one should salute Robert Delaunay, who has a grandeur and wealth of robust talent. The exuberance that he reveals guarantees his future. He develops in drawing and coloring, which are strong and lively.[54]

In Germany, the *City* paintings were the core of his presence in the first Blue Rider exhibition of 1911–12, accounting for two of the five works shown: *The City No. 1* and the watercolor *The Window on the City* (cat. no. 18). Shortly after the exhibition opened, Kandinsky wrote to Delaunay: "The artists who took part in the 'Blue Rider' exhibition have asked me to send you your kindest regards. We are very glad to have you with us."[55] As with *Saint-Séverin*, it was Delaunay's articulation of space in these paintings, and their dramatic movement and rhythm, that caught the eye of his Expressionist colleagues. Again, Busse's comments in *The Blaue Reiter Almanac* are noteworthy:

With the second Ville *Delaunay's formal development reached a stage at which he could stop for a while. He began to make use of his experiences in other aspects of painting. First he used the "landscape," or only a certain part of it, to demonstrate his ideas; then he decided to extend his ideas to everything that his eye and mind can conceive: the inherent laws of everything that exists and its subjective understanding and representation.*[56]

The influence of the *City* series was again felt by many. One notable example was Ludwig Meidner, an Expressionist painter active in Berlin, who at the very latest would have seen *The City No. 2* in 1912, when it was on exhibition at Walden's Der Sturm gallery. Meidner's apocalyptic visions of the city, such as *Brennende Stadt* (*Burning City*, 1913, fig. 21), are clearly indebted to Delaunay's example.

In choosing the city as his subject, and depicting it in a way that was dynamic and erupting, Delaunay was ahead of his contemporaries. As noted earlier, with a few isolated exceptions, the Cubist subject was traditional: landscape, still life, and nude. Delaunay's early embrace of the urban milieu as subject, in a manner far more charismatic than his Impressionist forebears, was not completely without context, however. Certain literary figures, most notably Jules Romains, venerated the city in their writings shortly after the turn of the century. In Romains's work, the city became synonymous

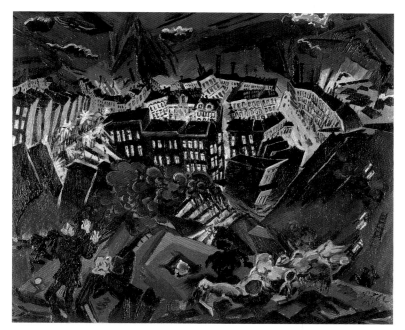

fig. 21. Ludwig Meidner, *Brennende Stadt* (*Burning City*), 1913. Oil on canvas, 67.3 x 79.4 cm (26 1/2 x 31 1/4 inches). The Saint Louis Art Museum, Bequest of Morton D. May

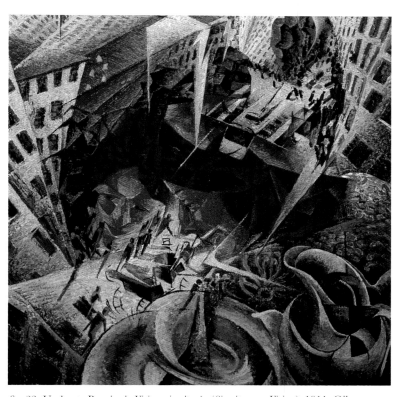

fig. 22. Umberto Boccioni, *Visions simultanées* (*Simultaneous Visions*), 1911. Oil on canvas, 60.5 x 60.6 cm (23 13/16 x 23 7/8 inches). Von der Heydt-Museum, Wuppertal

with existence itself, which was governed by an energy he called *unanimes*. Explored through a series of poems published in 1908 as *La Vie unanime, poemes 1904–1907*, Romains's ideas revolved around the belief that individual consciousness becomes subsumed by the dominant energy of a place, where everything and everyone is in relation to the other. A section from one of these poems could almost describe the *City* paintings from 1910–11:

The City is going to move this morning.
It is going to break away from the earth,
Root up its foundations
Disentangle them from the greasy clay[57]

While Delaunay did not meet Romains until 1912, his writings were well known in Paris at the time, especially to those artists with whom Delaunay was becoming acquainted, including Gleizes and Le Fauconnier.

Moreover, Romains's ideas had made an impression upon Filippo Tommaso Marinetti, the Italian Futurist poet whose "The Foundation and Manifesto of Futurism" was published in *Le Figaro* on February 20, 1909. In this tirade against conventional taste and tradition, Marinetti described a vision of modernity steeped in a language of the city, in which "a roaring car that seems to ride on grapeshot is more beautiful than the Victory of Samothrace."[58] However, the impact of Futurism on Delaunay, especially with respect to his *Eiffel Tower* paintings, which seem to borrow Futurism's vocabulary of chaos and destruction, has always been a point of contention. Delaunay himself repeatedly denied a connection to Futurism, especially when his friend Apollinaire later made the mistake of making a comparison between them. Delaunay declared, "Futurism is a machinist movement. It is not vital."[59] Certainly, Delaunay's propensity for compositions that convey an atmosphere of destabilization, as many of the *City* paintings do, could be read as being Futurist in spirit. But as Futurist works were not exhibited in Paris until 1912, the connection to Romains's *unanisme* seems more germane. Given the fact that Umberto Boccioni visited Paris in early 1911, it is entirely possible that he could have seen Delaunay's *City* paintings and that they in turn had an impact on such works as his *Visions simultanées* (*Simultaneous Visions*, 1911, fig. 22).[60]

In assessing the evolution of the *City* series, in 1938 Delaunay made a connection between the Futurists and the *Saint-Séverin* paintings:

The same things are going on, but sharpened. All spaces are broken up and divided, until infinitesimal dimension in every direction is achieved. It is a dynamism dissolving yet remaining complete. It is the liquidation of familiar methods in art as respects line, color value, volume, chiaroscuro, etc.[61]

Of the last works in the series, he later reflected: "In the new series of City pictures, I am driven by a need for motion, but the light-dark technique prevents me from realizing my concepts. Draftsmanship still prevents me from becoming a painter."[62] This will toward an art based on a "liquidation of familiar methods," in which stasis is replaced by dynamism and the continuity of form is shattered by the breaking up of space, was propelled not only by the investigations undertaken with the *City* paintings but also by another concurrent group of works, the *Eiffel Tower* series, which employed a slightly different strategy to achieve similar results.

The Eiffel Tower (1909–12)

Of all of Delaunay's subjects, none have as much expressive energy and power as does the *Eiffel Tower* series, nor do the others share quite the notoriety that it did. The *Eiffel Tower* paintings are the apogee of his "destructive period," the phase that began with *Saint-Séverin* and *The City*, the two series in which he tried to liberate himself from the shackles of conventional drawing and find a new means of representation. Delaunay called the *Eiffel Tower* series "CATASTROPHIC ART Dramatics, cataclysm. This is the synthesis of the entire period of destruction: a prophetic vision."[63] There are two phases to the *Eiffel Tower* paintings, the first took place from 1909 to 1912, and the second occurred as a revival of the theme in the 1920s and 1930s. Our primary focus here is on the first phase, which took place amid his work on the paintings discussed so far and which constitutes another body of work that built his early reputation. In characterizing Delaunay's passion for the Eiffel Tower as subject, Blaise Cendrars, a writer who befriended the artist in 1912, later recalled:

Delaunay wanted to show Paris simultaneously, to incorporate the Tower into its surroundings. We tried every vantage point, we studied it from different angles, from all sides. . . . And those thousand tons of iron, those almost seven hundred feet of girders and beams, those four arches spanning three hundred feet, that whole dizzying mass flirted with us.[64]

There are ten paintings, at least ten works on paper, and an unquantifiable number of rough sketches associated with the series, as well as a lithograph from the 1920s.[65] Centrally located within each of the compositions, the Eiffel Tower assumes the iconic drama of a portrait. In choosing the tower as a subject, Delaunay was again ahead of other artists by more than a decade. To be sure, Rousseau included the tower as an element in several landscapes of Paris, such as *Tour Eiffel et Trocadero* (*Eiffel Tower and Trocadero*, 1885, fig. 23). And yet another of Delaunay's heroes, Seurat, painted *Tour Eiffel* (*Eiffel Tower*, 1889, fig. 24), a small view in which the tower is given the same iconic status as in Delaunay's series. But not until the 1920s, and through the medium of photography, would the tower be venerated with quite the same enthusiasm and passion as Delaunay's.

Delaunay's first impressions of the Eiffel Tower are recorded in 1908–09 in such plein-air paintings as *Landscape of Paris* (fig. 26), but the first work identified with the series, *Tour. Première Etude* (*Tower. First Study*, cat. no. 22), was painted in the summer or fall of 1909, around the time of his early

studies for the *City* paintings. Small in scale, *Tower. First Study* depicts the landmark structure frontally and as if seen from an elevated height. Surrounded by broad, abbreviated patches of brown, gray, and ochre colors, the tower is portrayed as an image of stasis, not flux.

Rudenstine suggests a date of late 1909 or early 1910, since *Tower. First Study* was apparently painted as an engagement present for his wife-to-be, Sonia.[66] The Delaunays were married in November 1910, but their courtship began much earlier. They first met in 1907 while Delaunay was on leave from military service in Laon. When he returned to Paris in 1908, he was a frequent visitor to the salons of Uhde, Sonia's first husband. A close friendship with Sonia evolved quickly; she and Delaunay spent much of their time discussing art and aesthetics while walking around the vicinity of the Eiffel Tower.[67]

By August 1909, Delaunay and Sonia were practically inseparable. He was on vacation with his uncle in Chaville, and she took a room at a hotel across the street. It was shortly after their return to Paris on September 8 that Sonia asked for a divorce, granted in February 1910, after which time the two began living together.[68] Thus, that *Tower. First Study* commemorates their relationship is without question; the inscription at the upper right, "mouvement profondeur 1909 Franco-Russie"—a clear reference to Sonia's Russian heritage—commemorates their union. Sonia later recalled, "It was 'our' picture. The Eiffel Tower and the Universe were one and the same to him."[69] However, the palette and treatment are more consistent with the paintings Delaunay made while in Chaville (for example, *Factory at Chaville*, fig. 20), so it must date either to that summer or shortly after.

The next painting in the series, *Tour Eiffel* (*Eiffel Tower*, ca. 1909, cat. no. 23), is on the back of *Saint-Séverin No. 4* and is the first fully conceived, large-scale version. Seen from the perspective of the ground, this strictly frontal view of the Eiffel Tower is not unlike photographs from the period (fig. 25), which show the structure as a majestic and sturdy edifice. Delaunay framed the tower with foliage on either side, endowing those elements with curvilinearity reminiscent of such Cézanne paintings as *The Large Bathers* (fig. 7) and the *Saint-Séverin* paintings. The Cézanneian palette and construction, combined with the similarity of the trees to plant studies Delaunay executed in the summer of 1909 (for example, *Saint-Cloud. Study of Landscape*, fig. 14), suggest a date of fall 1909 for this work. In support of this, the faceting of the ground is not unlike that found in *Saint-Séverin No. 1* and *Saint-Séverin No. 3*. However, Buckberrough argues that the painting of Saint-Séverin was executed before the Eiffel Tower composition because it is painted on the primed side of the canvas.[70] If *Saint-Séverin No. 4* was done in 1910, as has been suggested earlier, then *Eiffel Tower* (cat. no. 23) would have to

fig. 23. Henri Rousseau, *Tour Eiffel et Trocadero* (*Eiffel Tower and Trocadero*), 1885. Oil on canvas, dimensions unknown. Location unknown

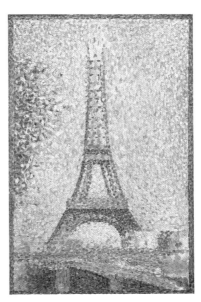

fig. 24. Georges Seurat, *Tour Eiffel* (*Eiffel Tower*), 1889. Oil on canvas, 24 x 15 cm (9 7/16 x 5 15/16 inches). The Fine Arts Museum of San Francisco, Museum purchase, William H. Noble Bequest Fund, 1979.48

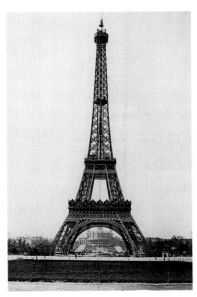

fig. 25. View of the Eiffel Tower and Trocadero, Paris

have been completed sometime later in the first quarter of that year. However, a "Tower" by Delaunay was exhibited as no. 4,357 at the March 1910 *Salon des Indépendants*. It must have been this painting, since the succeeding versions were painted later. Furthermore, *Saint-Séverin No. 4* is stylistically more evolved than the painting on its back. The question remains problematic.

From April to September 1910, Sonia and Robert Delaunay lived in La Cluse, near Nantua. Sonia recalled that two of the large *Eiffel Towers* were painted while there.[71] As Rudenstine suggests, these were probably the next two works in the series: *Tour Eiffel aux arbres* (*Eiffel Tower with Trees*, 1910,

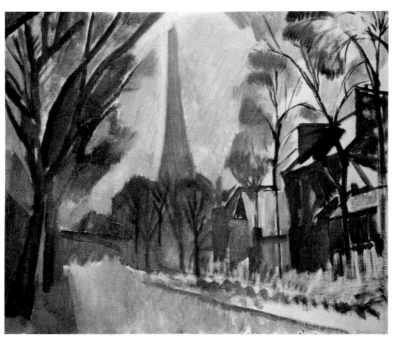

fig. 26. *Paysage de Paris* (*Landscape of Paris*), 1908–09. Oil on canvas, 49 x 61 cm (19 ⁵⁄₁₆ x 24 inches). Location unknown

cat. no. 24) and *Tour Eiffel* (*Eiffel Tower*, 1910, cat. no. 25).[72] With these two works, the essential syntax of the *Eiffel Tower* series truly begins. Portrayed as a structure in tumult, the Eiffel Tower stands astride an earth in chaos, with small circles of smokelike clouds swimming around it. These works exemplify Delaunay's description of the *Eiffel Tower* series as "visions of catastrophic insight . . . ; cosmic shakings, desire for the great cleanup, for burying the old, the past . . . Europe crumbles. Breath of madness (Futurism before the theory): dislocation of the successive object."[73] This last comment is particularly important, for it quantifies the pictorial innovation that Delaunay introduced in these pictures: the concept of multiple viewpoints, as if more than one moment in time is captured at once. It is simultaneity of form and time, though not quite light and color, which would follow shortly.

Eiffel Tower with Trees, which has a sketchlike finish, retains the foliage elements found in *Eiffel Tower* (cat. no. 23), connecting these two works in a general way. If the latter version was painted after the painting of Saint-Séverin on its other side, then the possibility exists that it was made along with *Eiffel Tower with Trees* in the summer of 1910 and that *Tower, First Study* was exhibited at the *Salon des Indépendants* in March. However, *Eiffel Tower with Trees* has more in common with *Eiffel Tower* (cat. no. 25). In addition to both works showing the tower in a state of deconstruction, like all subsequent versions, the tower's height is truncated by the exclusion of its tip. The tower is also portrayed in successively redder hues.[74] *Eiffel Tower* (cat. no. 25) is further distinguished by an evolving fragmentation of the tower; it is now almost split apart and is pushed forward. The framing foliage has been eliminated, and instead the tower straddles a tumultuous vision of the

city like that found in *The City No. 2* (cat. no. 19; this is yet another reason for dating that work to 1910).

The handling in *Eiffel Tower* (cat. no. 25) is rough, with parts of the image left abbreviated as in a study. Habasque identifies this work as no. 18, which is listed as *Etude pour la tour* (1910),[75] in Delaunay's 1912 exhibition at Galerie Barbazanges. It is logical to assume that that painting was a study for *Tour Eiffel* (*Eiffel Tower*, 1910–11, cat. no. 26), a painting known only through reproduction because it was destroyed in a fire in 1945. This painting was probably begun in the late autumn of 1910—after the Delaunays moved into their new studio on rue des Grands-Augustins in November—and finished by the early spring of 1911. The Eiffel Tower now sits astride a sea of undulating and distorted buildings, framed on either side by more buildings that form an "arch" similar to the arches in the *Saint-Séverin* pictures. It is hard to determine from the photographic evidence, but the overall impression is sketchlike once again, with the left side appearing spare or unpainted.

Eiffel Tower (cat. no. 26) was exhibited in the famed *Salon des Indépendants* of April 1911,[76] and led Apollinaire to proclaim: "His *Eiffel Tower* has dramatic force and his craft is already very secure."[77] It was later one of the five works shown in the first Blue Rider exhibition (dated 1911 in the catalogue), selling to its only owner, a coal merchant named Bernhard Köhler (who was also August Macke's uncle), soon after the exhibition opened. Shortly after acquiring the work, Köhler asked Delaunay for an interpretation of it, to which the artist replied: "I created this picture at a time when I had great aesthetic preoccupations and still no fullness; my means show me that which I took years to discover, but it turns out that the style of the moment is deeply felt and conveys this dramatic air and power."[78]

By June of 1911, Delaunay had completed another version, almost exactly like the previous one, but probably larger (the dimensions of Köhler's painting were never recorded). Indeed, *Tour Eiffel* (*Eiffel Tower*, 1911, cat. no. 27) is the largest painting in the entire series. It was included as no. 54 in the exhibition *Les Indépendants* in Brussels (June–July 1911) along with *Saint-Séverin No. 1*, and was probably painted at the same time Delaunay was working on *The City* (cat. no. 20). The right side of the Eiffel Tower now dissolves into a mélange of buildings and clouds. The left side, which looked unfinished in *Eiffel Tower* (cat. no. 26), reads clearly here as a semitransparent plane of color, like a veil or curtain. The rendering of light and forms as geometric planes that cut through the composition place the painting squarely within the Cubist idiom, a progression similar to the one taking place with the *City* paintings. In particular, the painting shares an affinity with paintings by Léger, whom Delaunay had first met in October 1910. The materialization of space in a work like

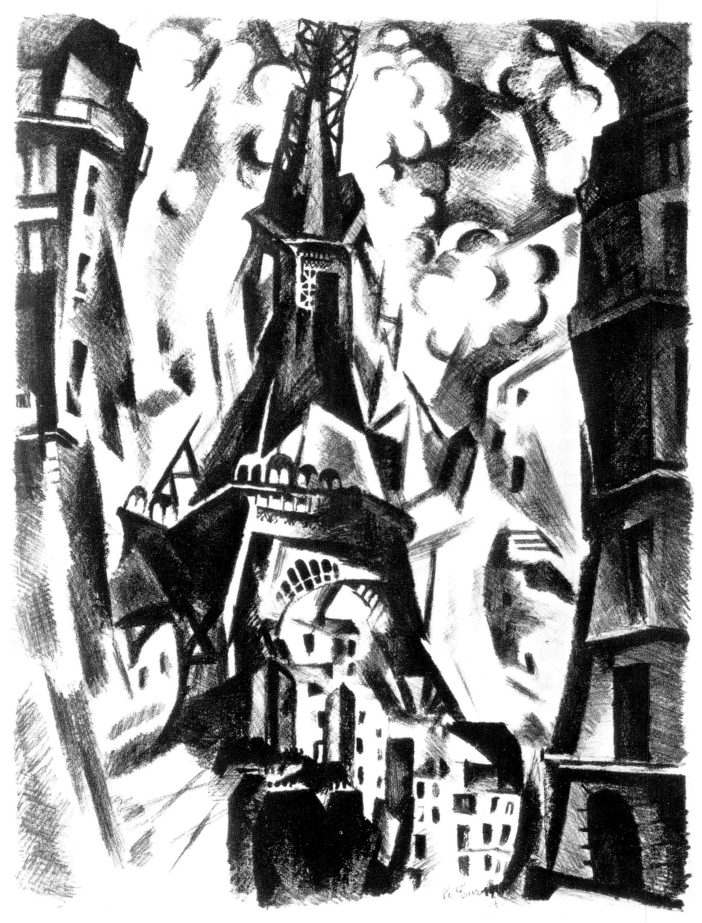

fig. 27. *La Tour* (*The Tower*), 1925. Lithograph on paper, 62 x 44.5 cm
(24 ⁷⁄₁₆ x 17 ½ inches). Bibliothèque Nationale, Paris, Fonds Delaunay

fig. 28. Fernand Léger, *Essai pour trois portraits* (*Study for Three Portraits*), 1910–11. Oil on canvas, 193.7 x 114.5 cm (76 ¼ x 45 ¹⁄₁₆ inches). Milwaukee Art Museum, Anonymous gift

Léger's *Essai pour trois portraits* (*Study for Three Portraits*, 1910–11, fig. 28) is similar to that in Delaunay's painting, as is the suggestion of simultaneous viewpoints. The bubbles of smoke are also comparable.[79]

Although *Eiffel Tower* (cat. no. 27) is inscribed "1910" on the front and back, the evidence for dating it to 1911 is compelling. Delaunay must still have been working on this version when *Eiffel Tower* (cat. no. 26), securely dated to 1911, appeared in the major exhibitions of 1911. Delaunay himself dated *Eiffel Tower* (cat. no. 27) to 1911 in his notebooks.[80] Moreover, the drawing *Tour Eiffel* (*Eiffel Tower*, cat. no. 28) is related to this version and the previous one, but its highly finished character suggests that it was most likely made after-

fig. 29. Study for *Tour Eiffel* (*Eiffel Tower*), 1911. Pencil on paper, 24.6 x 16.2 cm (9 ¹¹⁄₁₆ x 6 ⅜ inches). Städtische Galerie im Lenbachhaus, Munich

fig. 30. Study for *Tour Eiffel* (*Eiffel Tower*), 1911 (verso of fig. 29)

ward, sometime in 1911.[81] The date on the drawing originally read "1911," but a crude attempt to change the final "1" to a "0" points to Delaunay's habit of dating works to the inception of the series, rather than to the individual artwork's execution. Another related work, dated 1910 in the image, is the lithograph *La Tour* (*The Tower*, fig. 27), which was executed in 1925, suggesting that Delaunay later considered *Eiffel Tower* (cat. no. 26) and *Eiffel Tower* (cat. no. 27) as the archetypal examples of the series.

The next painting in the series, *La Tour Eiffel* (*The Eiffel Tower*, 1910–11, cat. no. 29), is also monumental in scale, though slightly smaller than the preceding one, *Eiffel Tower* (cat. no. 27). The composition is less frenetic and more schematic than the earlier paintings. Both the Eiffel Tower and the surrounding buildings are more planar and abstract, with an infusion of yellow highlights not present in the other versions. It has about it some of the color schema found in the watercolor *The Window on the City* (cat. no. 18), a work this essay places within the *City* series and discusses as a possible link between the *City* and *Eiffel Tower* series. Although inscribed "1910" on the front, *The Eiffel Tower* (cat. no. 29) is inscribed "1910–11" on the back. Representing a stylistic progression away from *Eiffel Tower* (cat. no. 27), it surely postdates that version and was probably painted sometime in the summer of 1911.

At this point, Delaunay's occasional habit of leaving works unfinished and returning to them later creates some confusion in the chronology of the series. What looks like the next painting in the series, *La Tour Eiffel* (*Champs de Mars: The Red Tower*, 1911/1923, cat. no. 30) has been argued as following two other works that are quite different: *Tour Eiffel* (*Eiffel Tower*, probably 1911–12, cat. no. 32) and *La Tour rouge* (*Red*

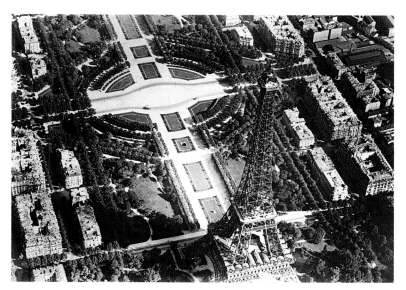

fig. 31. View of the Eiffel Tower and Champs de Mars, Paris

fig. 32. Study for *Tour Eiffel* (*Eiffel Tower*), 1910 [1913]. Ink on paper, 40 x 30.8 inches (15 ¾ x 12 ⅛ inches). Location unknown

fig. 33. Study for *Tour Eiffel* (*Eiffel Tower*), 1910 [1913]. Ink on paper, 40.5 x 32.4 cm (15 ¹⁵⁄₁₆ x 12 ¾ inches). Location unknown

Eiffel Tower, 1911–12, cat. no. 33). *Champs de Mars: The Red Tower* shares the general morphology of the preceding paintings in the series: an imploding Eiffel Tower astride an undulating cityscape, framed on either side by buildings. The general articulation of the tower's upper half and the arched windows on its first floor are consistent with preceding works, but overall the details of each pictorial element are more clearly delineated. Both the shattering planes of light and the architectural motifs show a further evolution of Delaunay's interpretation of Cubism. However, the tower in the painting has shifted axis, conforming to the view found in *Eiffel Tower* (cat. no. 32) and *Red Eiffel Tower*. The work should, therefore, logically be viewed as a bridge between those paintings and the preceding version, *The Eiffel Tower* (cat. no. 29).

However, Rudenstine has shown that *Champs de Mars: The Red Tower* was exhibited and published in an unfinished state in 1912.[82] The disklike treatment of the forms surrounding the top of the Eiffel Tower also suggests a later development. Rudenstine states that the diagonal shafts of light hitting the top of the tower are similar to those found in a painting Delaunay created early in 1912, his monumental *La Ville de Paris* (*The City of Paris*, fig. 39), but Buckberrough notes that the palette and other stylistic conventions suggest that Delaunay completed *Champs de Mars: The Red Tower* at a later date.[83] *The City of Paris* is very much a summing up of Delaunay's work to date and should be seen as a pastiche of many preexisting elements, especially since the work was reportedly executed in great haste.[84] His reversion to the language of previous *Eiffel Tower* paintings makes sense in this context, but not so much in the case of a single *Eiffel Tower* painting, contrary to the argument advanced by Rudenstine.[85] Thus, based on style and morphology, *Champs de Mars: The Red Tower* should be placed after *The Eiffel Tower* (cat. no. 29)—which Delaunay began in early autumn 1911—and before

Eiffel Tower (cat. no. 32) and *Red Eiffel Tower*, whether or not it was finished at a later date.

What *Champs de Mars: The Red Tower* does share with *Eiffel Tower* (cat. no. 32) and *Red Eiffel Tower* is a new view of the Eiffel Tower. Its situation in space is now somewhat axonometric, twisted into a diagonal orientation. Two studies for *Tour Eiffel* (*Eiffel Tower*, 1911, figs. 29 and 30) show this new orientation clearly, with an emphasis placed on the left span of the tower. Again departing from Rudenstine's chronology, the next painting in the series should be the unfinished version, *Eiffel Tower* (cat. no. 32). Probably begun in autumn 1911, the painting's articulation of the lower portion of the tower is similar to that of *Champs de Mars: The Red Tower*, as might the upper portion of the tower have been had it been completed (the blocked out unfinished area suggests such a similarity). No longer flanked by buildings, the painting's upper section shows the beginning of curtain motifs, which will evolve in subsequent versions and which relate to *City* paintings of 1911–12: *The City* and *The Window on the City No. 3* (cat. nos. 20 and 21). Moreover, Delaunay resituates the tower in a new space. It no longer sits astride a cityscape, but is now seen in situ. The large Ferris wheel, an element found in the two studies for *The City* from 1909 (cat. nos. 13 and 14), is reintroduced here. But most significant of all is the ground of sweeping ovals on which the tower rests, which resemble the pathways of the Champs de Mars seen from the air (see fig. 31). Thus, we not only see the tower from simultaneous angles frontally, but the view from the air brings new spatial and temporal elements into the work. As if to celebrate this new development, Delaunay gave the painting to his friend Apollinaire, with an inscription referring to simultaneity. It is the first time Delaunay associated the concept of simultaneity with his art, although it had become manifest in *The Window on the City No. 3* and would become

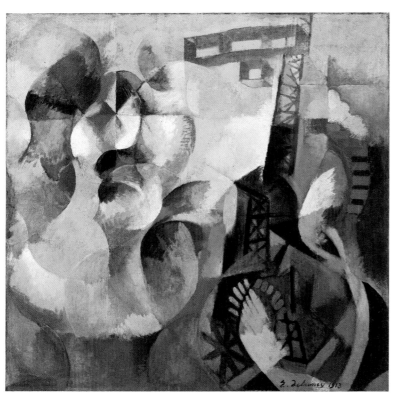

fig. 34. *Soleil, tour, aeroplane* (*Sun, Tower, Airplane*), 1913. Oil on canvas, 132.1 x 131.8 cm (52 x 51⅞ inches). Albright-Knox Art Gallery, Buffalo, A. Conger Goodyear, 1964

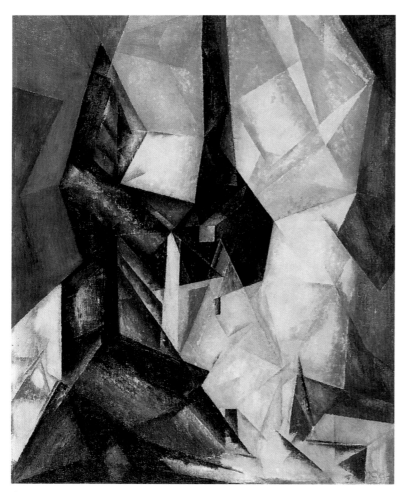

fig. 35. Lyonel Feininger, *Gelmeroda IV*, 1915. Oil on canvas, 100 x 79.7 cm (39⅜ x 31⅜ inches). Solomon R. Guggenheim Museum, New York 54.1410

more fully articulated with the *Windows* series just a few months later in 1912.

A related watercolor, *La Tour simultanée* (*The Simultaneous Tower*, cat. no. 31), inscribed "1910" but clearly a work from at least 1911 (if not later), shows more clearly the evolution of Delaunay's thinking in *Eiffel Tower* (cat. no. 32). The right side and upper portion of the Eiffel Tower have been completed, and the curtain motif at the upper right is more pronounced. Inscribed to Walden, the art dealer who began to show Delaunay's work at his Der Sturm gallery in Berlin in 1912, the drawing also carries the inscription "La Tour simultanée," further connecting Delaunay's interest in simultaneity with the *Eiffel Tower* paintings of this period.

With *Red Eiffel Tower*, Delaunay's new conception of the monument is fully realized. The general atmosphere of the painting is more diffuse and abstract, with broad areas described as contrasting elements of color. The sweeping arcs of the ovals are more pronounced, and the Eiffel Tower is less transparent, appearing to fuse with the background at midsection. The cloud forms have become more disklike at right—with the Ferris wheel barely distinguishable from them—while what was formerly a cityscape at left in *Eiffel Tower* (cat. no. 25) is now a system of interlocking planes. Finally, the curtains at either side at top, suggestive of a view through a window, are stylistically consistent with his *City* paintings of the period, helping to place this undated work to late 1911, possibly completed in early 1912.[86]

A group of drawings (figs. 32 and 33, cat. nos. 34–37) has been associated with *Red Eiffel Tower* (cat. no. 33). While two (figs. 32 and 33) are undated, the other four (cat. nos. 34–37) are inscribed "1910." Despite the fact that they all manifest many of the qualities found in *Red Eiffel Tower*, including the Ferris wheel, oval arcs, and general delineation of the Eiffel Tower, Rudenstine convincingly redates these works to 1913.[87] In addition to documenting that several were made for publication in 1913, she persuasively demonstrates that these works relate more closely to *Soleil, tour, aeroplane* (*Sun, Tower, Airplane*, fig. 34), a work Delaunay executed in 1913.

Theoretically, this phase of Delaunay's *Eiffel Tower* series should end with *Red Eiffel Tower*. It is the culmination of all of his pictorial experiments with the Eiffel Tower's structure, which he synthesized into a tableau whose every form and shape resonates with rhythmic movement. There is a painting, however, whose placement in the chronology of the series poses serious questions about Delaunay's conceptual development of the *Eiffel Tower* paintings before 1912, as opposed to when he reprised the theme in the 1920s.

Habasque dates *La Tour aux rideaux* (*The Tower with Curtains*, probably ca. 1920–22, cat. no. 40) to 1912, presumably on the basis of the inclusion of curtains, which appear in the late *City* and early *Windows* paintings.[88] Delaunay also men-

tioned it, without a date, within a grouping of works from around 1912.[89] Habasque lists another painting with the same subject, but that work has not been located and was only reproduced once, poorly, in 1955.[90] If one looks at Delaunay's curtain motifs in *City* paintings from 1910–11 (cat. nos. 18–20), they are stylistically inconsistent with the painting; where the curtains in the *Eiffel Tower* painting verge on trompe l'oeil, those in the *City* paintings are clearly nondescriptive and abstract. The treatment of the Eiffel Tower is similar to that found in *Champs de Mars: The Red Tower, Eiffel Tower* (cat. no. 32), and *Red Eiffel Tower*, but it is stiffer, and the rendering of the city elements does not correspond either to those paintings or *The City of Paris*.

The Tower with Curtains was redated to 1910 sometime after entering the collection of the Kunstsammlung Nordrhein-Westfalen, Düsseldorf, perhaps based on its color scheme, but we have just seen that the rendering of the Eiffel Tower itself is more consistent with works of 1911–12 (cat. nos. 30–33).[91] The two drawings that exist as "studies" for *The Tower with Curtains* (cat. nos. 38 and 39), were more likely made after the fact, as they have the polished look associated with drawings Delaunay made after paintings, such as the study for *Saint-Séverin* (cat. no. 6). One of the studies for *The Tower with Curtains* (cat. no. 39) is inscribed "1910," but we are by now familiar with Delaunay's practice of dating works to a time when a series was first conceived, rather than the date of an individual work. Thus, the drawing cannot be used to secure an actual date for the painting. The fact that the painting carries an overpainted inscription of which only three digits, "191," are legible—as if it had once been dated 1910—only suggests that the year Delaunay associated with the beginning of the *Eiffel Tower* series rather than a date for the work's specific execution was placed on the painting.

The Tower with Curtains is recorded for the first time in 1922, when it was included as no. 13 in an exhibition at Galerie Paul Guillaume in Paris (May–June 1922). In this regard, it is conceptually and stylistically consistent with the two portraits of Philippe Soupault, which have both been dated to 1922 (see cat. no. 41),[92] when Delaunay returned to the theme of the Eiffel Tower after nearly a decade. Moreover, the painting appears as an element in *Portrait de Madame Mandel (Portrait of Madame Mandel*, fig. 36), a portrait Delaunay painted in 1923 of a woman modeling one of Sonia Delaunay's clothing designs in the Delaunays' apartment. In a photograph from 1925, *The Tower with Curtains* is also shown hanging in Delaunay's studio amid a group of portraits he executed in the early 1920s (fig. 37).

While it is possible that *The Tower with Curtains* was begun early, left unfinished, and completed later—as may have been the case with *Saint-Séverin No. 7* and *Fenêtre aux rideaux oranges (Window with Orange Curtains*, 1912, cat. no. 44)—it is more

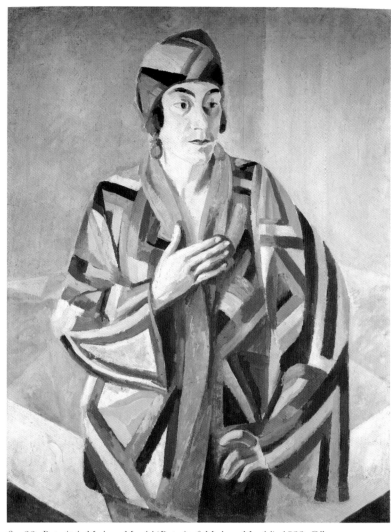

fig. 36. *Portrait de Madame Mandel (Portrait of Madame Mandel)*, 1923. Oil on canvas, 123 x 124 cm (48 7/16 x 48 7/8 inches). Location unknown

fig. 37. Robert Delaunay painting a portrait of Thérèse Bonney at 19 boulevard Malesherbes, Paris, 1925

likely that it is a 1920s reprise (finished by 1922) of his early *Eiffel Tower* paintings, couched in a slightly new vocabulary. That scholars have generally avoided the painting is an indication of the problems involved in interpreting the work. The dating to 1910 would make this painting fundamentally unique and out of character with Delaunay's work before 1914.[93]

The *Eiffel Tower* paintings became Delaunay's most celebrated, if not notorious, works when they first appeared. He recalled later that when they were first exhibited, he was accused of being a spy or a traitor for rendering an image of Paris in destruction.[94] Far more critics saw the foresight Delaunay had exercised in celebrating the structure. In the preface to the catalogue for Delaunay's 1912 exhibition at Galerie Barbazanges, Maurice Princet wrote:

In spite of its appearance, the Eiffel Tower is not an infantile and ridiculous plaything. We concede that it is planted there without anything to justify it; at the first glance this absence of harmony deceives us. But is it necessary to look closer. The grace of its curves and the peculiar slenderness of its lines gives it true beauty.[95]

Delaunay's paintings were especially well received by a number of writers predisposed to urban themes, such as Apollinaire, Louis Aragon, Cendrars, and Vicente Huidobro, who composed poems about the tower and dedicated them to Delaunay (see pp. 132–37 in this volume).

In Germany, the celebrity of the *Eiffel Tower* series was carried along with the acclaim given to the *City* and *Saint-Séverin* paintings. It is hard to imagine Lyonel Feininger's *Gelmeroda* paintings (for example, fig. 35) without Delaunay's example, and in celebrating him as the first Expressionist, Theodore Daubler wrote of the *Eiffel Tower* paintings:

Already the face of the icy tower. The grid is knit. The hero is falling from the stars as well as rising from the earth. . . . The earth sinks under the weight of the stars, thus the Tower implodes all over. It is an accordion, held from above as well as from below. . . . The Eiffel Tower has become the modern building par excellence.[96]

In the 1920s, when Delaunay returned to the subject of the Eiffel Tower, he imbedded it as a prominent motif in works that combined past themes into a single composition, such as *La Ville de Paris, la femme et la tour* (*The City of Paris, the Woman and the Tower*, 1925, cat. no. 42). His singular views of the tower approached it from new vantage points, either from above like an aerial view or from below, as in *La Tour rouge* (*The Red Tower*, 1928, cat. no. 43), which celebrated the tower's dynamism through radical foreshortening and bold colors. In the works from the 1920s, however, the explosive drama that Delaunay had earlier invested in the subject gave way to a more serene and classical impression, as if the feverish attempts at

articulating the tower's majesty described by Cendrars gave way to a more contemplative reverence for the tower.

The Windows (1912–14)

1912 was a pivotal year for Delaunay, one in which the experiments of his "destructive" period gave way to a more confident phase of work he frequently called his "constructive" period. It began with his having experienced enormous success through his participation in the Blue Rider exhibition, in which four of the five works shown had sold. After spending the month of January painting in Laon, where he had been stationed in the military in 1907, he and Sonia returned to Paris in early February, whereupon he set about preparing for his first solo exhibition. Held from February 28 to March 13, 1912 at Galerie Barbazanges in Paris, the exhibition amounted to a retrospective, encompassing forty-seven works from 1904 to 1912.[97] Princet's preface to the catalogue portrayed Delaunay as "a vibrant character with truly French qualities of life and exuberance, he incorporates the most rigorous discipline into the research of the methods of his art. Craft, long disregarded both by the representatives of tradition as well as by the revolutionary independent, seem to him the essential work of the artist."[98] The exhibition included many of the paintings discussed here so far, though curiously only one painting from the *Saint-Séverin* series was shown, *Saint-Séverin No. 1.*

In the wake of this large project, Delaunay was left without any work to submit to the *Salon des Indépendants* in March. So in the space of only fifteen days,[99] he created his monumental *The City of Paris* (fig. 39), a painting that drew upon the basic motifs developed in the *City* and *Eiffel Tower* series, with the addition of classical subject matter: the figures of the "Three Graces." It is clearly a summation of the artist's achievements to date, and its nostalgia is underscored by the left panel's inclusion of a quotation from a painting by Delaunay's beloved Rousseau, *Moi-Même: Portrait, paysage* (*Myself: Portrait, Landscape*, 1890, fig. 38). *The City of Paris* caused a sensation. In his review of the exhibition, Apollinaire wrote:

Decidedly, the picture by Robert Delaunay is the most important of this salon. The City of Paris *is more than an artistic manifestation. This picture marks the advent of a conception of art lost perhaps since the great Italian painters. . . . He sums up, without any scientific pomp, the entire effort of modern painting.*[100]

Less daring than the more intuitive explorations of the *City* and *Eiffel Tower* paintings, it nonetheless suggested—in the diagonal shafts and colored planes that envelop the Eiffel Tower and cityscape—the shift that was about to take place in Delaunay's attempt to privilege light and color over line.

We have seen how in his *City* series, Delaunay demonstrated a gradual evolution toward an increasingly abstract composition, one whose objective forms become gradually subsumed by planes of contrasting colors. Finished in January 1912, *The Window on the City No. 3* (cat. no. 21) marked the high point of this development, with the image of the city disintegrating into a mosaic of color. It became, in effect, the first painting of the *Windows* series. Delaunay created this series during his "constructive" period, beginning in earnest in April 1912 and finishing in January 1913 (although one work, cat. no. 59, is dated 1914). In the space of less than a year, Delaunay produced a body of work that marked a major turning point in his career. After three years of struggling to outgrow the hegemony of line over color, he achieved a breakthrough that caused a radical shift in his style, in which color became the primary means of pictorial construction. Several factors have been cited as having catalyzed Delaunay toward this new direction.

During the spring of 1912, Princet, who had written so enthusiastically on Delaunay in February, was at work on an essay on Seurat.[101] We have seen earlier how Delaunay cited Seurat as important to his artistic development. Central to Seurat's craft was the rendering of light through harmonious contrasts of scientifically applied color. In realizing this effect, he was indebted to the color theories of Chevreul, whose laws of simultaneous contrast had informed Delaunay while he was exploring neo-Impressionism from 1905 to 1907. Princet, whose work on Seurat apparently rekindled this interest in Chevreul, wrote to Delaunay: "I wanted to show that you alone have continued Seurat's work by extricating everything that pertained to the true substance of his idea."[102]

In addition, the work of Kandinsky had begun to make an impression upon Delaunay. Though they did not actually meet until 1937, the two began a correspondence in the fall of 1911, which dealt with Delaunay's upcoming participation in the first Blue Rider exhibition. Moreover, Delaunay had become aware of Kandinsky's forays into abstraction through the *Salon des Indépendants*, to which Kandinsky had been submitting examples of his work since 1911. In such paintings as *St. Georg II* (1911, fig. 40), Kandinsky demonstrated that form could be defined by pure color, and he was already well on his way toward achieving works in which rules of color and harmony, not line and volume, were the basis for pictorial construction. Though he did not read Kandinsky's book, *Concerning the Spiritual in Art* until later,[103] Delaunay was no doubt familiar with its contents through his wife, Sonia, and a friend, Elizabeth Epstein, who had suggested Delaunay for inclusion in the Blue Rider exhibition. In his book, Kandinsky wrote of the relationship between abstract visual form and musical harmony. An awareness of these ideas is manifest in a letter Delaunay wrote to Kandinsky in the

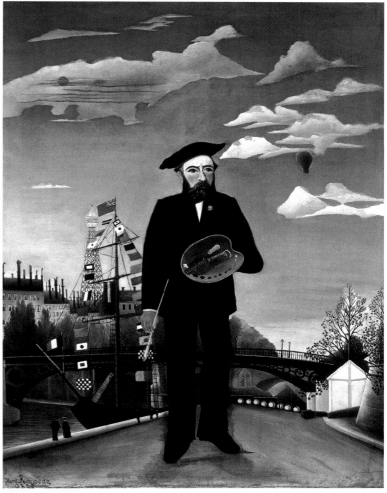

fig. 38. Henri Rousseau, *Moi-Même: Portrait, paysage* (*Myself: Portrait, Landscape*), 1890. Oil on canvas, 143 x 110 cm (56 ⁵⁄₁₆ x 43 ⁵⁄₁₆ inches). Národní Galerie, Prague

spring of 1912, in which he attempted to describe the new developments in his art:

Your latest pictures brought me right back to an inquiry I had undertaken last year at the Indépendants where I had also seen your canvases.[104] *. . . I have not yet figured out how to transpose into words my investigations into this new area that has been my sole effort for a long time. I am still waiting for a loosening up of the laws comparable to musical notes I have discovered, based on research into the transparency of color, which have forced me to find* color movement.[105]

This "transparency of color" and "color movement" were associated by Delaunay with the concept of "simultaneity" or "simultaneism." With Chevreul as a general point of departure, the notion of "simultaneous contrasts" of color became Delaunay's means for rendering form dynamically, so that values of opacity and transparency collided and subverted conventional pictorial perspective. He wrote: "Simultaneism in color creates a total formal construction, an aesthetic of all the crafts. . . . *Color gives depth* (not perspective, *nonsequential* but *simultaneous*) *and form and movement*."[106] While these ideas were already being explored in the *City* series, it was not until the

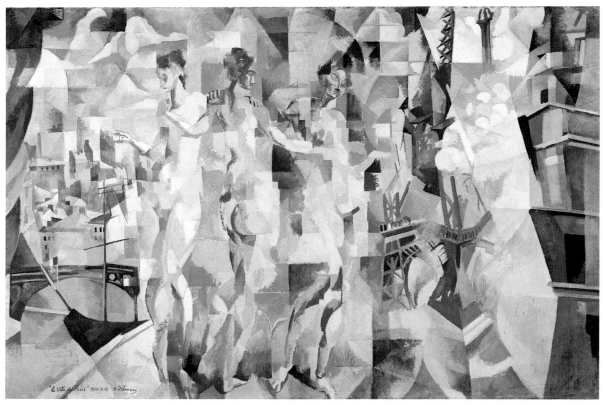

fig. 39. *La Ville de Paris (The City of Paris)*, 1910–12 [1912]. Oil on canvas, 267 x 406 cm (105 ⅛ x 159 ⅞ inches). Musée National d'Art Moderne, Centre Georges Pompidou, Paris

written during the summer of 1912: "*The Eye* is our highest sense, the one which communicates most closely with our *brain and consciousness*, the idea of the living movement of the world, and its movement is *simultaneity*."[110]

In April 1912, the Delaunays moved to La Madelaine in the Chevreuse Valley for the summer. It is not clear whether or not the *Windows* were begun in Paris, but it is generally accepted that most of them were executed during the summer months. To date, twenty-three paintings and drawings, and one later lithograph, have been associated with the series, but the possibility that others exist cannot be disregarded.[111] Three paintings have been securely dated to April 1912: *Les Fenêtres sur la ville (1ère partie, 2e motif)* (*The Windows on the City [1st Part, 2nd Motif]*, cat. no. 45), *Les Fenêtres simultanées [1ère partie, 2e motif, 1ère réplique]* (*The Simultaneous Windows [1st Part, 2nd Motif, 1st Replica]*, cat. no. 46), and *Les Fenêtres (The Windows*, cat. no. 48). Two other works, the large gouache *Les Fenêtres (The Windows*, Chenu Collection, Venice)[112] and *Fenêtres en trois parties* (*Windows in Three Parts*, cat. no. 54) can be dated to June 1912. Finally, *Les Trois Fenêtres, la tour et la roue (The Three Windows, the Tower and the Wheel*, cat. no. 56) has been dated to December 1912.[113] However, trying to establish a precise chronology for the *Windows* poses greater challenges than any of the preceding series. To date, no one has been able to discern any logic or system to the cryptic titles Delaunay assigned the works, and many solid attempts to present a clear chronology remain largely speculative, as will the one here.[114]

The painting generally regarded as the first in the series is the unfinished *The Windows on the City (1st Part, 2nd Motif)*, formerly in the collection of Sonia Delaunay. Similar in palette to *The Window on the City No. 3* and *The City of Paris*, it has the tentative quality of a sketch, suggesting that the artist was beginning to map the general territory for the *Windows* series. *The Simultaneous Windows (1st Part, 2nd Motif, 1st Replica)* appeared with a date of April 1912 in the special album on the *Windows* prepared by Apollinaire for Delaunay's exhibition at Der Sturm gallery in January 1913.[115] It is the first

Eiffel Tower series that Delaunay began to associate simultaneity with this kind of pictorial energy (see, for example, *The Simultaneous Tower* and *Red Eiffel Tower*).

In asserting simultaneity as a perceptual, rather than temporal concept, Delaunay sought to distinguish himself from the Italian Futurists, who applied the concept to a kind of sequential dynamism that Delaunay found too mechanical. Spate was the first to point out that Delaunay's preoccupation with perceptual cognition appears to have been inspired by the writings of Leonardo da Vinci, which had recently appeared in a popular French translation.[107] In the 1920s, Delaunay would write:

The first time that I came upon a suggestion of this idea was in the notes of Leonardo da Vinci, who wrote on the differentiation between the arts of painting and literature, but this appreciation deals only with the function of the eye. He tries to prove the intellectual superiority given by simultaneity, by our eyes, windows of the soul, over the auditory and successive function of hearing. It is only a matter of color *for the sake of* color *in the* Windows *paintings.*[108]

In his notes on Leonardo's work, Delaunay made the following citation: "Para. 358 [of Leonardo's notebooks]. The eye, which is called the window of the soul, is the principal means by which the mind can consider, largely and in their splendor, the infinite works of nature."[109] This passage resonates in the following excerpt from Delaunay's essay "Light"

completed painting that presents the basic typology that governs most of the works in the series. Centrally located, the Eiffel Tower is reduced to an opaque form enveloped in a sea of alternatingly opaque and transparent planes of color. The city is barely discernible as such, with only the slightest indication of windows in a building at the bottom. The semblance of a foreground or background has been surrendered; everything seems to exist in a singular space. Only with prior knowledge of the *City* pictures can we recognize the pedigree for this work. Otherwise, it almost passes for pure abstraction. Interestingly, the painting extends out onto the frame, wedding it with the structure of the composition, a practice common with Seurat and other neo-Impressionist painters and suggestive of Delaunay's reference to them in his conceptualization of the series.[116]

Les Fenêtres (*The Windows*, 1912, Collection of George Ullman, Great Neck, New York)[117] is inscribed as the second work in the series, followed by *Les Fenêtres sur la ville n° 3 (2ᵉ motif, 1ère partie)* (*The Windows on the City No. 3 [2nd Motif, 1st Part]*, 1912, cat. no. 47)[118] and *Les Fenêtres* (*The Windows*, cat. no. 48), which is inscribed "4-1912." These works shift in scale, gradually becoming larger and more abstract, with a palette that varies greatly between them, testifying to the range of experimentation undertaken by Delaunay in executing them.

Two other works that belong in this early group are *Les Fenêtres simultanées (2ᵉ motif, 1ère partie)* (*The Simultaneous Windows [2nd Motif, 1st Part]*, 1912, cat. no. 49) and *Fenêtre* (*Window*, probably 1912, cat. no. 50). The former bears a general resemblance in color to *The Simultaneous Windows (1st Part, 2nd Motif, 1st Replica)*, though the increased scale of the Eiffel Tower suggests a later placement within the group. On the back of the latter version is a sketch for *The Cardiff Team*, a series of paintings that Delaunay executed at the end of 1912 and beginning of 1913. For this reason, *Window* has sometimes been dated 1912–13. But the similarity of the palette, composition, and handling to *The Simultaneous Windows (2nd Motif, 1st Part)* suggests that it belongs earlier in the series, to April or May.

Fenêtres ouvertes simultanément (1ère partie, 3ᵉ motif) (*Windows Open Simultaneously [1st Part, 3rd Motif]*, 1912, cat. no. 51), which appeared after Habasque's catalogue raisonné was published in 1957, has been dated by the Tate Gallery, London, to May or June, placing it after *The Simultaneous Windows (1st Part, 2nd Motif, 1st Replica)* and *The Simultaneous Windows (2nd Motif, 1st Part)* but before *Windows in Three Parts*, which was made in June.[119] Its rich tapestry of color leaves only one form, the Eiffel Tower, as a discernible objective element. Conforming to the same basic composition as the preceding works, both *La Fenêtre* (*The Window*, 1912, cat. no. 52) and *Les Fenêtres* (*The Windows*, 1912, cat. no. 53) seem to belong with them. However, the palette in both is closer to

fig. 40. Vasily Kandinsky, *St. Georg II*, 1911. Oil on canvas, 107 x 95 cm (42 ⅛ x 37 ⅜ inches). The State Russian Museum, Saint Petersburg

paintings executed later in the year, so it is possible that Delaunay reprised the motif at a later stage.

In June, a fundamental shift occurred in the syntax of the series with *Windows in Three Parts*. The basic vertical window view was transmogrified into a horizontal composition with three repeated sequences. Intimate in scale, each part merges almost seamlessly into the next, as if three views now exist simultaneously. This concept was applied more abstractly in a work that probably follows this one, *Fenêtres ouvertes simultanément (1ère partie, 3ᵉ motif)* (*Windows Open Simultaneously [1st Part, 3rd Motif]*, 1912, cat. no. 55), which is distinguished from the rest of the paintings by its oval format.[120] It is interesting to note that by late 1911, Braque and Picasso had adopted the oval format for many of their Cubist compositions. Thus, Delaunay's adaptation of the shaped canvas, though applied only once, appears as an attempt to claim Cubist convention as his own.

All of the works from the summer period are distinguished by the increasing or fluctuating elimination of clear references to specific objects. In his writings from this period, Delaunay advocated an art of pure painting, devoid of representation: "Simultaneity of colors by means of simultaneous contrasts and all measures (uneven) evolved from colors, according to the visible movement—this is the only reality

fig. 41. Paul Klee, *in der Einöde* (*In the Desert*), 1914. Watercolor on paper, 17.6 x 13.7 cm (6 ¹⁵⁄₁₆ x 5 ⅜ inches). Private collection, Switzerland

which painting can construct."[121] In 1913, on the heels of his work on the *Windows* series, Delaunay applied this thinking to its absolute in creating *First Disk* (fig. 3), the first nonobjective painting by a French artist. Though clearly related to his conception of natural and artificial light expressed in paintings from 1906–08, such as *Landscape with Sun Disk* (fig. 2) and *Blue Still Life* (fig. 5), it also evolved directly out of his preoccupation with color theory; the disk bears a distinct likeness to a printer's color wheel. However, when Delaunay returned to the *Windows* series in the winter of 1912–13, he reintroduced the object into his compositions, as if he were unable to sustain a dialogue with pure abstraction at this point in his career.

The Three Windows, the Tower and the Wheel is dated by Delaunay to December 1912.[122] The horizontal format departs from the predominant vertical orientation in the series. The form of the Eiffel Tower appears to resonate in several places, not the least of which is at the center, where its girders are clearly described. The large Ferris wheel, an element in early *City* and later *Eiffel Tower* paintings, reappears—made prominent for the first time in any of Delaunay's works—sitting astride a partial yet distinct view of a cityscape at right. The form of a propeller appears left of center, foreshadowing the motifs found in *Sun, Tower, Airplane*

painted in 1913. *Une Fenêtre. Etude pour les trois fenêtres* (*A Window. Study for the Three Windows*, cat. no. 57) has a similar palette and temperament to *The Three Windows, the Tower and the Wheel*, for which it appears to have been a study, but in the *Windows* album it is dated 1912–13, suggesting that the former may not have been finished until then either.

The last definite work in the series is small in scale but quite grand in conception. *Les Fenêtres sur la ville (1ère partie, 1ers contrastes simultanes)* (*The Windows on the City [1st Part, 1st Simultaneous Contrasts]*, 1912, cat. no. 58) returns to the grand horizontal format found in *Windows in Three Parts*, with elements of every *Window* painting discussed so far appearing in the composition. At various locations in the canvas, we find the motif of the Eiffel Tower, sometimes only as a dark silhouette, at other times rendered as a transparent, three-dimensional object. The image of the wheel astride the city found in *The Windows* (cat. no. 53) returns, as do the propeller-like forms. The overall abbreviation of the brushwork, especially at right, suggests the possibility that the painting was being made as a study for a grander, never realized composition.

There are two works dated to 1914, as well as one dated 1912, whose dates pose the usual havoc in trying to determine Delaunay's chronology. The first, *The Window on the City* (cat. no. 17) was begun in 1910 and reworked in 1914. This painting is discussed in this essay in connection with the *City* series, to which it essentially belongs. However, the curtain motifs and rendering of light in the upper region of the painting display the results of lessons learned through the *Windows* of 1912. Begun so early and reworked so late, it is unfair to include it in a strict progression of either series, so it must remain an anomaly.

Another anomaly is *Window with Orange Curtains*, which Habasque dates to 1912.[123] Perfectly square in format, the painting has the entire semblance of the *City* series, with a trace of the abstract qualities of the *Windows*. It could be seen as dating from the intervening period between *The Window on the City No. 3* and *The Windows on the City (1st Part, 2nd Motif)*. Although its treatment of the Eiffel Tower and cityscape represent several steps backward from the former, placing *Window with Orange Curtains* as a work that might precede both *The Window on the City No. 3* and *The Windows on the City (1st Part, 2nd Motif)* poses problems with the chronology. *Window with Orange Curtains*, too, seems to be a work that was begun early and worked on later, joining company with *The Window on the City* (cat. no. 17).

Finally, there is a small wax painting, *Fenêtre sur la ville* (*Window on the City*, cat. no. 59), which is dated to October 1914 in an inventory prepared by Sonia Delaunay in 1916.[124] The painting is very close in handling to the early group of works made in April–May 1912, so if it was indeed painted late in 1914, it is very curious that it has so many of the qual-

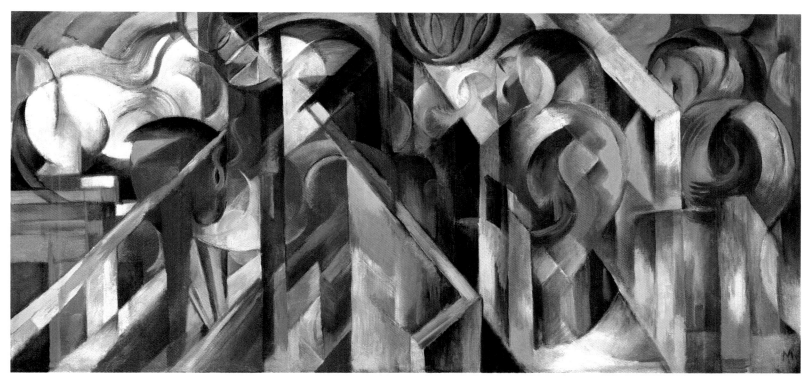

fig. 42. Franz Marc, *Stallungen* (*Stables*), 1913. Oil on canvas, 73.6 x 157.5 cm (29 x 62 inches). Solomon R. Guggenheim Museum, New York 46.1037

ities found in works painted two years earlier. Without knowing more about the circumstances of its execution—whether it was begun as early as 1912 and finished later in 1914, or simply painted almost one year after the last definite painting in the series, *The Windows on the City (1st Part, 1st Simultaneous Contrasts)*, it is difficult to make either a definitive or tentative judgement about the work.

The *Windows* were first exhibited in July 1912 at the *Moderner Bund* in Zurich.[125] Paul Klee, who may or may not have seen the earliest examples when he visited Delaunay in Paris the previous April,[126] reviewed the exhibition and was clearly moved by the work:

This inconsistency [of the Cubist transformation of nature] especially troubled Delaunay, one of the most brilliant artists of our time. He solved it in a startlingly simple way: by creating a type of independent picture which leads its own formal existence without borrowing its motifs from nature. A vividly palpable creation which, incidentally, is almost as different from a carpet as a Bach fugue. A very close link to this last period could be seen in Zurich: his Windows on the City (First Part, Second Motif).[127]

The influence of Delaunay's example can be seen in Klee's Tunisian watercolors of 1914 (for example, *In der Einöde* [*In the Desert*], fig. 41), which employ a grid structure and transparent colors.[128]

When Delaunay returned to Paris from La Madelaine in October 1912, he found the German painters Macke and Franz Marc eagerly waiting to see him. The *Windows* paint-

ings Delaunay brought back with him apparently sparked great interest among them, leading to more studio visits and a correspondence that continued over the next year (see pp. 128–31 in this volume).[129] Though little discernible influence can be seen specifically in his art, Macke was clearly enthusiastic about Delaunay's new work. In March 1913, Macke wrote about *The Windows* to Köhler: "If you . . . will trust me that these pictures above all others can fill you with a downright heavenly joy in life and in sunshine— they are not abstract at all; they are of supreme reality."[130] Marc's response to the work was more sober. He wrote Kandinsky following the Paris visit: "it seems to me that he still relies too much on complimentary colors and prism effects; but his things are definitely talented, and [he] is full of great intentions."[131] However, it is hard to imagine the stylistic evolution that Marc's work underwent in 1913, in a work such as *Stallungen* (*Stables*, fig. 42), without the example of Delaunay's *Windows*.

The Windows formed the backbone of Delaunay's first solo exhibition in Germany, held at Walden's Der Sturm gallery from January to February 1913.[132] Of the nineteen works shown, thirteen were from the *Windows* series. For the occasion, a special album was published illustrating eleven of the *Windows* with a poem by Apollinaire of the same name, written in homage to the works.[133]

At the same time, Delaunay's essay "Light," the most comprehensive expression of his ideas to date, was translated by Klee and published in the January issue of *Der Sturm* (see pp. 124–27 in this volume).[134] Written as a series of sin-

gular pronouncements strung together in manifesto-like fashion, it encompassed all of the myriad impulses he had been struggling with over the past four years—color, light, rhythm, and perception—and presented them as a coherent whole. It began:

Impressionism is the birth of light in painting. Light reaches us through our perception. Without visual perception, there is no light, no movement. Light in Nature creates color-movement. Movement is provided by relationships of uneven measures, of color contrasts among themselves that make up Reality. This reality is endowed with Depth (we see as far as the stars) and thus becomes rhythmic simultaneity. Simultaneity in light is the harmony, the color rhythms which give birth to Man's sight.[135]

At the opening of the exhibition at Der Sturm, Apollinaire delivered a lecture entitled "Modern Painting," which was published in the February issue of *Der Sturm.*[136] In it, he tried to establish a historical pedigree for the concept of Orphism, his attempt at distinguishing a generation of avant-garde artists (Delaunay, Marcel Duchamp, Léger, and Francis Picabia, among others) against the more generic understanding of Cubism. With Delaunay as the leading example, he sought to distinguish the Orphic tendency by virtue of its capacity to embody an art of "pure painting," based on plastic laws rather than observed reality. Elsewhere, he wrote:

It is the art of painting new structures with elements which have not been borrowed from visual reality, but have been entirely created by the artist, and which have been endowed by him with a powerful reality. The works of the Orphic artists must simultaneously give pure aesthetic pleasure, a structure which is self-evident, and a sublime meaning, that is to say, the subject. It is pure art. The light in Picasso's works contains this art which Robert Delaunay for his part is inventing.[137]

But by gradually including so many artists within the boundaries of Orphism, Apollinaire diluted its effectiveness as a concept. Later, Delaunay objected to what Apollinaire had done, citing the tendency to "align with cubism every manifestation of the art of that era"[138] and asserted instead:

Les Fenêtres *was a great deal more significant as plastic and poetic sensibility and novelty. If we compare it with the past at the moment of its actual making, it stands as a real creation. I want to say here that there is nothing like it within the tradition and at the present time I think that it is misunderstood.*[139]

Later Years (1914–41)

Feeling misunderstood would become a mantra for Delaunay. World War I broke out in 1914, catching him and Sonia by surprise while on vacation in Fuenterrabia, Spain. Instead of returning to France and supporting the war effort, they stayed away and concentrated on making art. They set up a studio in Vila do Conde, Portugal, sharing a villa with Eduardo Vianna, a Portuguese artist, and an American friend, Sam Halpert. At a time of intense French nationalism, their absence from the war caused resentment and confusion among the more patriotic of their friends. One, the writer Ricciotto Canudo, wrote: "I received with great shock your card, very surprised that Robert Delaunay continues to stay at a distance from the war of the fatherland, where [Dunoyer de] Segonzac and others have spilled their blood until dead. Surprised, that one speaks at this time of simultaneism, colored speech and other nonsense that I no longer understand."[140] Apparently undeterred by such sentiments, the Delaunays self-imposed Portuguese exile became an opportunity to explore new directions in their art. Sonia's interests in fashion and handicrafts flourished, nurtured by regional examples, and Delaunay embarked further into abstraction, in some cases revisiting older works and reworking them to reflect more recent thinking (for example, *Saint-Séverin No. 7*). The two artists solidified a collaborative relationship that had been nourished by common interests since their courtship, now manifested in works of art whose shared vocabulary revolved around prismatic abstract forms.[141]

When Delaunay and his wife returned to Paris in 1921, his reputation had slipped somewhat from its prewar peak. Nonetheless, catalyzed by Sonia's magnetic personality, their home quickly became an important destination point within the Parisian cultural community, especially for writers and poets like André Breton, Vladimir Mayakovski, Soupault, and Tristan Tzara. At the same time that Delaunay revived the theme of the Eiffel Tower for his work, he turned to portrait painting, and his works from these years help document the rich landscape of personalities active in Paris (for example, *Le Poète Philippe Soupault* [*The Poet Philippe Soupault*, cat. no. 41]; see also fig. 37). In 1925, the Delaunays participated in the landmark *Exposition International des Arts Décoratifs*. Sonia's "Boutique Simultanée" became a successful outlet for her fashion designs, leading to further success in Germany. Delaunay's entry, *The City of Paris, the Woman and the Tower* (cat. no. 42), was rejected by a jury that was far too conservative to embrace its nudity and abstract pictorial language, but their decision was reversed after he mustered the support of other Modern artists. The painting's large scale reflects the artist's increasing interest in bringing his ideas into an architectural context; it was to have been part of a collaboration with the architect Robert Mallet-Stevens and Léger to decorate the hall of an embassy. Delaunay's greatest achievement in this regard was a large-scale commission to decorate the Palais de l'Air and Palais de Chemins de Fer for the Exposition Internationale de Paris, 1937. He and Sonia enlisted a team

of artists in the effort, creating a suite of murals and decorations that proved to be the most monumental expression of their ideas in their careers.

In 1941, with World War II underway, the Delaunays moved to Mougins, Switzerland, and joined up with their friends Jean Arp and his wife, Sophie Taeuber. Delaunay's health had been poor prior to the move, but by the fall of that year his condition worsened, and he died of cancer on October 25 in a clinic in Montpellier. His art from these last years lacked the intensity and visionary spirit of the paintings executed between 1909 and 1914, yet his reputation did not suffer for it. Sonia dedicated the rest of her life to ensuring that Delaunay's contributions to twentieth-century art were not overshadowed by the hegemony of Picasso and Cubism, successfully positioning him as a major voice for abstract painting in his own right.

Unless an English-language edition of a publication is cited, translations are by the author.

1. While considerable time and effort was spent working in Robert Delaunay's two archives in Paris—Fonds Delaunay, Département de Documentation, Musée National d'Art Moderne, Centre Georges Pompidou, Paris (hereafter referred to as Fonds Delaunay, MNAM) and Fonds Delaunay, Bibliothèque Nationale, Paris (hereafter referred to as Fonds Delaunay, BN)—I am obliged to single out the role that Angelica Zander Rudenstine's scholarship played in shaping the issues covered in this essay. Though no more than a few pages each in length, her entries on Delaunay in Rudenstine, *The Guggenheim Museum Collection: Paintings 1880–1945*, vol. 1 (New York: Solomon R. Guggenheim Museum, 1976), provide a model of clarity and synthesis that still holds merit more than twenty years later.

2. See, for instance, Delaunay, "Three Notes on the Differences between Delaunay's Art and Impressionism and Expressionism" (1920s?), in Arthur A. Cohen, ed., *The New Art of Color: The Writings of Robert and Sonia Delaunay*, trans. David Shapiro and Cohen (New York: Viking Press, 1978), pp. 56–61, and Delaunay, "Le Petit Cahier de Robert Delaunay" (1933/1939), in Robert Delaunay, *Du Cubisme à l'art abstrait, Documents inédits publiés par Pierre Francastel et suivis d'un catalogue de l'oeuvre de R. Delaunay par Guy Habasque*, (Paris: S.E.V.P.E.N., 1957), pp. 72–77.

3. This correspondence is cited in Gustav Vriesen, "Robert Delaunay's Life and Work from the Beginning to Orphism," in Vriesen and Max Imdahl, *Robert Delaunay: Light and Color*, trans. Maria Pelikan (New York: Harry N. Abrams, 1967), p. 18.

4. Delaunay, "Three Notes," p. 57.

5. The first appearance of *Disk* paintings was in 1922 when *Premier Disque (First Disk)* was exhibited at Galerie Paul Guillaume in Paris. It was dated 1912 in the exhibition catalogue, but as Virginia Spate has demonstrated, it is extremely unlikely that this or any of the other works in the series was made before the second half of 1913. See Spate, *Orphism: The Evolution of Non-figurative Painting in Paris 1910–1914* (Oxford: Oxford University Press, 1979), p. 377.

6. Sonia Delaunay, unpublished biographical notes on Delaunay, box 48, Fonds Delaunay, MNAM.

7. The 1913 version is lost. The 1922 version is in the Musée National d'Art Moderne, Centre Georges Pompidou, Paris. There is also a watercolor study for the last version in a private collection.

8. See Francastel, introduction to Delaunay, *Du Cubisme à l'art abstrait*, pp. 17, 19, 34, and Vriesen, p. 20. Vriesen assumed that the painting was destroyed in 1912, since a painting entitled *Le Manège* was shown as no. 3 in Delaunay's exhibition that year at Galerie Barbazanges in Paris.

9. Because *The Window on the City No. 3* was shown as no. 10 in Delaunay's exhibition at Galerie Barbazanges in 1912 (see Habasque, p. 362), Vriesen's assumption that *Carousel of Pigs* was destroyed in 1912 is wrong. Many people at the Solomon R. Guggenheim Museum, New York, were involved in the identification of the fragment of *Carousel of Pigs* on the verso of *The Window on the City No. 3*. Conservation intern Friederike Steckling was the first to suggest the painting's identity in 1994 during work performed treating the side with *The Window on the City No. 3*. Working with Conservator Gillian McMillan, and then NEA Conservation intern Julie Barten, through a complete cleaning of the back, I was able to verify the identification, supported by archival research.

10. Delaunay, "Comments on the Backs of Photographs" (1938–39), in Cohen, p. 27.

11. Delaunay was not only motivated by altruism. After World War I, when his finances were weak, he apparently sold Rousseau paintings to make ends meet. There are correspondence and bills of sale to support this in Fonds Delaunay, MNAM.

12. Delaunay, "Letter to Kandinsky" (1912), in Cohen, p. 112.
13. Delaunay, "Passages from Old Methods to New" (ca. 1938), in Cohen, p. 12.
14. Ibid.
15. A concise architectural history of the church may be found in M. Jean Verrier, "L'Eglise Saint-Séverin," *Congrès Archéologique de France* 104 (1947), pp. 136–62.
16. The choice of a medieval subject would have political implications in France later in the decade. In an essay published in 1913, "Cubisme et la Tradition," Albert Gleizes celebrated the French proletariat's Celtic heritage, in opposition to the conservative view of French culture's Latin roots. This identification of "the Gothic" as something French as opposed to German was also tied to anti-German rhetoric leading up to World War I. An excellent analysis of this subject can be found in Mark Antliff, "The Body of the Nation: Cubism's Celtic Nationalism," chap. 4 in *Inventing Bergson: Cultural Politics and the Parisian Avant-Garde* (Princeton: Princeton University Press, 1993), pp. 106–34. My thanks to Matthew Affron for first bringing this to my attention.
17. Delaunay, "Three Notes," p. 58. He specifically refers to Monet's series as *Haystacks*; in recent years, this series has also been known as *Grainstacks* and *Wheatstacks*.
18. Vriesen, p. 28, and Sherry A. Buckberrough, *Robert Delaunay: The Discovery of Simultaneity* (Ann Arbor: UMI Research Press, 1982), p. 38.
19. Quoted in Vriesen, p. 26.
20. Buckberrough, pp. 41–44. For the dating of *Saint-Cloud. Study of Landscape*, see Michel Hoog, *Inventaire des collections publiques françaises: Robert et Sonia Delaunay* (Paris: Editions des Musées Nationaux, 1967), p. 43 n. 12.
21. See Delaunay, "Constructionism and Neoclassicism" (1924), in Cohen, p. 12, and Maurice Raynal, *Anthologie de la Peinture en France* (Paris: Editions Montaigne, 1927), pp. 114, 116.
22. See Rudenstine, pp. 80–84.
23. Referring to himself in the third person, Delaunay wrote: "These investigations were begun by the observation of the action of light on objects which led to the discovery that the line, according to the old laws of painting, no longer existed, but was deformed, broken by luminous rays (Robert Delaunay: *La Ville*, 1909, *Saint-Séverin*, 1909–10, *La Tour*, 1910–11)." See Delaunay, "Draft of a Letter to Nicolas Maximovitch Minsky" (1912/1918?), in Cohen, p. 63.
24. It was exhibited as no. 4,358 in *Salon des Indépendants*, Paris, March–May 1910.
25. Rudenstine, pp. 80–84.
26. Habasque no. 150, p. 274. Habasque citations refer to numbered entries in Guy Habasque, *Catalogue de l'oeuvre de Robert Delaunay*, in Delaunay, *Du Cubisme à l'art abstrait*. This was the first attempt at a comprehensive catalogue of Delaunay's work in all mediums. While it is an extremely important and useful source, it contains many errors and should be used with caution.
27. Buckberrough, p. 42.
28. Delaunay, notes, in Delaunay, *Du Cubisme à l'art abstrait*, pp. 86–87.
29. Guillaume Apollinaire, "Prenez Garde la Peinture!" in L.-C. Breunig, ed., *Chroniques d'art* (Paris: Librairie Gallimard, 1960), pp. 75–76; originally published in *L'Intransigeant*, March 18, 1910. He might also have been referring to *La Ville nº 1* (*The City No. 1*, 1910, cat. no. 16).
30. Maurice Princet, preface to *Robert Delaunay*, exh. cat. (Paris: Galerie Barbazanges, 1912), from a typescript in box 50, Fonds Delaunay, MNAM, unpaginated. The exhibition was held February 28–March 13, 1912.
31. E. v. Busse, "Robert Delaunay's Methods of Composition," in Wassily Kandinsky and Franz Marc, eds., *The Blaue Reiter Almanac* (1912), new documentary edition, ed. Klaus Lankheit (New York: Da Capo Press, 1989), p. 121.
32. Theodor Däubler, *Der neue Standpunkt* (Dresden: Hellerau Verlag, 1916), p. 181.
33. For more about Delaunay's connections to Germany, see Peter-Klaus Schuster, "Delaunay und Deutschland" in Schuster, ed., *Delaunay und Deutschland*, exh. cat. (Cologne: DuMont Buchverlag, 1985), pp. 69–80.
34. In 1916, B. Diebold wrote of "the famous rider of Kandinsky" and "Delaunay's cathedral" in connection with German cinema. See Diebold, "Expressionismus und Kino" (Berlin, 1916), unpaginated. Anagret Hoberg first cited this source in Schuster, *Delaunay und Deutschland*, p. 357. A copy of this brochure is in Fonds Delaunay, BN.
35. Johannes Langner, "Zu den Fenster-Bildern von Robert Delaunay," *Jahrbuch der Hamburger Kunstsammlungen* 7 (1962), pp. 70–72.
36. I agree with Rudenstine that the study for *The City* (cat. no. 13) is the first work, although Langner, pp. 70–72, argues that the study for *La Ville* (*The City*, 1909, cat. no. 14), which I indicate as the second version, precedes it. See Rudenstine, p. 94.
37. Buckberrough, p. 52, and Rudenstine, p. 96.
38. Delaunay, "Draft of a Letter to Nicolas Maximovitch Minsky," p. 63.
39. Delaunay, "Passage from Old Methods to New," p. 12. He might also have been thinking of later versions of *The City* in placing them after *Saint-Séverin*.
40. Habasque no. 71, p. 257, and Buckberrough, pp. 336–37 n. 25. The painting was restored in 1955, but details of that restoration have not been made available.
41. Rudenstine, p. 96.
42. W. Bombe, "Franz Marc und der Expressionismus," *Das Kunstblatt* (March 1917), p. 75.
43. Once again, Rudenstine's research has convincingly cleared up a mistake in the record. It was heretofore thought that *La Ville* (*The City*, 1911, cat. no. 20) was in this exhibition, along with *La Ville nº 2* (*The City No. 2*, 1910, cat. no. 19). However, by noting that *The City No. 1* was purchased by Jawlensky from the exhibition and that *The City No. 2* is illustrated in Busse's essay on Delaunay in *The Blaue Reiter Almanac*, she sets the record straight. See Rudenstine, pp. 94–97.
44. Habasque no. 146, p. 274.
45. *La Ville nº 2* was the title Delaunay gave to *La Ville* (*The City*, cat. no. 20) when it was shown in the 1912 exhibition at Galerie Barbazanges. *La Ville nº 2* (*The City No. 2*, cat. no. 19) was shown as an *étude*, or study. At some later time, he simply called cat. no. 20 *La Ville* and cat. no. 19 *La Ville nº 2*, without referring to it as a study.
46. Rudenstine, pp. 94–97.
47. Habasque no. 350, p. 307. This watercolor was catalogued in the Philadelphia Museum of Art's A. E. Gallatin Collection as *Tour Eiffel* (*Eiffel Tower*), but has recently been correctly entitled *La Fenêtre sur la ville* (*The Window on the City*).
48. It is often suggested that this view, though documented as coming from a postcard (fig. 18), might also have been the view from Delaunay's studio window at 23 rue des Grands-Augustins.
49. See Delaunay, "Simultanisme de l'art moderne contemporaine peinture. Poésie," in Delaunay, *Du Cubisme à l'art abstrait*, p. 110. The painting is dated 1912 in the 1912 Galerie Barbazanges exhibition catalogue, and December 1911 in Guillaume Apollinaire, *Robert Delaunay*, exhibition album (Berlin: Der Sturm, 1913).
50. Rudenstine, p. 97. She also clarifies a misunderstanding about the title for *The Window on the City No. 3*. At some point, Delaunay inscribed it "1909–1910 Paris 1911" and "La Fenêtre sur la Ville nº 4," seeing *The City No. 2* (cat. no. 19) as a painting in its own right, rather than as a study for the subsequent version, *The City* (cat. no. 20). However, he never retitled the third version. See Rudenstine, p. 98.
51. See Spate, pp. 374–75.

52. Exactly which of the *City* paintings appeared in the 1911 *Salon des Indépendants* is not certain, but chronologically it would have to be *The City No. 1*. See Apollinaire, "Prenez Garde la Peinture!," pp. 75–76.

53. As Rudenstine notes on p. 93, it is very difficult to ascertain which paintings were in this exhibition, other than *Eiffel Tower* (cat. no. 26), which appeared in Roger Allard's review of the exhibition, "Sur Quelques Peintres," *Les Marches de Sud-Ouest*, no. 2 (June 1911), pp. 57–64. Delaunay inscribed the back of at least four paintings as having been in the 1911 *Salon des Indépendants*, although we know that only three appeared in the exhibition.

54. Apollinaire, "La Jeunesse artistique et les nouvelles disciplines," in Breunig, *Chroniques d'art*, p. 164; originally published in *L'Intransigeant*, April 21, 1911.

55. Kandinsky to Delaunay, December 20, 1911, quoted in Vriesen, pp. 36, 38. The letter is in Fonds Delaunay, MNAM.

56. Busse, pp. 122–23.

57. Quoted in Buckberrough, p. 54. Her extended discussion of *unanisme* and the literary parallels to Delaunay's art is very useful. Romains's ideas were in turn indebted to such philosophers as Henri Bergson. For an excellent account of Bergson's relevance to the art of this era, see Mark Antliff, *Inventing Bergson: Cultural Politics and the Parisian Avant-Garde* (Princeton: Princeton University Press, 1993).

58. F. T. Marinetti, "The Foundation and Manifesto of Futurism" (1909), in Charles Harrison and Paul Wood, eds., *Art in Theory 1900–1990* (Cambridge, Mass.: Blackwell Publishers, 1992), p. 147.

59. Delaunay, "Simultaneism in Contemporary Modern Art, Painting, Poetry" (October 1913), in Cohen, p. 48. His disagreements with Futurism actually evolved into a debate, captured in an exchange of letters between him and Umberto Boccioni. See Delaunay, correspondence fragment, in *Du Cubisme à l'art abstrait*, pp. 135–43.

60. Françoise Cachin, "Futurism in Paris 1909–13," *Art in America* 62, no. 2 (March–April 1974), pp. 38–44. This idea is not postulated in the article, but the author does note that Apollinaire wrote "Jules Romains" in the margin of the catalogue of the first Futurist exhibition in 1912 near Boccioni's works.

61. Delaunay, "Passages from Old Methods to New," p. 13.

62. Quoted in Vriesen, p. 34.

63. Delaunay, "Passages from Old Methods to New," p. 13.

64. Cendrars, writing in 1931, quoted in Vriesen, p. 29.

65. Several sketches are recorded in Habasque, but others have emerged since his catalogue raisonné. There were apparently several sketchbooks, which were at some point dismantled. It may never be possible to fix an absolute number to these works.

66. Rudenstine, p. 85.

67. From Sonia Delaunay's unpublished notes, Fonds Delaunay, MNAM.

68. See the accounts given in Georges Bernier and Monique Schneider-Manoury, *Robert et Sonia Delaunay: Naissance de l'art abstrait* (Mesnil-sur-l'Estrée: Editions Jean Claude Lattès, 1995), pp. 69–71, and Vriesen, pp. 24–25.

69. Quoted in Vriesen, p. 25.

70. Buckberrough, p. 49.

71. Vriesen, p. 32.

72. Rudenstine, p. 85. *Eiffel Tower with Trees* is inscribed "1909," but Rudenstine convincingly dates it to 1910.

73. Delaunay, "Passages from Old Methods to New," p. 13.

74. The fact that Delaunay chose to portray the Eiffel Tower in red is intriguing. While his early impressions of it convey the dark color of its iron skin, the red hue becomes a distinguishing feature of the series and his reprisal of the subject in the 1920s. The only other artist who appears to have bestowed this color scheme upon the tower is Georges Seurat.

75. Habasque no. 83, p. 260.

76. First noted by Habasque, p. 258, Rudenstine provided further evidence by showing that it was reproduced in Allard, "Sur Quelques Peintres," pp. 57–64. See Rudenstine, p. 92 n. 2.

77. Apollinaire, "La Jeunesse artistique et les nouvelles disciplines," p. 164.

78. Delaunay to Köhler, March 12, 1912, NAF 25,642, Fonds Delaunay, BN.

79. Buckberrough, pp. 57–58.

80. Delaunay, "Robert Delaunay's First Notebook" (1939), in Cohen, p. 21.

81. Rudenstine, p. 90. One could imagine that it was made much later. It was not Delaunay's habit to make formal drawings of major compositions, preferring to work directly on the canvas.

82. It was exhibited as no. 5 in Delaunay's exhibition at Galerie Barbazanges in 1912, and reproduced in Apollinaire, *Robert Delaunay*, unpaginated. See Rudenstine, pp. 104–05.

83. Buckberrough, p. 72.

84. Vriesen, p. 40.

85. Rudenstine, p. 105.

86. Ibid., pp. 102–08. Rudenstine's dating here seems correct.

87. Ibid., pp. 106–07.

88. Habasque no. 103, p. 264.

89. Delaunay, "Robert Delaunay's First Notebook" (1939), p. 22.

90. Habasque no. 101, p. 264.

91. Attempts to gain more insight into the Kunstsammlung Nordrhein-Westfalen's view of the work were unsuccessful.

92. The other version is *Le Poète Philippe Soupault* (*The Poet Philippe Soupault*, 1922, Musée National d'Art Moderne, Centre Georges Pompidou, Paris).

93. I am not alone in reaching this conclusion. Buckberrough writes, "Although one cannot totally eliminate the possibility that the painting fits into Delaunay's 1911 development, it is far more likely that it is a pastiche created at a much later date" (p. 338 n. 50).

94. George L. K. Morris, "Dialogues with Delaunay," *Artnews* 53, no. 9 (January 1955), p. 65.

95. Princet, unpaginated.

96. Daubler, p. 181.

97. The catalogue lists forty-one works, but a typescript of the checklist in Fonds Delaunay, MNAM, lists an additional six works.

98. Princet, unpaginated.

99. Vriesen, p. 40. As he notes, the date of the work (1910–1912) reflects Delaunay's by now familiar habit of including the date of conception in the work along with the date of execution.

100. Apollinaire, "Le Salon des Indépendants," in Breunig, *Chroniques d'art*, pp. 224–25; originally published in *L'Intransigeant*, March 20, 1912.

101. Vriesen, p. 44. See also Buckberrough, pp. 101–04.

102. Princet to Delaunay, spring 1912, quoted in Vriesen, p. 44. I was unable to find the entire letter in the artist's archives.

103. Delaunay received a copy of Kandinsky's *Concerning the Spiritual in Art* in the spring of 1912, but wrote that he had to wait for it to be translated before reading it. See Delaunay, "Letter to Kandinsky," p. 112.

104. Delaunay is referring to one of Kandinsky's *Improvisations* and to his own *The City No. 2* (cat. no. 19).

105. Delaunay, "Letter to Kandinsky," p. 112.

106. Delaunay, "Simultaneism in Contemporary Modern Art, Painting, Poetry" (October 1913), in Cohen, p. 48.

107. Spate, pp. 187–90.

108. Delaunay, "Orphisme" (ca. 1928–29), in Delaunay, *Du Cubisme à l'art abstrait*, p. 171.

109. Delaunay, "De Leonardo da Vinci" (n.d.), in Delaunay, *Du Cubisme à l'art abstrait*, p. 175. Spate points out that Delaunay must have read a 1910 translation by Péladan. Her section on Leonardo's influence on Delaunay is the most concise and erudite account, and my comments here largely attempt to condense her more complex argument. See Spate, pp. 187–90.

110. Delaunay, "Light" (1912), in Cohen, p. 82.

111. Habasque records nineteen works, and three more have come to light since then: *Fenêtre* (*Window*, probably 1912, cat. no. 50), *Fenêtres ouvertes simultanément (1ère partie, 3e motif)* (*Windows Open Simultaneously [1st Part, 3rd Motif]*, 1912, cat. no. 51), and *Fenêtre sur la ville* (*Window on the City*, 1914, cat. no. 59).

112. Habasque no. 351, p. 307.

113. Langner, pp. 67–82. This is the first credible attempt at establishing a chronology for the series.

114. See, for instance, Buckberrough, pp. 111–18.

115. Apollinaire, *Robert Delaunay*.

116. Sonia Delaunay notes that this feature was added later: "The picture was begun on the canvas, but afterward, Delaunay found the picture too small and extended it out onto the frame." Quoted in Vriesen, p. 46.

117. Habasque no. 743, p. 393.

118. This work is inscribed "1911–12," but it is likely a later inscription. While Habasque has accepted Delaunay's dating of several works in the series to 1911, it is more likely that, as on other occasions, Delaunay is associating the painting with the conceptual point of departure for the series, which was *The Window on the City No. 3* (cat. no. 21), begun in 1911.

119. Buckberrough, pp. 112–13, quotes from entry about the painting in the Tate Gallery's catalogue of its collection.

120. Rudenstine, in her catalogue of the Peggy Guggenheim Collection (*Peggy Guggenheim Collection, Venice* [New York: Harry N. Abrams; Solomon R. Guggenheim Foundation, 1985], pp. 208–13), prefers a date of autumn 1912, following an argument advanced by Buckberrough, pp. 112ff. While the argument is plausible, the strong similarity of this work to those produced in the spring and summer leads me to disagree, a view which is supported in Spate, p. 376.

121. Quoted by Apollinaire, as quoted in Vriesen, pp. 44, 46. These words are from Delaunay's "Note on the Construction of Reality in Pure Painting" (1912), which he wrote for Apollinaire, who quoted from it in "Réalité: Peintre pure," *Les Soirées de Paris*, no. 11 (1912). Apollinaire's essay was subsequently published in German in *Der Sturm*, nos. 138–39 (December 1912). Cohen, pp. 94–96, publishes a poor translation of Delaunay's note and misdates it to 1913.

122. Delaunay, notes on the verso of correspondence fragment, in Delaunay, *Du Cubisme à l'art abstrait*, p. 139.

123. Habasque no. 102, p. 264.

124. Habasque, p. 397. While there are several such inventories in Fonds Delaunay, MNAM, this particular one was not located. No subsequent references to the work were noted either.

125. Paintings from the *Windows* series were exhibited in *Moderner Bund. Zweite Ausstellung*, Kunsthaus Zurich, July 7–31, 1912. Of the two works shown, no. 30 has been identified as *The Windows on the City (1st Part, 2nd Motif)* (cat. no. 45).

126. Rudenstine, *The Guggenheim Museum Collection*, pp. 109–10.

127. Quoted in Vriesen, p. 52; originally published as "Die Ausstellung des Moderner Bundes im Kunsthaus Zurich," *Die Alpen* 6, no. 12 (1912). A typescript of Klee's article is in Fonds Delaunay, MNAM.

128. Andrew Kagan, "Klee's Development," in *Paul Klee at the Guggenheim Museum*, exh. cat. (New York: Solomon R. Guggenheim Museum, 1993), p. 24.

129. Vriesen, pp. 50–52.

130. Macke to Köhler, March 10, 1913, quoted in Vriesen, p. 46.

131. Quoted in Vriesen, p. 50.

132. The exhibition, *Zwölfte Ausstellung: R. Delaunay*, was held at Der Sturm, Berlin, January 27–February 20, 1913.

133. Apollinaire, *Robert Delaunay*, unpaginated. For Apollinaire's poem "Les Fenêtres" ("Windows"), see p. 132 of this volume.

134. Delaunay, "Uber das Licht," trans. Paul Klee, *Der Sturm* 3, nos. 144–45 (January 1913).

135. Delaunay, "Light" (1912), in Cohen, p. 81.

136. Apollinaire, "Modern Painting," in Cohen, pp. 99–102; originally published in German in *Der Sturm*, nos. 148–49 (February 1913).

137. Quoted in Spate, p. 73. Her book remains the most extensive and interesting work on the subject. The quotation is taken from Apollinaire, *Les Peintres cubistes* (Paris, 1913), p. 57.

138. Delaunay, "Two Notes on Orphism" (1930; 1928–30), in Cohen, p. 104.

139. Ibid., p. 106.

140. Canudo to Sonia Delaunay, November 16, 1914, Fonds Delaunay, MNAM.

141. For more on their collaboration, see Whitney Chadwick, "Living Simultaneously: Sonia and Robert Delaunay," in Chadwick and Isabelle de Courtivron, eds., *Significant Others: Creativity and Intimate Partnership* (New York: Thames and Hudson, 1993), pp. 31–48.

Saint-Séverin

1.
Saint-Séverin nº 1 (**Saint-Séverin No. 1**), 1909
Oil on canvas
116 x 81 cm (45 $^{11}/_{16}$ x 31 $^{7}/_{8}$ inches)
Private collection, Switzerland

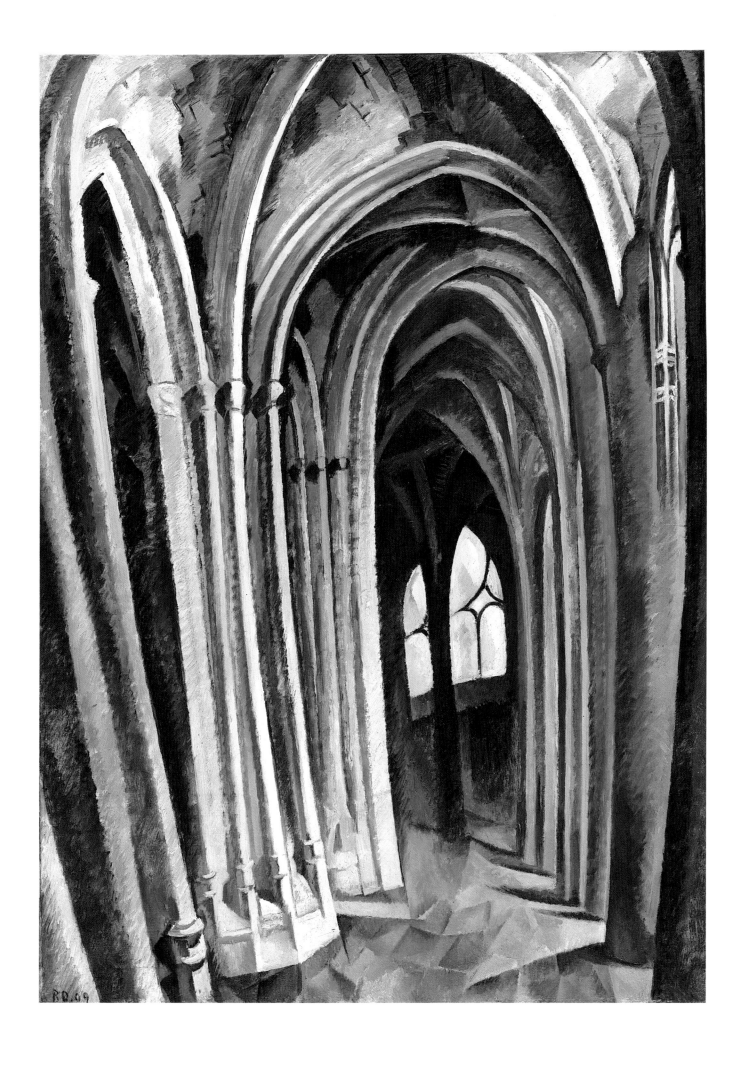

2.
Saint-Séverin n° 2 (Saint-Séverin No. 2), 1909
Oil on canvas
99.4 x 74 cm (39⅛ x 29⅛ inches)
The Minneapolis Institute of Arts,
The William Hood Dunwoody Fund

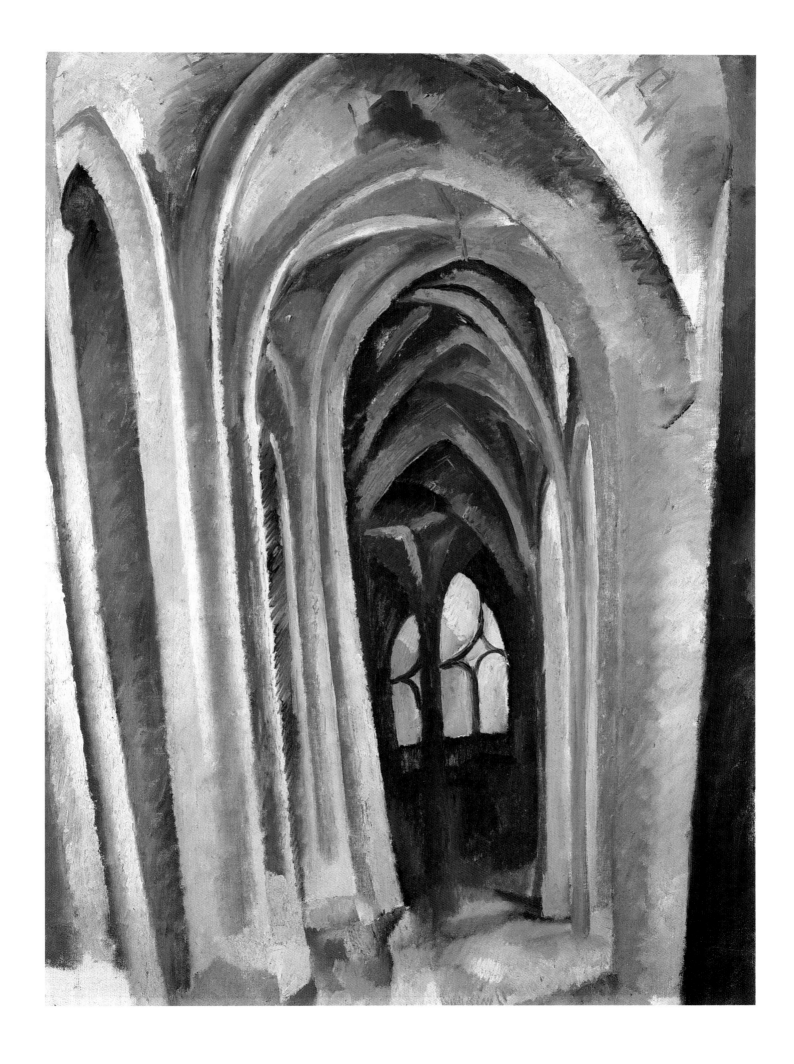

3.
Saint-Séverin nº 3 (Saint-Séverin No. 3), 1909–10
Oil on canvas
114.1 x 88.6 cm (44 $^{15}/_{16}$ x 34 $^{7}/_{8}$ inches)
Solomon R. Guggenheim Museum, New York,
Gift, Solomon R. Guggenheim 41.462

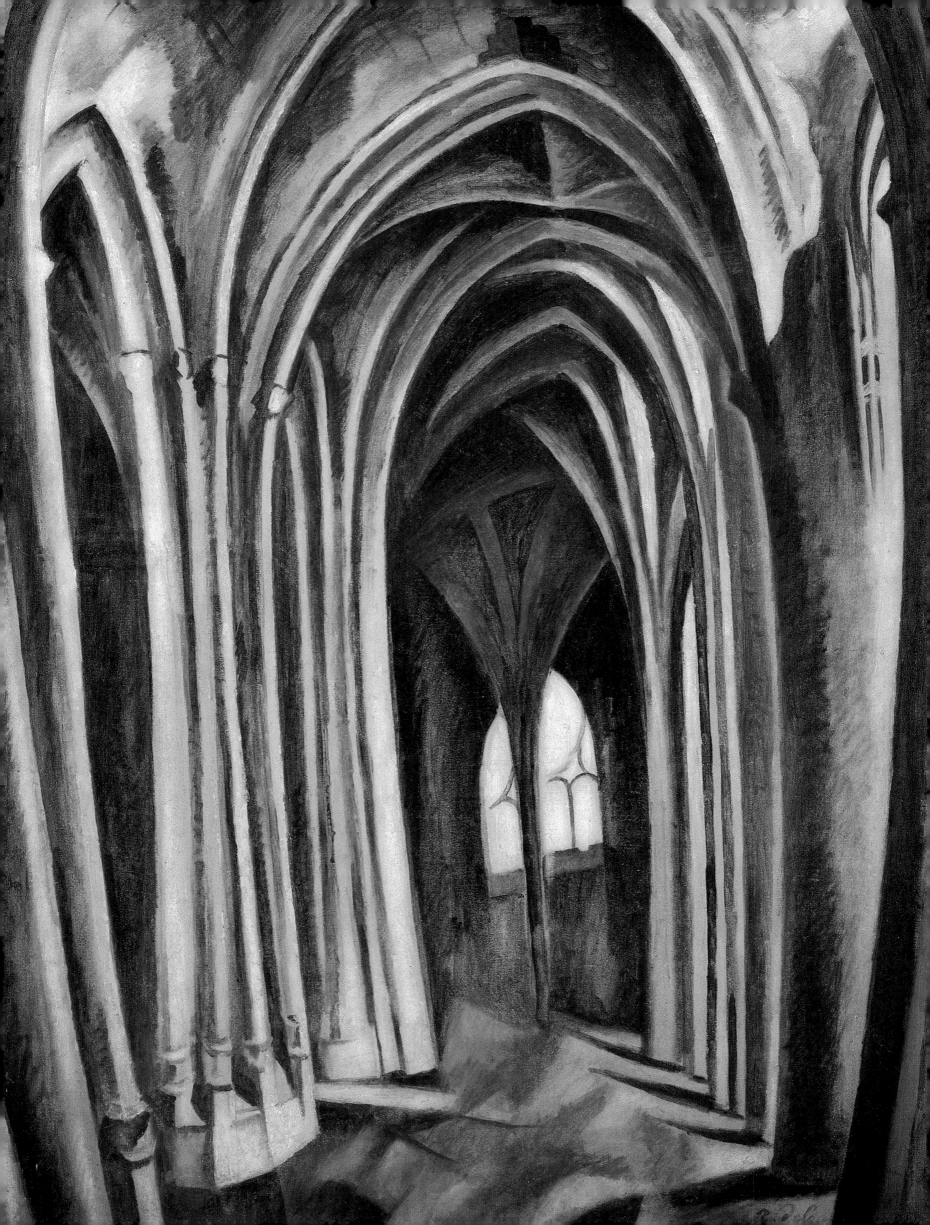

4.
Saint-Séverin n° 4 (**Saint-Séverin No. 4**),
1909 [1909–10]
Oil on canvas
96.5 x 70.5 cm (38 x 27 ¾ inches)
Philadelphia Museum of Art,
The Louise and Walter Arensberg Collection

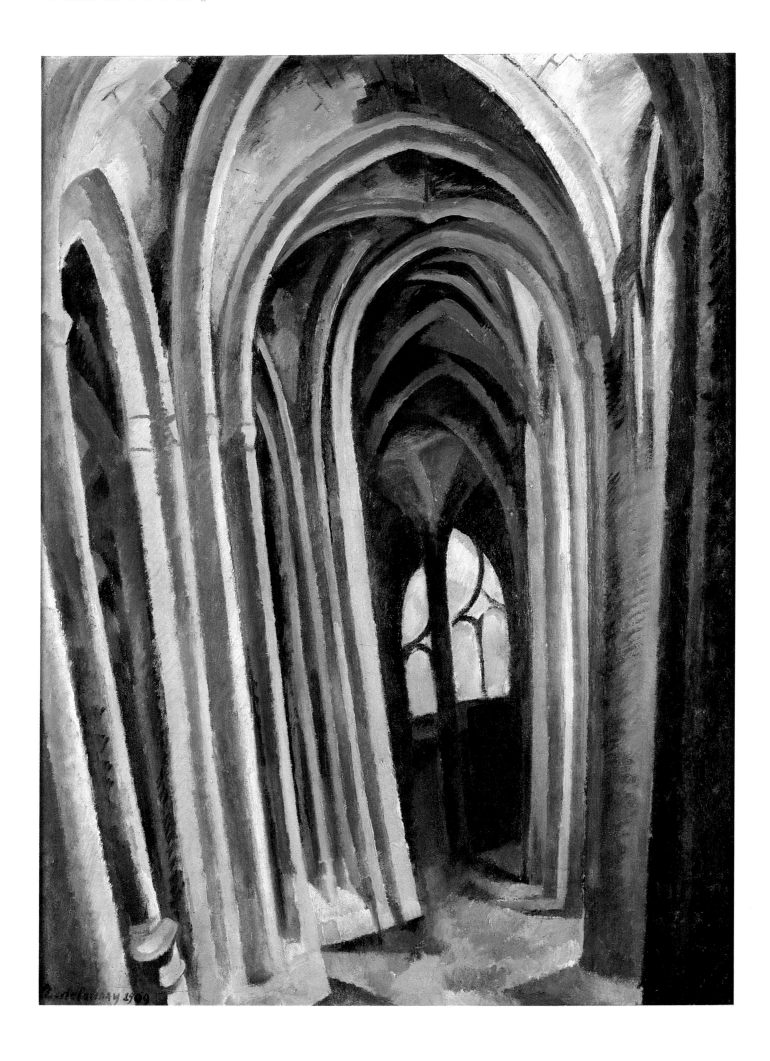

5.
Study for **Saint-Séverin**, 1909–10 [1909]
Pencil on paper
31 x 23.5 cm (12¼ x 9¼ inches)
Musée National d'Art Moderne,
Centre Georges Pompidou, Paris

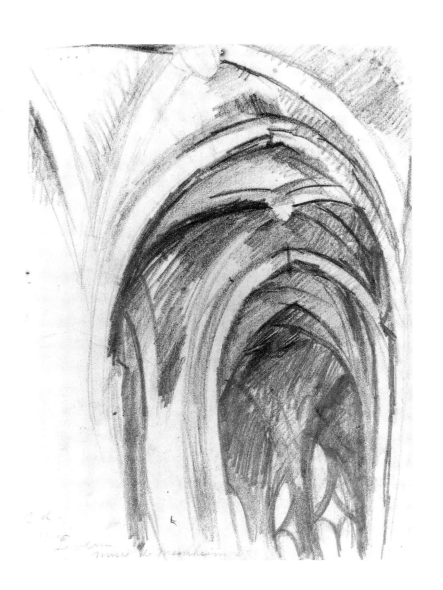

6.
Study for **Saint-Séverin**, 1909–10 [1910]
Ink on paper mounted on cardboard
25 x 19.6 cm (9 7/8 x 7 3/4 inches)
Musée National d'Art Moderne,
Centre Georges Pompidou, Paris,
Donation of Sonia and Charles Delaunay, 1963

7.
Study for **Saint-Séverin**, ca. 1909–10
Pencil on paper
42.5 x 31.1 cm (16 3/4 x 12 1/4 inches)
Location unknown

8.
Study for **Saint-Séverin**, 1909 [1910]
Crayon on paper
42.8 x 31.1 cm (17 x 12 1/4 inches)
The Art Institute of Chicago,
Worcester Sketch Fund Income, 1968.164

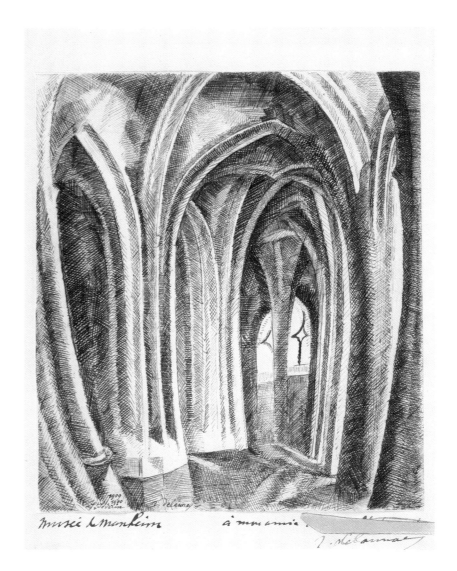

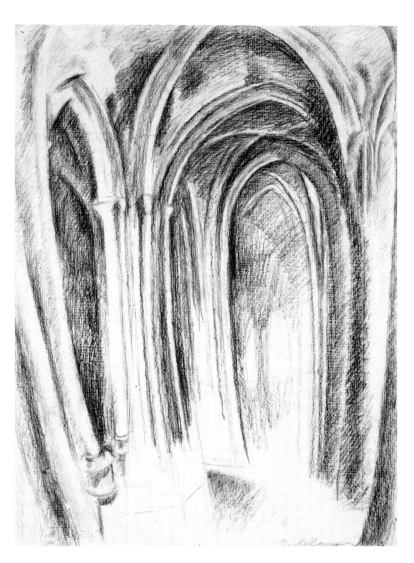 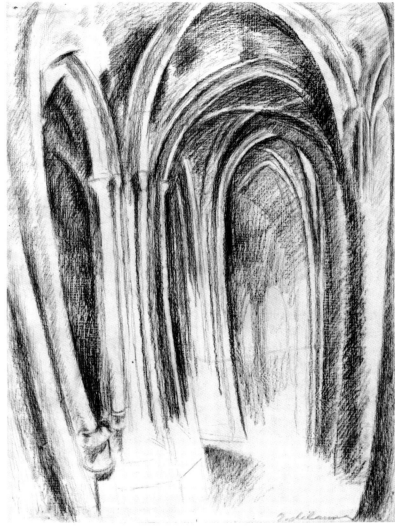

9.
Saint-Séverin n° 5. L'Arc-en-ciel
(**Saint-Séverin No. 5. The Rainbow**), 1909 [1910]
Oil on canvas
58.5 x 38.5 cm (23 x 15 ³⁄₁₆ inches)
Moderna Museet, Stockholm

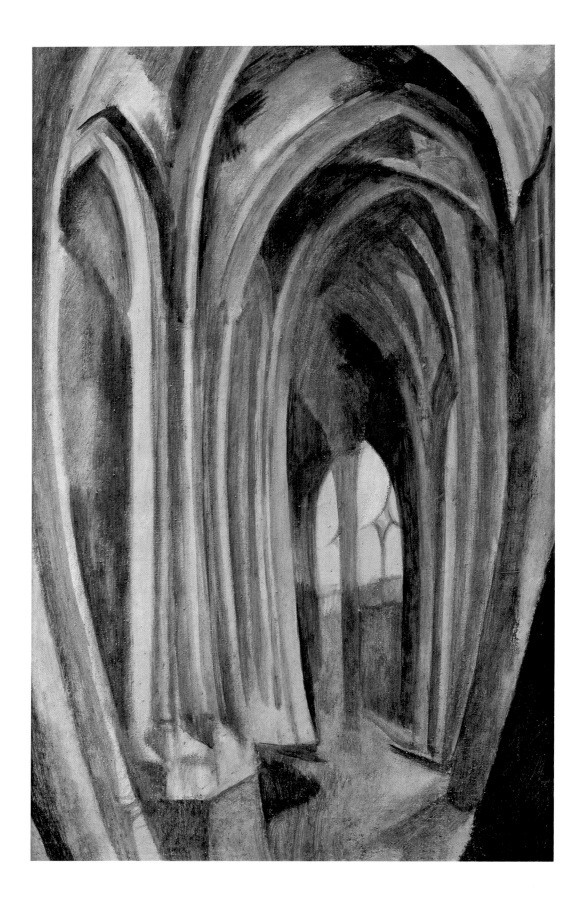

10.
Saint-Séverin n° 6 (**Saint-Séverin No. 6**), 1910
Oil on metal
36 x 26 cm (14 ⁵⁄₁₆ x 10 ¼ inches)
Private collection, Switzerland

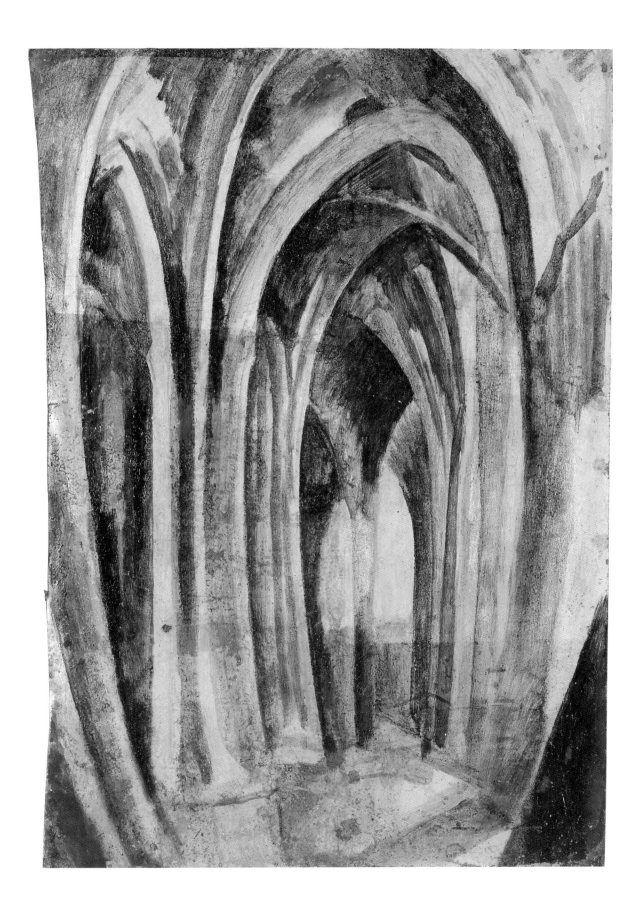

11.
Saint-Séverin, 1909 [1910]
Watercolor and pencil on paper
48.5 x 34.4 cm (19 ⅛ x 13 ⁹/₁₆ inches)
Museum of Fine Arts, Boston,
Bequest of Betty Barlett McAndrew

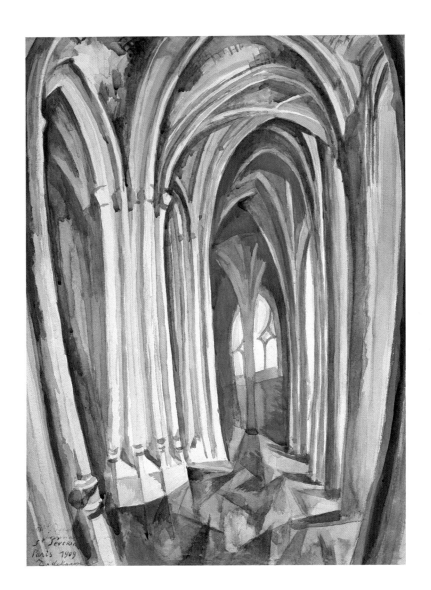

12.
Saint-Séverin nº 7 (Saint-Séverin No. 7),
ca. 1909–10/1915
Wax on canvas
139.5 x 99 cm (54¹⁵⁄₁₆ x 39 inches)
Private collection, France

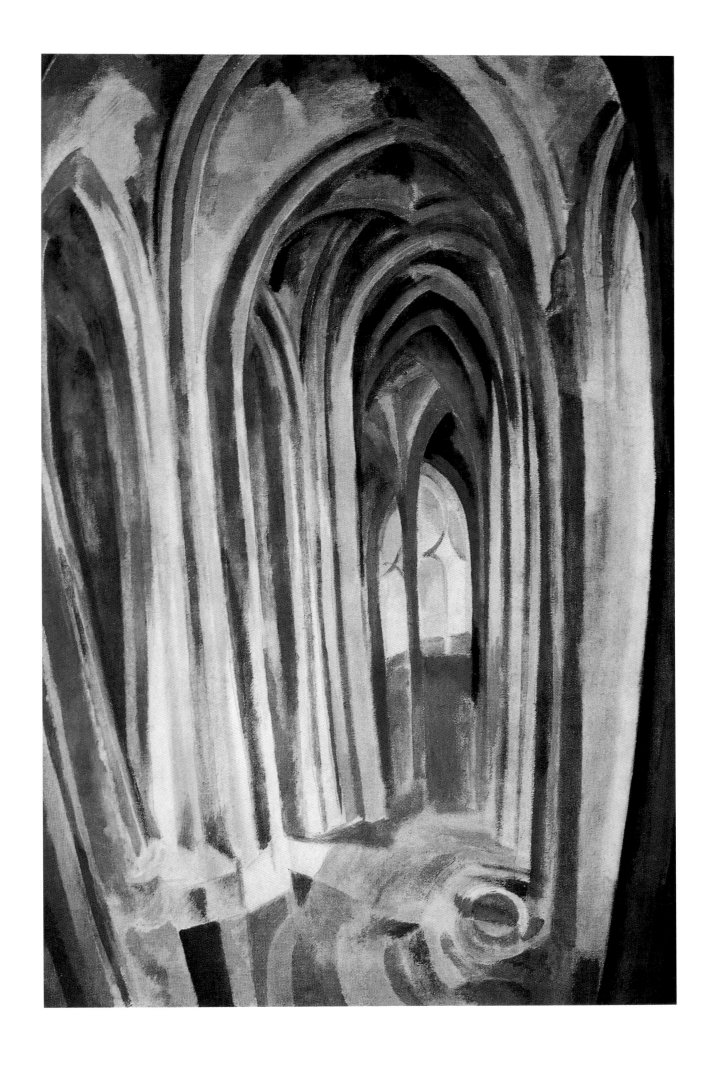

The City

13.
Study for **La Ville** (**The City**), 1909
(verso of *Saint-Séverin No. 2*, 1909)
Oil on canvas
99.3 x 73.9 cm (39 $\frac{1}{16}$ x 29 $\frac{1}{16}$ inches)
The Minneapolis Institute of Arts,
The William Hood Dunwoody Fund

14.
Study for **La Ville** (**The City**), 1909
Oil on canvas
80.5 x 67.5 cm (31 11/16 x 26 9/16 inches)
Kunstmuseum Winterthur

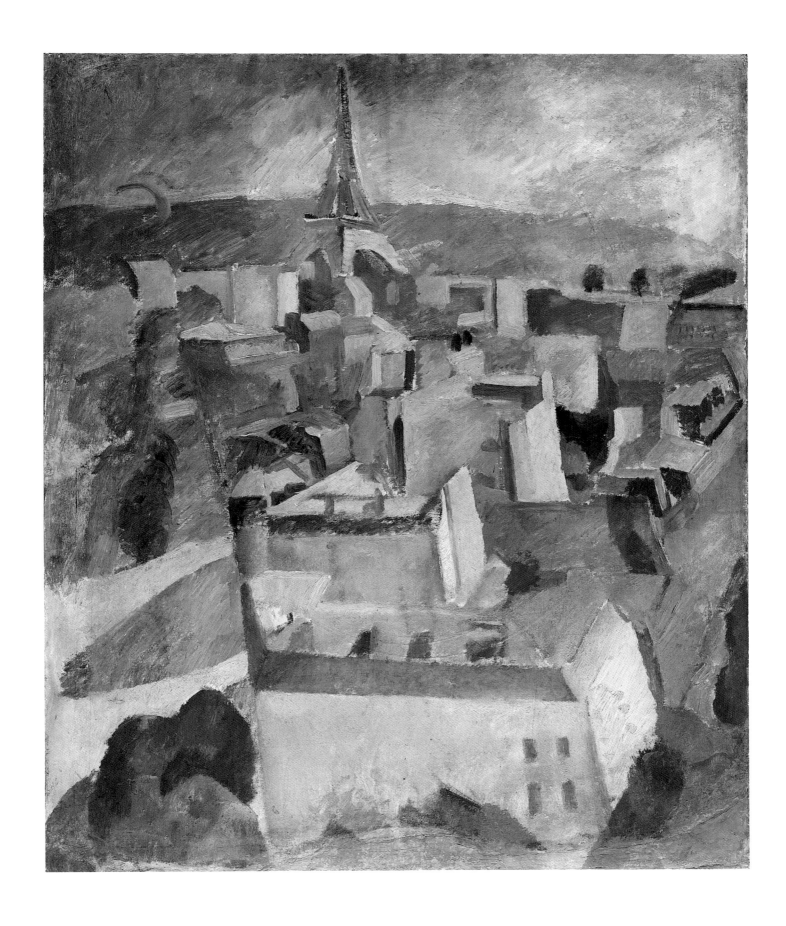

15.
Ville. Première Etude (City. First Study),
1909 [1909–10]
Oil on canvas
88.3 x 124.5 cm (34 ¾ x 49 inches)
Tate Gallery, London, Purchased 1958

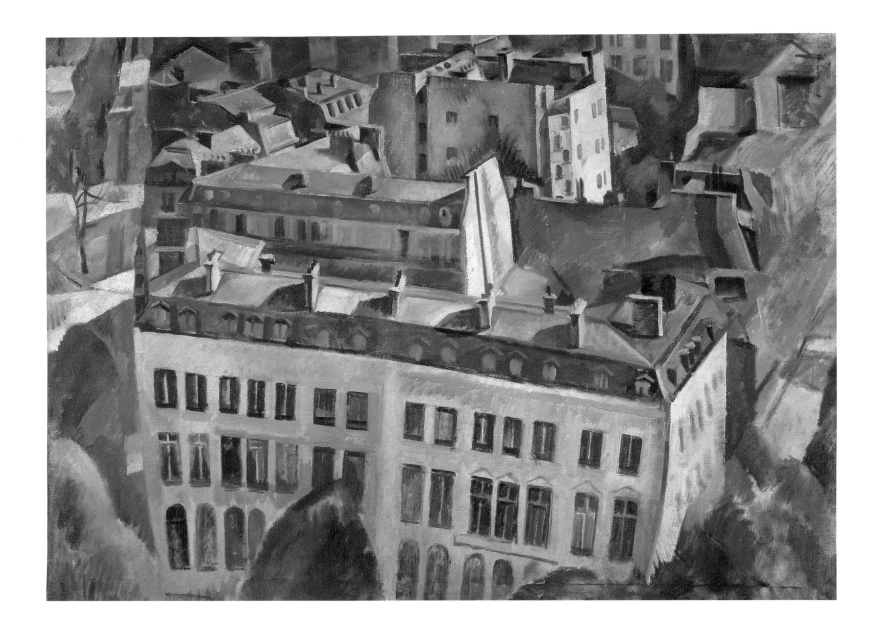

16.
La Ville nᵒ 1 (The City No. 1),
1910
Oil on canvas
Dimensions unknown
Location unknown

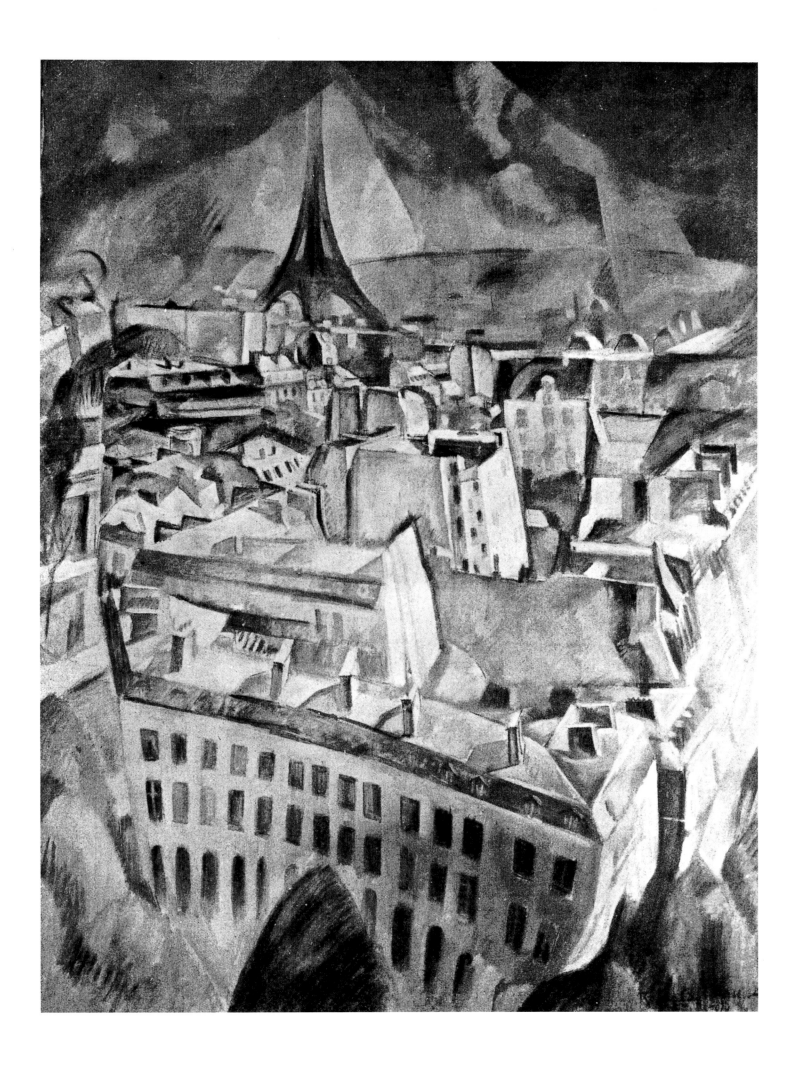

17.
La Fenêtre sur la ville (**The Window on the City**),
1910/1914
Wax on canvas
56 x 46 cm (22 x 18 ⅛ inches)
Städtische Kunsthalle Mannheim

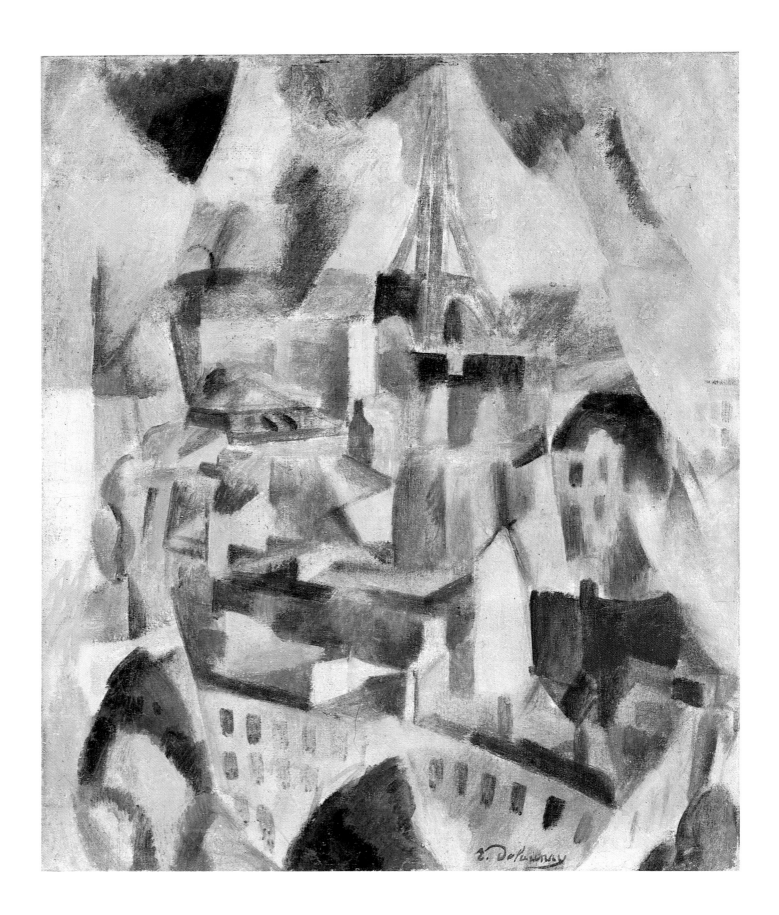

18.
La Fenêtre sur la ville (The Window on the City),
1910–11
Watercolor on paper
62.2 x 49.5 cm (24 ½ x 19 ½ inches)
Philadelphia Museum of Art,
A. E. Gallatin Collection

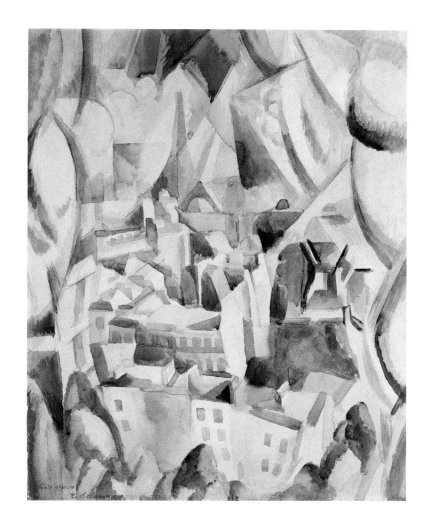

19.
La Ville n° 2 (**The City No. 2**), 1910
Oil on canvas
146 x 114 cm (57 ½ x 44 ⅞ inches)
Musée National d'Art Moderne, Centre
Georges Pompidou, Paris

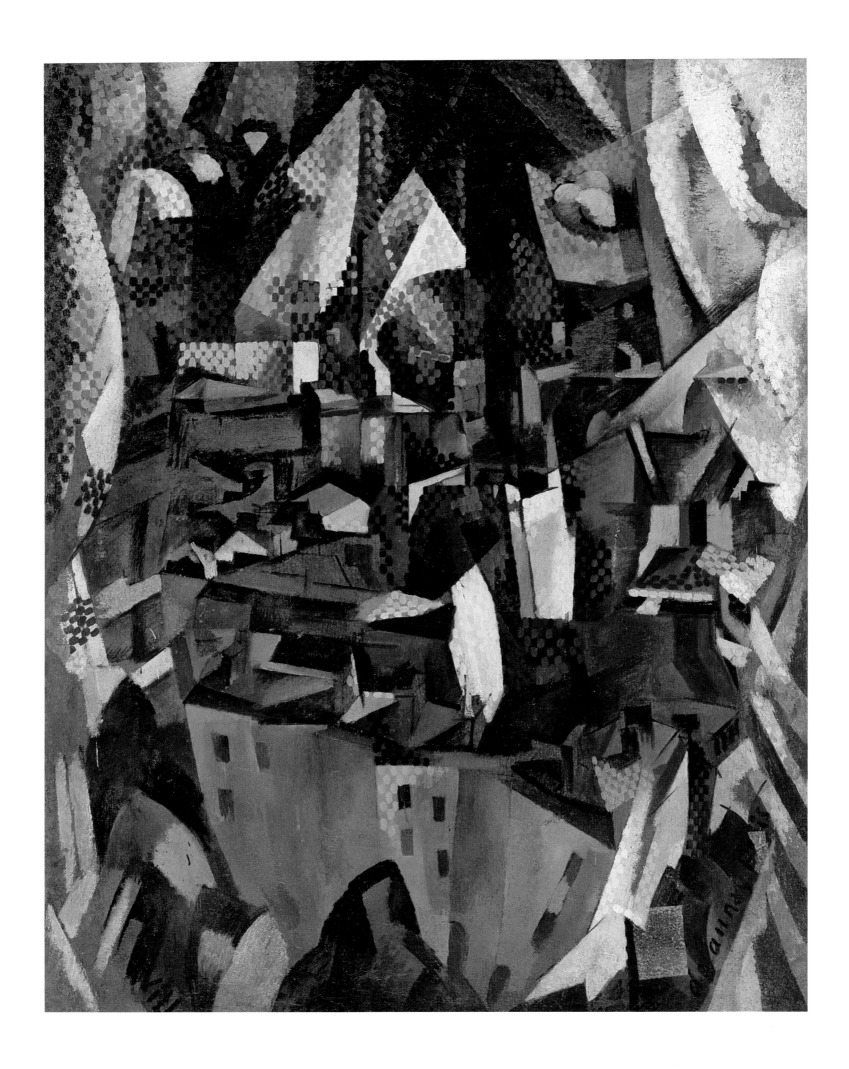

20.
La Ville (**The City**), 1911
Oil on canvas
145 x 112 cm (57 ¹/₁₆ x 44 ¹/₈ inches)
Solomon R. Guggenheim Museum, New York,
Gift, Solomon R. Guggenheim 38.464

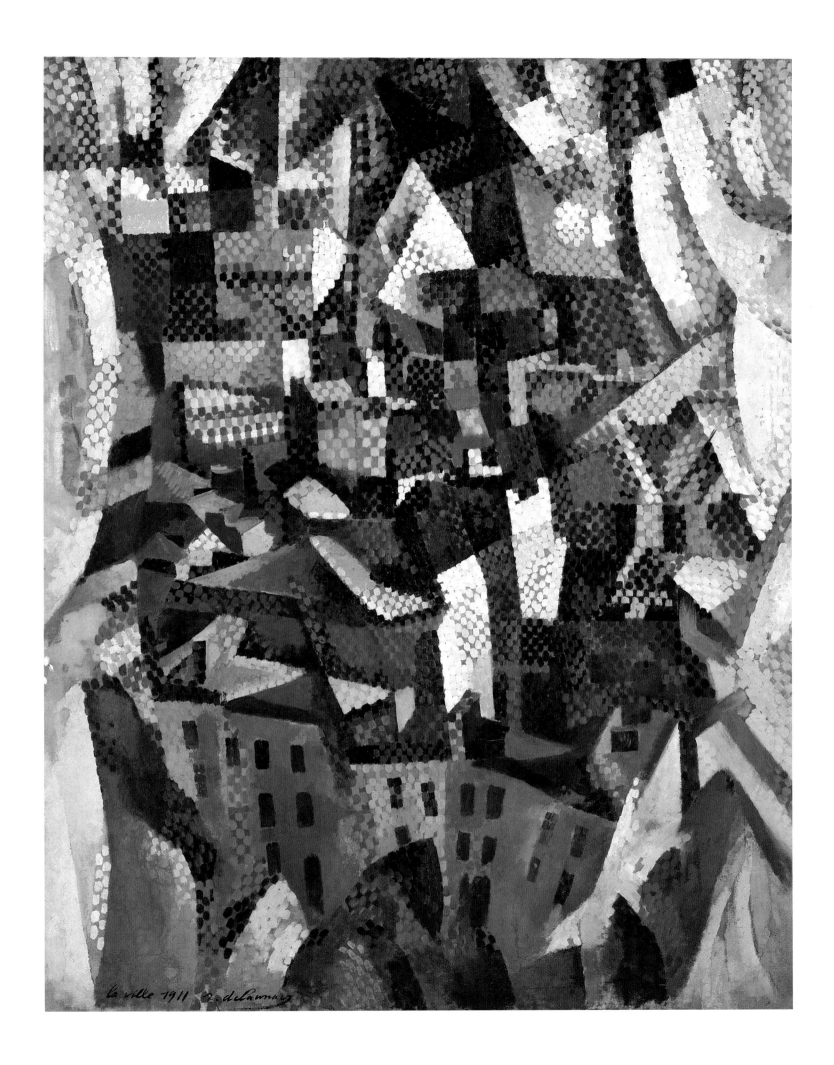

21.
La Fenêtre sur la ville n° 3
(**The Window on the City No. 3**), 1911–12
Oil on canvas
113.7 x 130.8 cm (44 ¾ x 51 ½ inches)
Solomon R. Guggenheim Museum,
New York 47.878.1

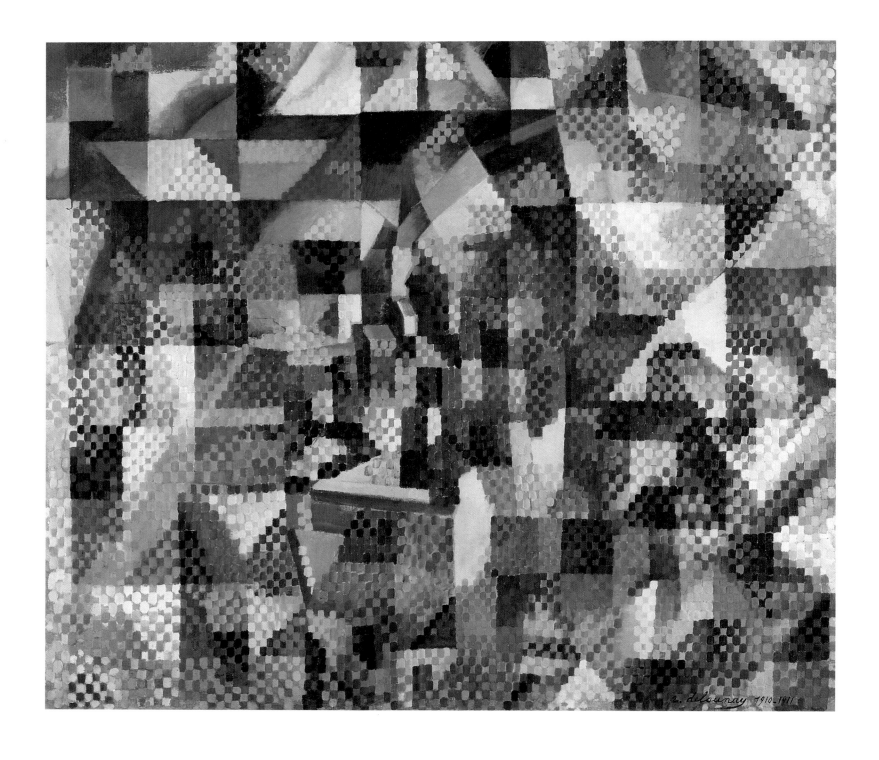

The Eiffel Tower

22.
Tour. Première Etude
(Tower. First Study), 1909
Oil on canvas
46.2 x 38.2 cm (18 ³⁄₁₆ x 15 ¹⁄₁₆ inches)
Location unknown

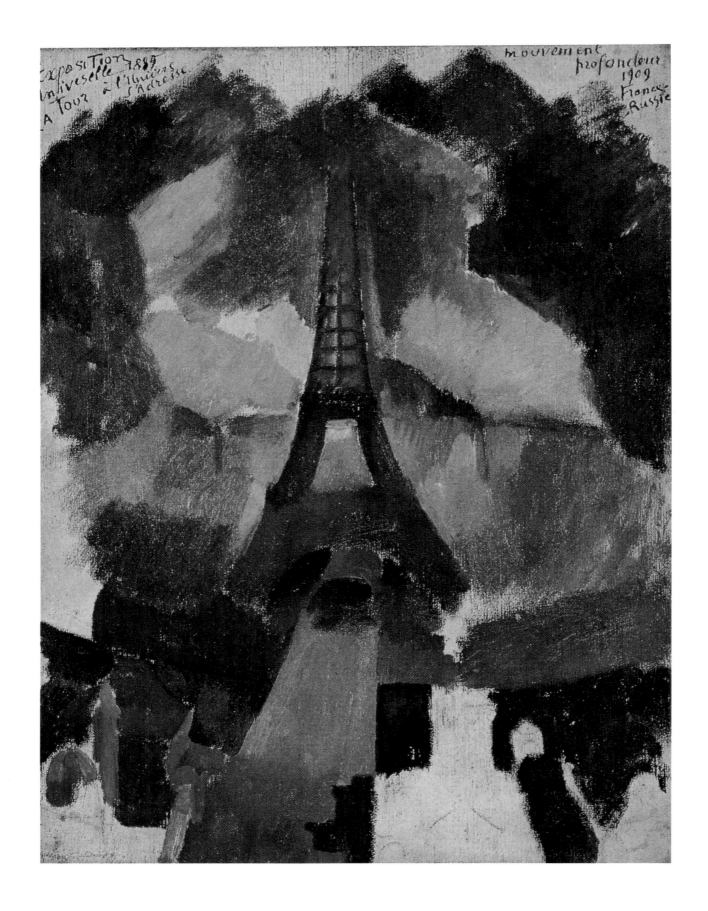

23.
Tour Eiffel (**Eiffel Tower**), ca. 1909
(verso of *Saint-Séverin No. 4*, 1909 [1909–10])
Oil on canvas
96.5 x 70.5 cm (38 x 27 ¾ inches)
Philadelphia Museum of Art,
A. E. Gallatin Collection

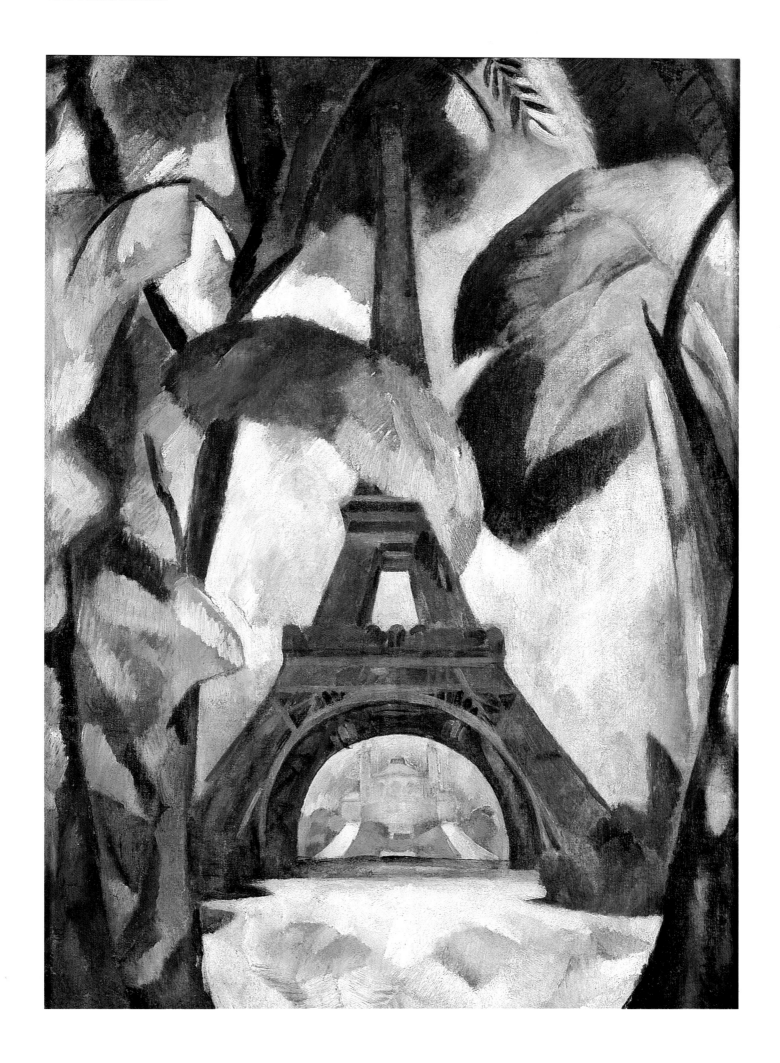

24.
Tour Eiffel aux arbres
(**Eiffel Tower with Trees**), 1910
Oil on canvas
126.4 x 92.8 cm (49¾ x 36⁹⁄₁₆ inches)
Solomon R. Guggenheim Museum,
New York 46.1035

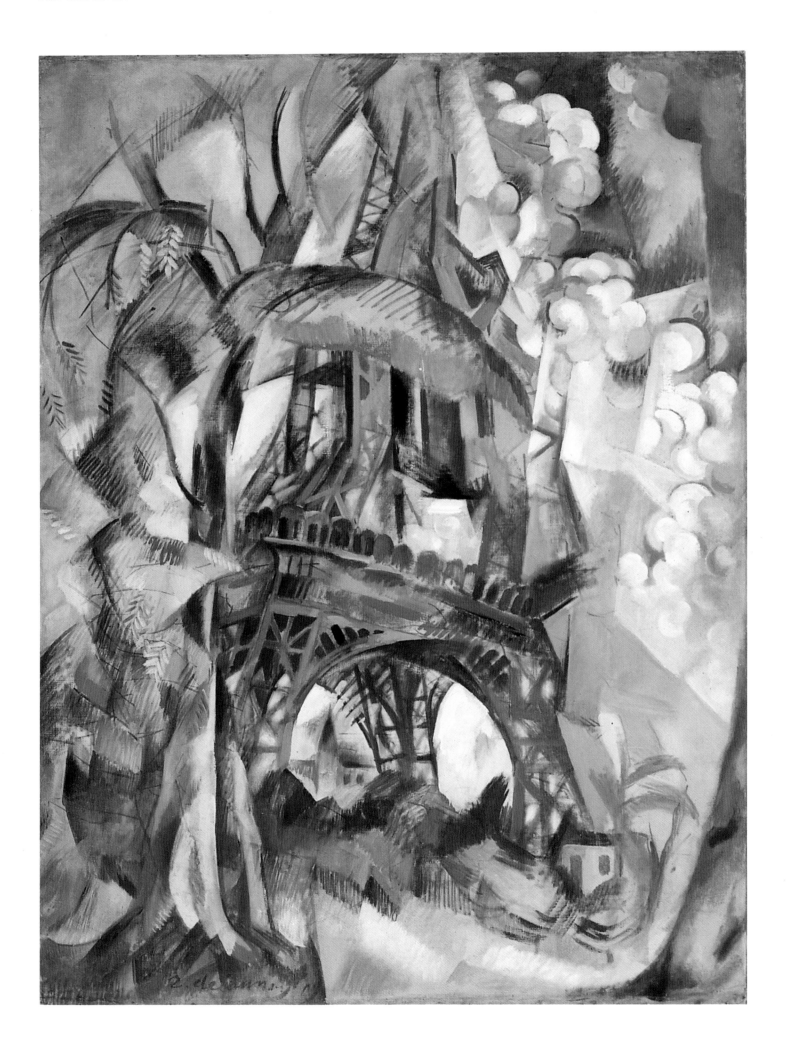

25.
Tour Eiffel (Eiffel Tower), 1910
Oil on canvas
116 x 81 cm (45 $^{11}/_{16}$ x 32 inches)
Staatliche Kunsthalle Karlsruhe

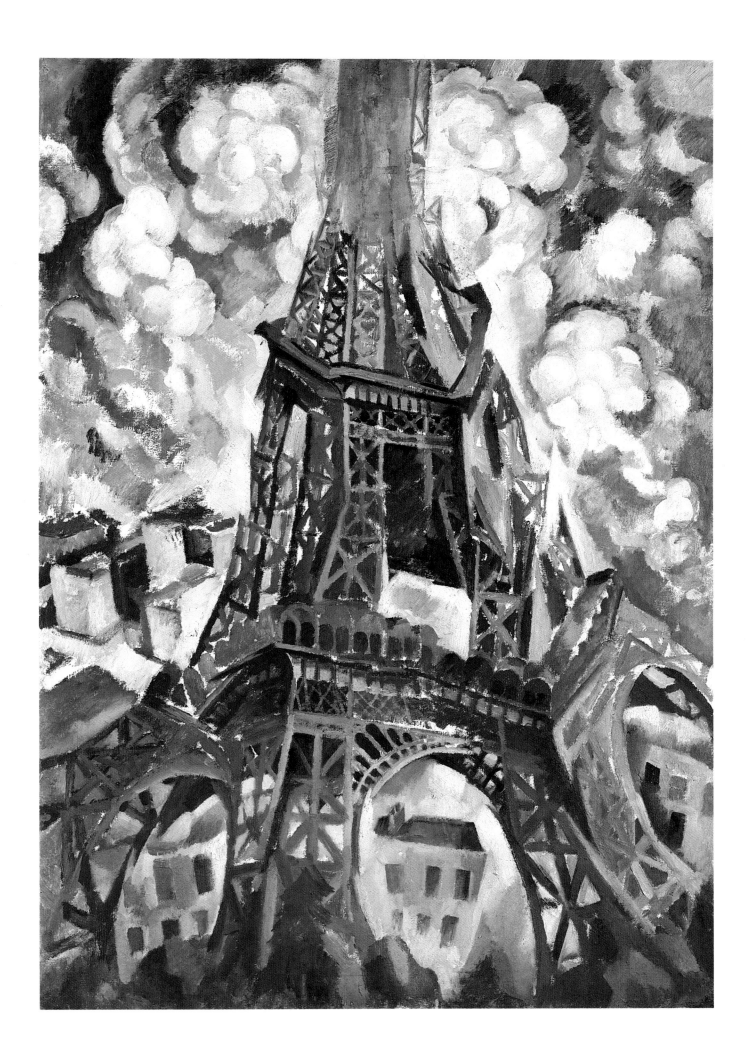

26.
Tour Eiffel (**Eiffel Tower**), 1910–11
Oil on canvas
Dimensions unknown
Destroyed in 1945

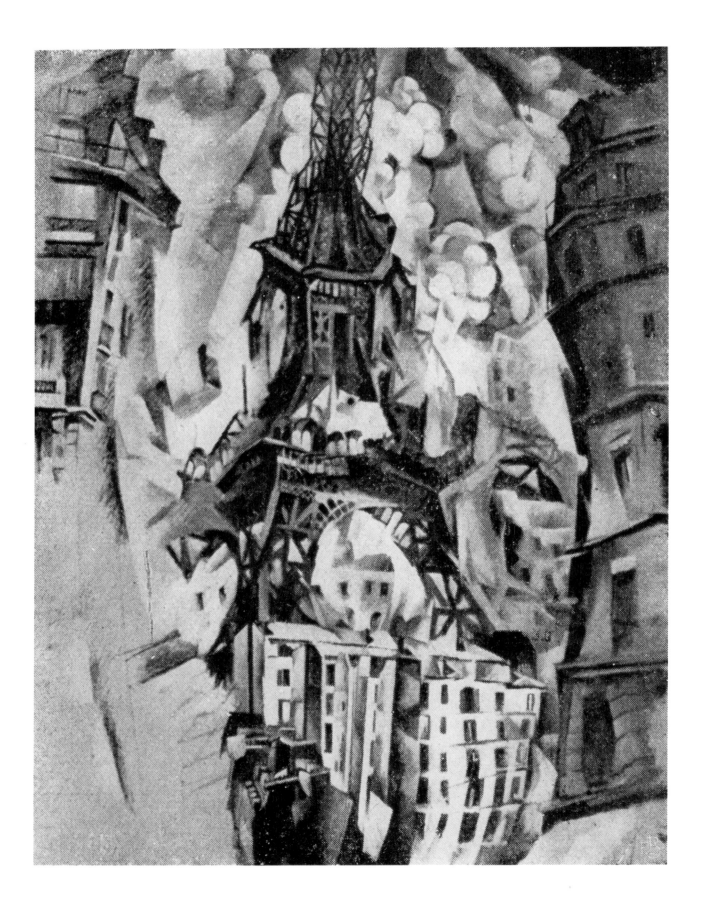

27.
Tour Eiffel (**Eiffel Tower**), 1911
Oil on canvas
202 x 138.4 cm (79½ x 54½ inches)
Solomon R. Guggenheim Museum, New York,
Gift, Solomon R. Guggenheim 37.463

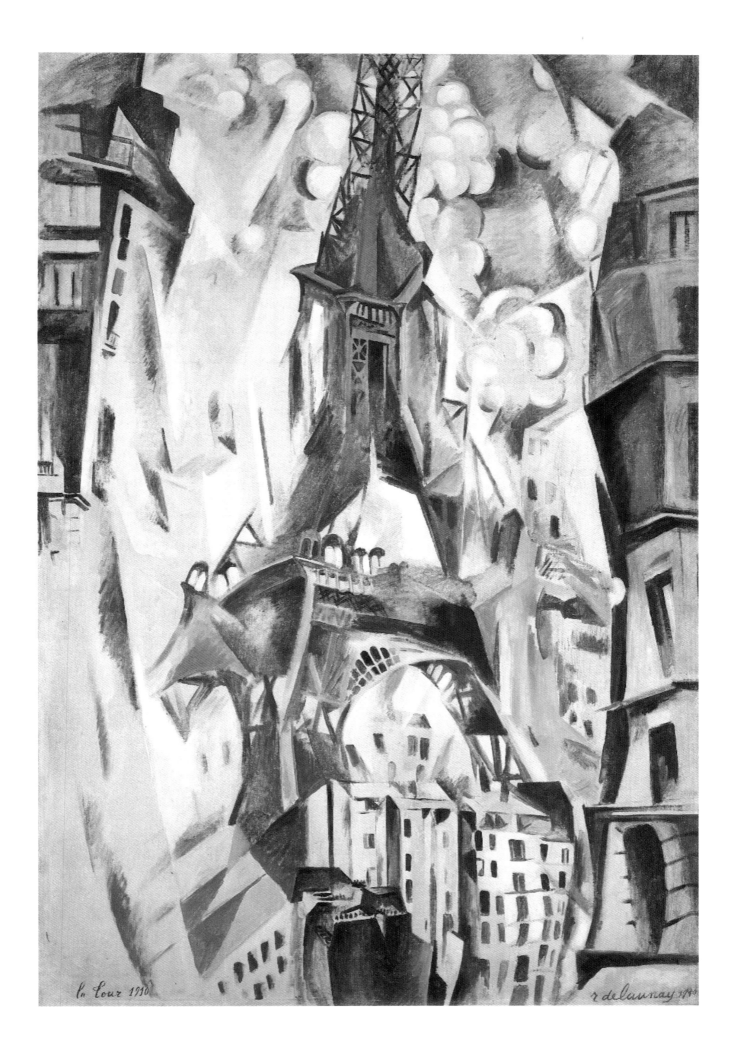

28.
Tour Eiffel (**Eiffel Tower**), 1911
Pen, ink, and traces of pencil on cardboard
54 x 49 cm (21 ¼ x 19 ¼ inches)
The Museum of Modern Art, New York,
Abby Aldrich Rockefeller Fund

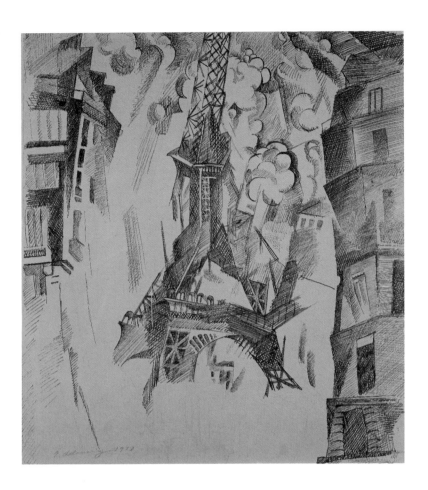

29.
La Tour Eiffel (**The Eiffel Tower**), 1910–11
Oil on canvas
195.5 x 129 cm (77 x 50 13/16 inches)
Kunstmuseum Basel, Emanuel Hoffmann Foundation

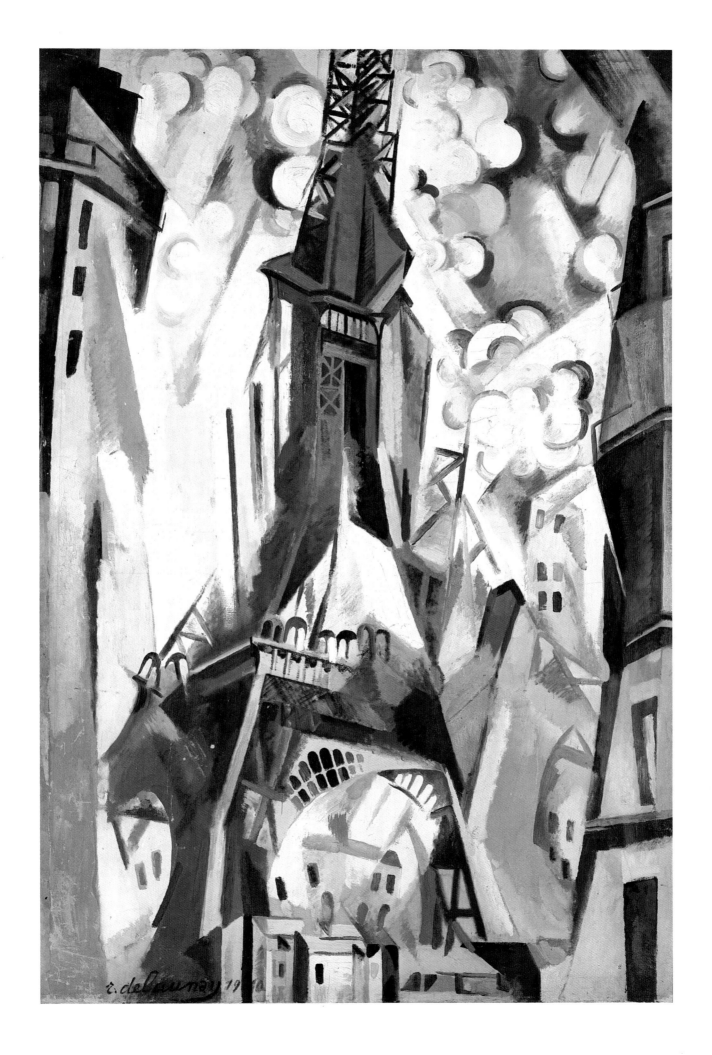

30.
La Tour Eiffel (Champs de Mars: The Red Tower),
1911/1923
Oil on canvas
162.6 x 130.8 cm (64 $\frac{1}{16}$ x 51 $\frac{1}{2}$ inches)
The Art Institute of Chicago,
Joseph Winterbotham Collection, 1959.1

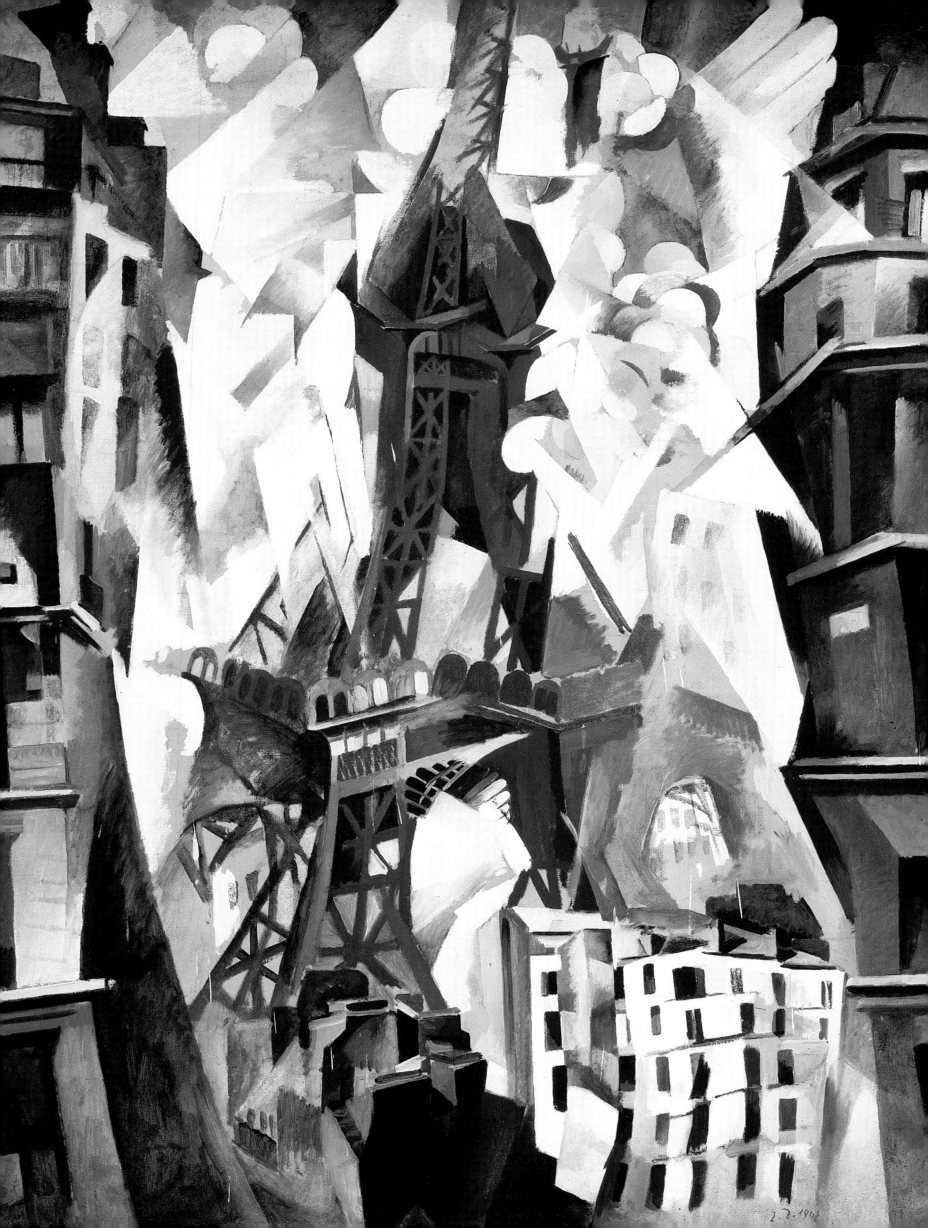

31.
La Tour simultanée (The Simultaneous Tower),
1910 [ca. 1911]
Ink, watercolor, gouache, and traces of pencil on paper
63.5 x 47.5 cm (25 x 18 $^{11}/_{16}$ inches)
Private collection, Courtesy of Marc Blondeau, Paris

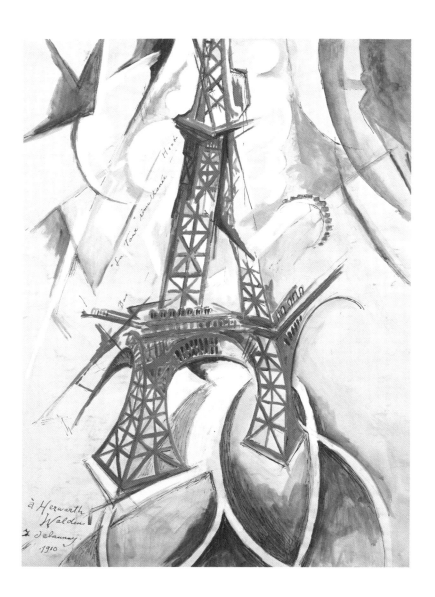

32.
Tour Eiffel (**Eiffel Tower**), 1910 [1911–12]
Oil on canvas
130.2 x 97 cm (51¼ x 38 ³⁄₁₆ inches)
Museum Folkwang, Essen

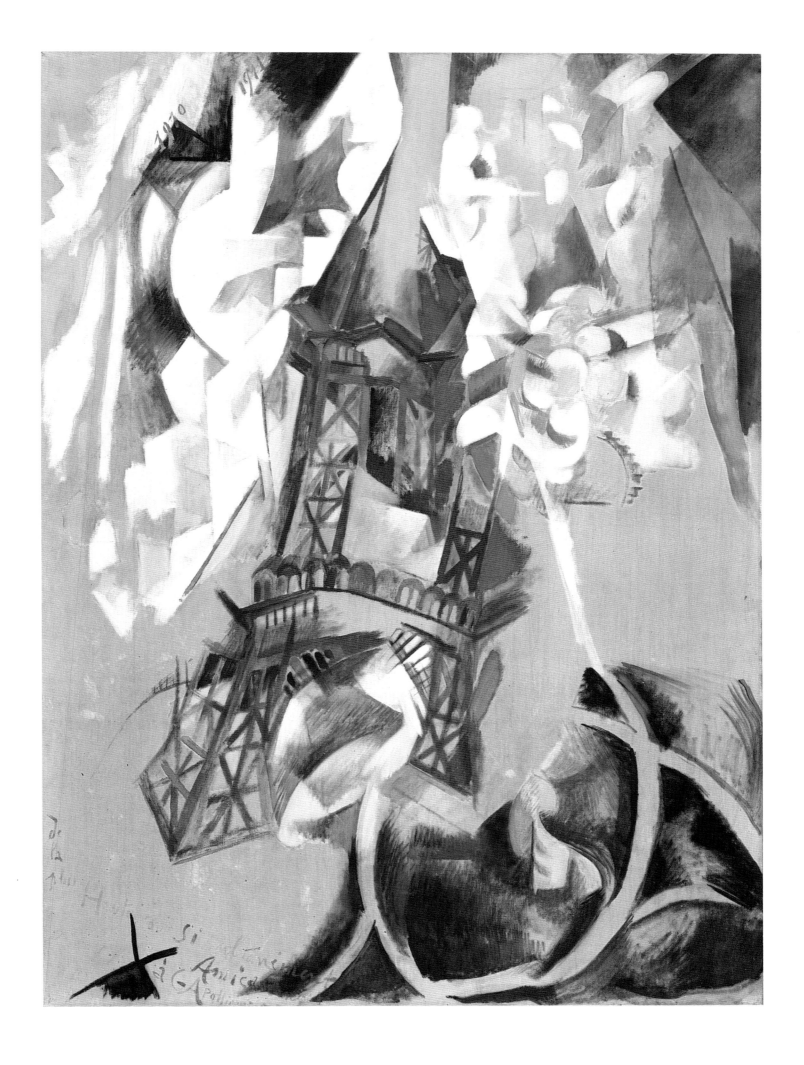

33.
La Tour rouge (**Red Eiffel Tower**), 1911–12
Oil on canvas
125 x 90.3 cm (49 $^{3}/_{16}$ x 35 $^{3}/_{8}$ inches)
Solomon R. Guggenheim Museum,
New York 46.1036

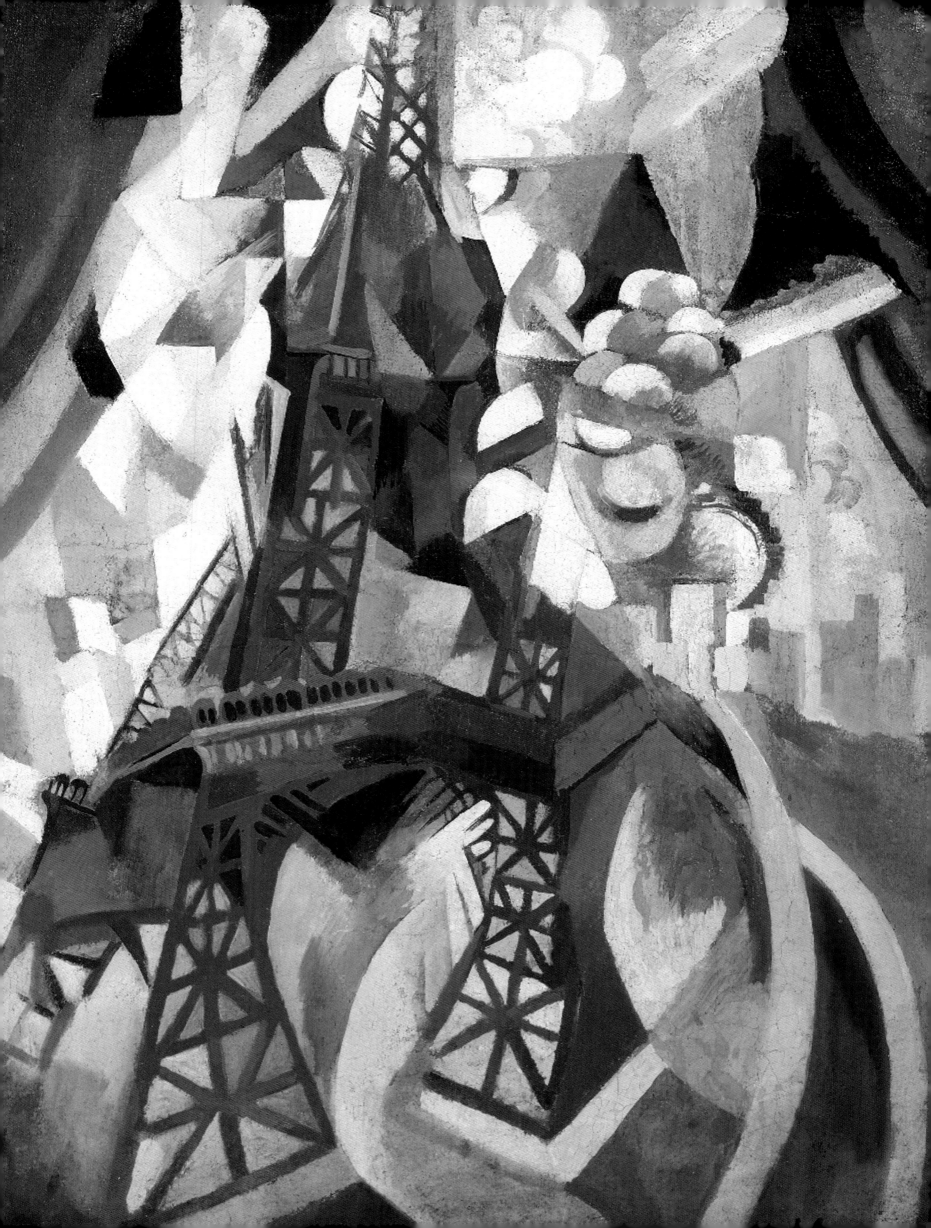

34.
Study for **Tour Eiffel** (**Eiffel Tower**),
1910 [1913]
Ink on paper
29 x 20 cm (11 $^{7}/_{16}$ x 7 $^{7}/_{8}$ inches)
Location unknown

35.
Study for **La Tour Eiffel**
(**The Eiffel Tower**), 1910 [1913]
Ink on paper
63 x 47 cm (24 $^{13}/_{16}$ x 18 $^{1}/_{2}$ inches)
Musée National d'Art Moderne,
Centre Georges Pompidou, Paris,
Donation of Sonia and Charles Delaunay, 1963

36.
Study for **La Tour et la roue**
(**The Tower and the Wheel**), ca. 1912–13 [1913]
Brush and pen with ink on paper
64.7 x 49.7 cm (25 ½ x 19 ⁹/₁₆ inches)
The Museum of Modern Art, New York,
Abby Aldrich Rockefeller Fund

37.
Study for **Tour Eiffel** (**Eiffel Tower**), 1910 [1913]
Ink on paper
49.5 x 32 cm (19 ½ x 12 ⅜ inches)
Location unknown

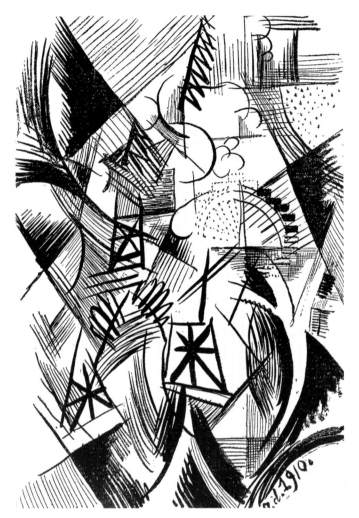

38.
Study for **La Tour aux rideaux**
(**The Tower with Curtains**), 1910 [ca. 1920–22]
Pencil and ink on paper
21.1 x 14 cm (8 5/16 x 5 1/2 inches)
Location unknown

39.
Study for **La Tour aux rideaux**
(**The Tower with Curtains**), 1910 [ca. 1920–22]
Pen and ink on paper
25.8 x 21 cm (10 3/16 x 8 1/4 inches)
Location unknown

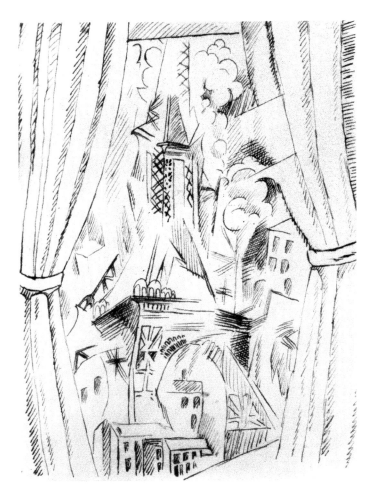

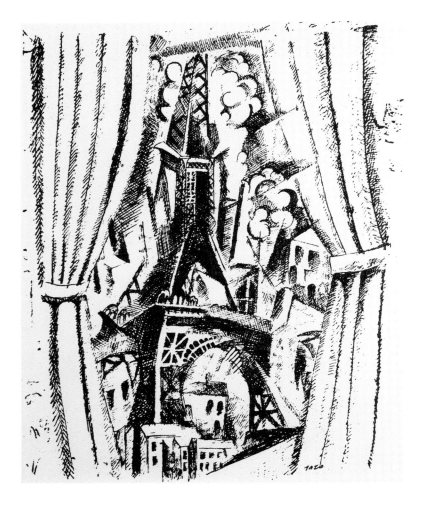

40.
La Tour aux rideaux (**The Tower with Curtains**),
1910 [ca. 1920–22]
Oil on canvas
116 x 97 cm (45 11/$_{16}$ x 38 3/$_{16}$ inches)
Kunstsammlung Nordrhein-Westfalen, Düsseldorf

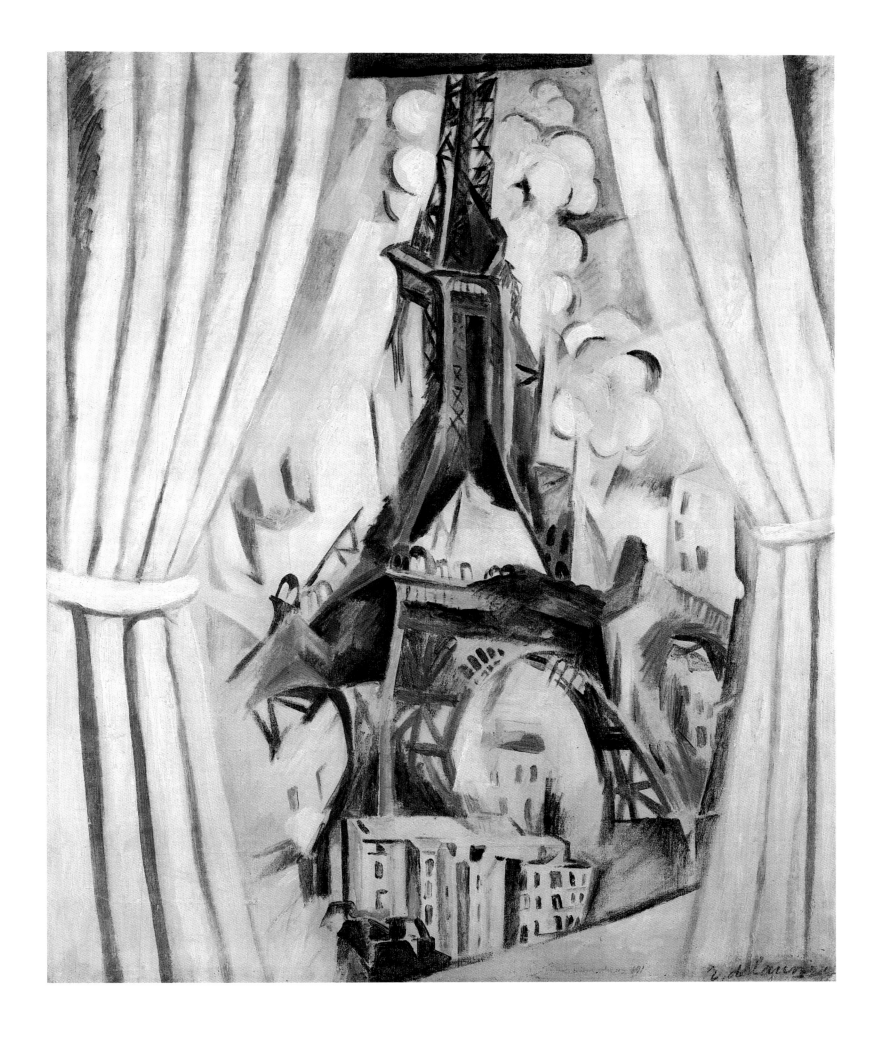

41.
Study for **Portrait de Philippe Soupault
(Portrait of Philippe Soupault**), 1922
Gouache, charcoal, and chalk on
paper mounted on canvas
195 x 130 cm (76 ¾ x 51 ³⁄₁₆ inches)
Hirshhorn Museum and Sculpture Garden,
Smithsonian Institution, Washington, D.C.,
Gift of Joseph H. Hirshhorn Foundation, 1972

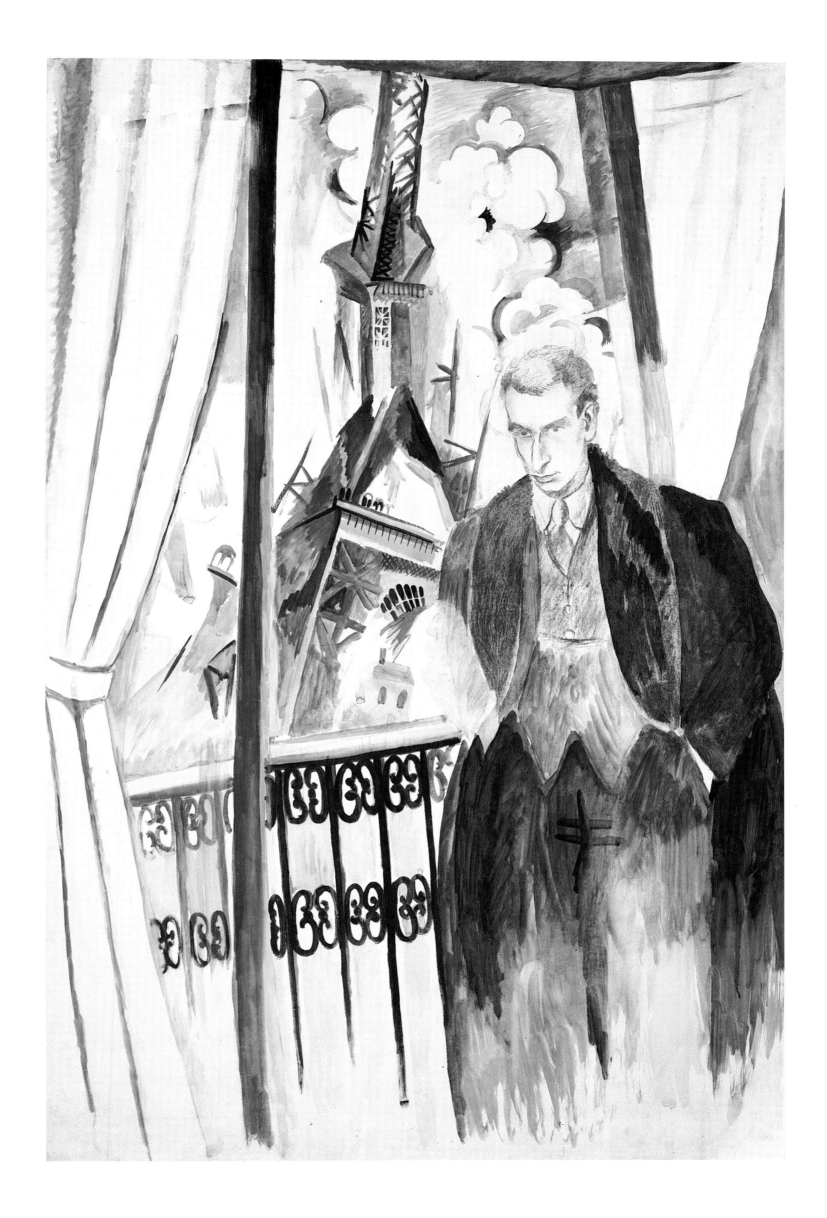

42.

**La Ville de Paris, la femme et la tour
(The City of Paris, the Woman and
the Tower**), 1925
Oil on canvas
450 x 94 cm (177 ³⁄₁₆ x 37 inches)
Deutsche Bank AG, Frankfurt am Main

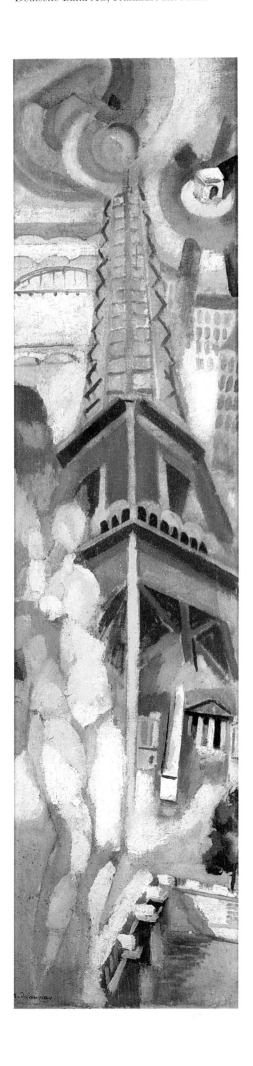

43.
La Tour rouge (The Red Tower), 1928
Oil on canvas
170 x 77.5 cm (66 ¹³/₁₆ x 30 ½ inches)
Private collection, Courtesy of Galerie
Gmurzynska, Cologne

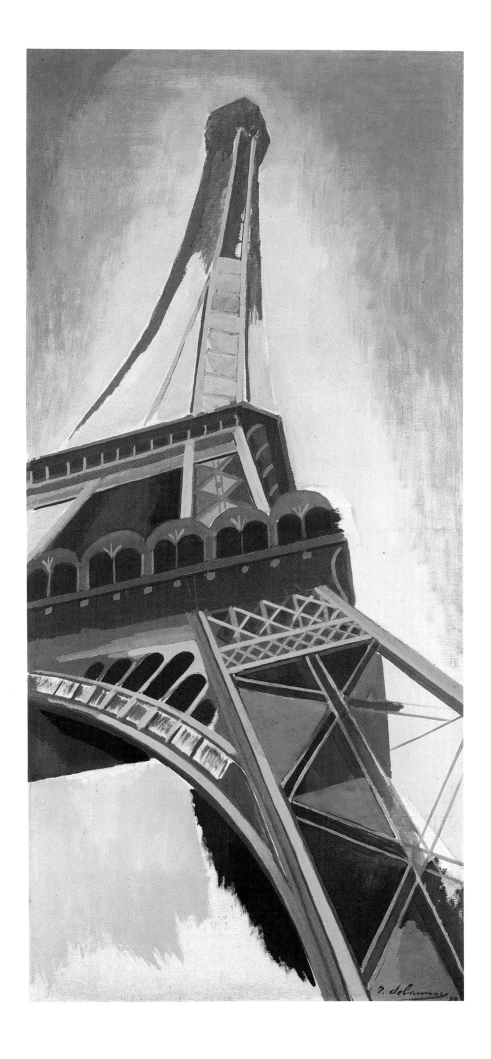

The Windows

44.
Fenêtre aux rideaux oranges
(**Window with Orange Curtains**), 1912
Oil on cardboard
59 x 59 cm (23¼ x 23¼ inches)
Location unknown

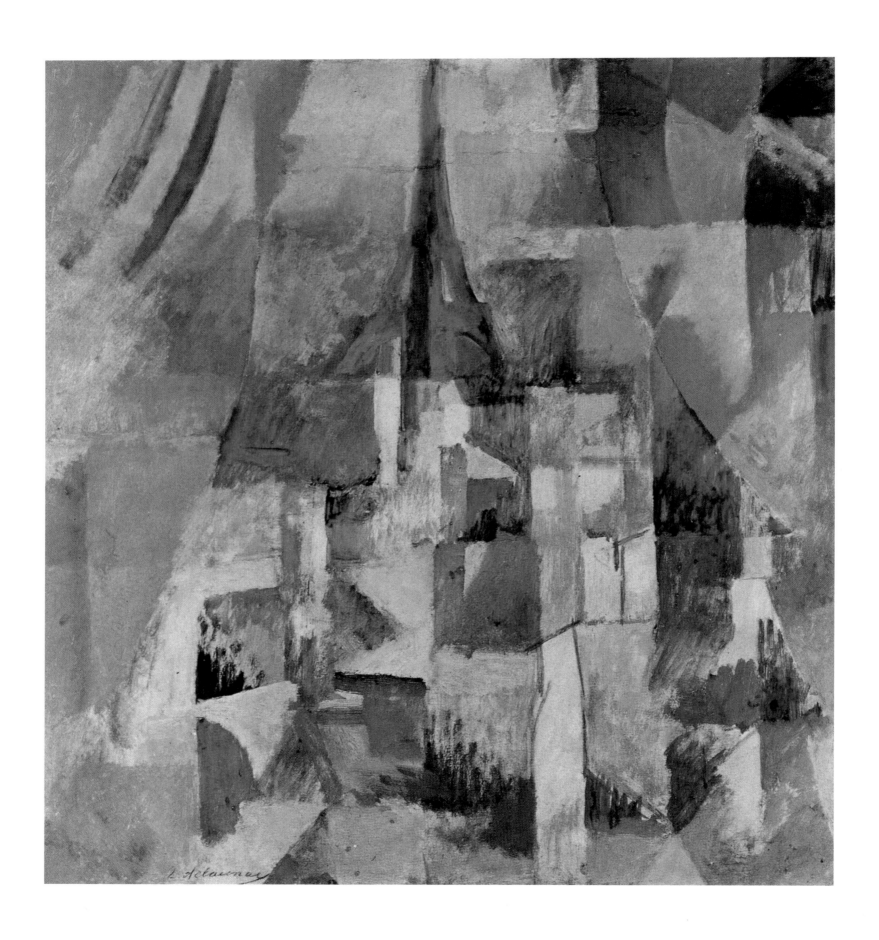

45.
Les Fenêtres sur la ville (1^{ère} partie, 2^e motif)
(The Windows on the City [1st Part, 2nd Motif]),
1912
Oil on cardboard
39 x 29.6 cm (15 ⅜ x 11 ⅝ inches)
Location unknown

46.
Les Fenêtres simultanées
[1ère partie, 2e motif, 1ère réplique]
(**The Simultaneous Windows [1st Part,**
2nd Motif, 1st Replica]), 1912
Oil on canvas
46 x 40 cm (18 1/8 x 15 3/4 inches)
Hamburger Kunsthalle

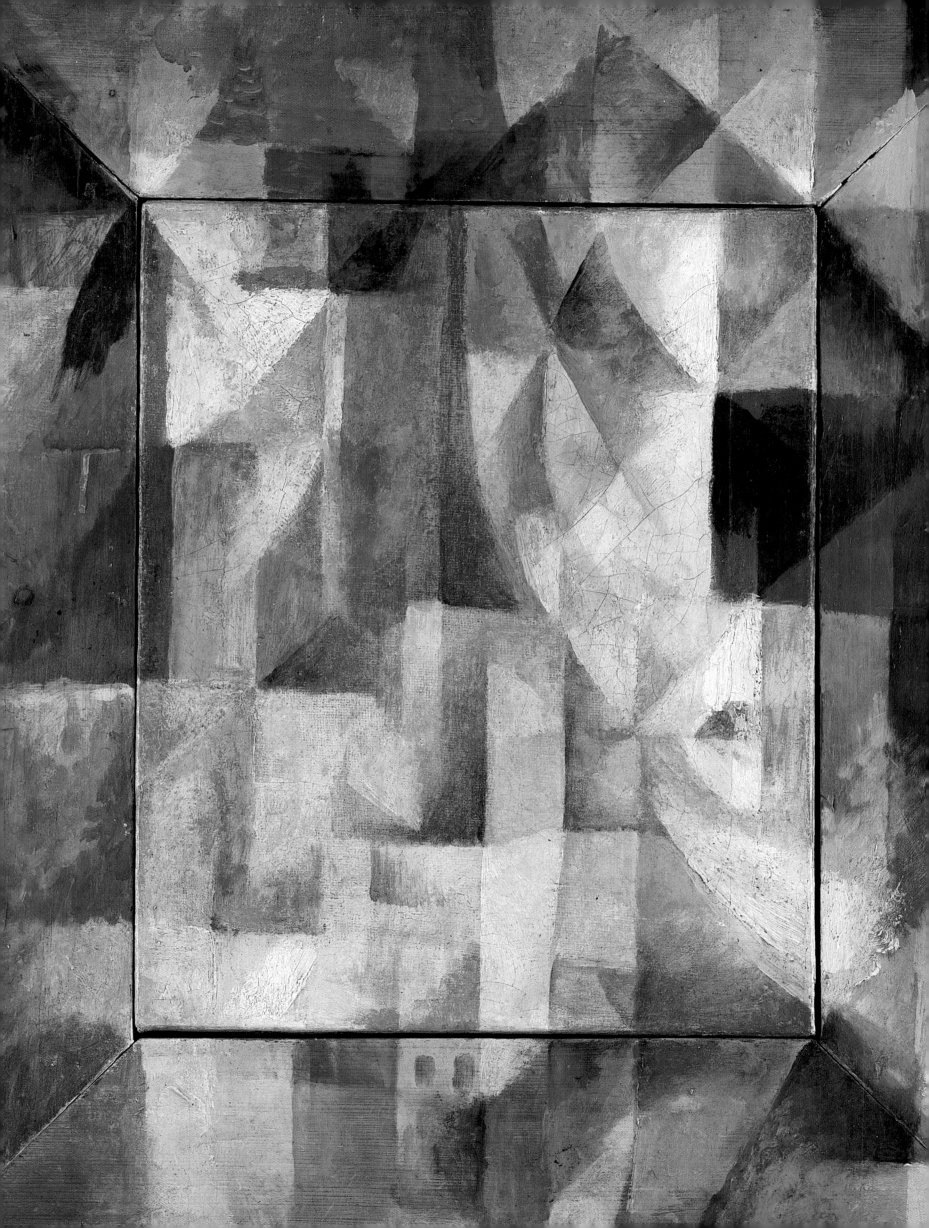

47.
**Les Fenêtres sur la ville n° 3 (2ᵉ motif,
1ᵉʳᵉ partie) (The Windows on the City No. 3
[2nd Motif, 1st Part]),** 1912
Oil on canvas
79 x 64.5 cm (31 ⅛ x 25 ⅜ inches)
Kunstmuseum Winterthur,
Bequest Clara and Emil Friedrich-Jezler

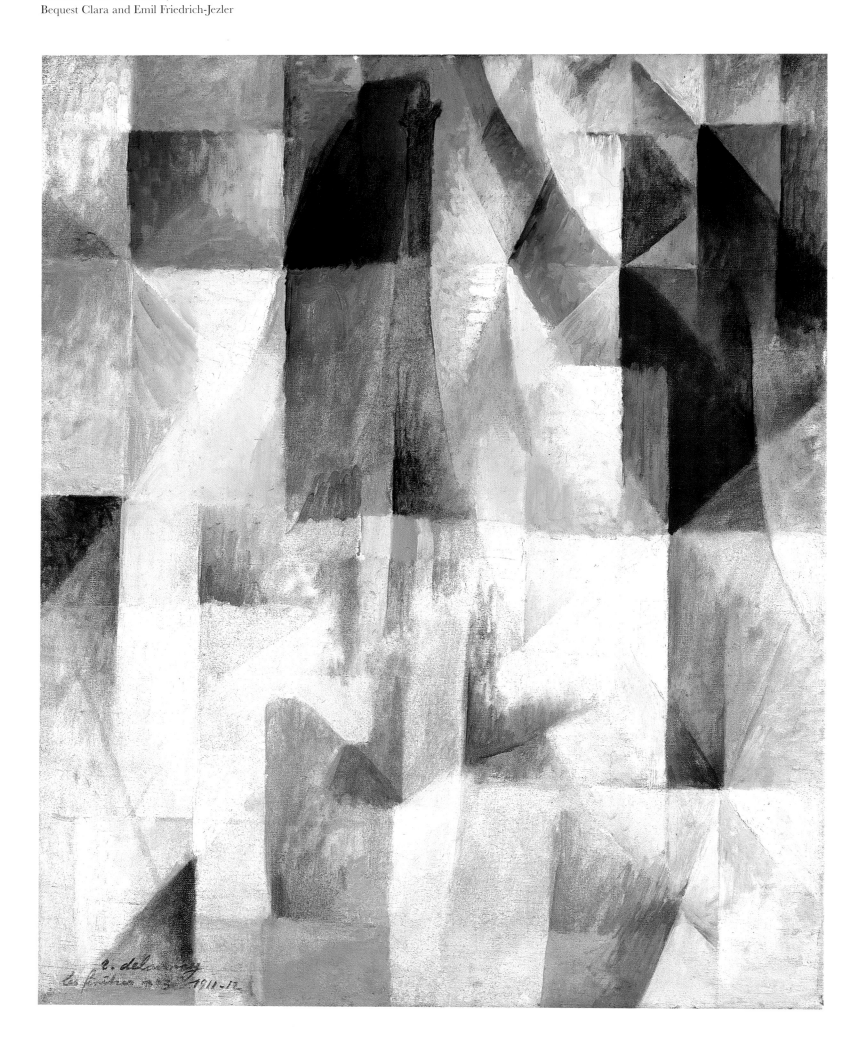

48.
Les Fenêtres (**The Windows**), 1912
Oil on canvas
91 x 85 cm (35¹³⁄₁₆ x 33⁷⁄₁₆ inches)
The Morton G. Neumann Family Collection,
On loan to The National Gallery of Art,
Washington, D.C.

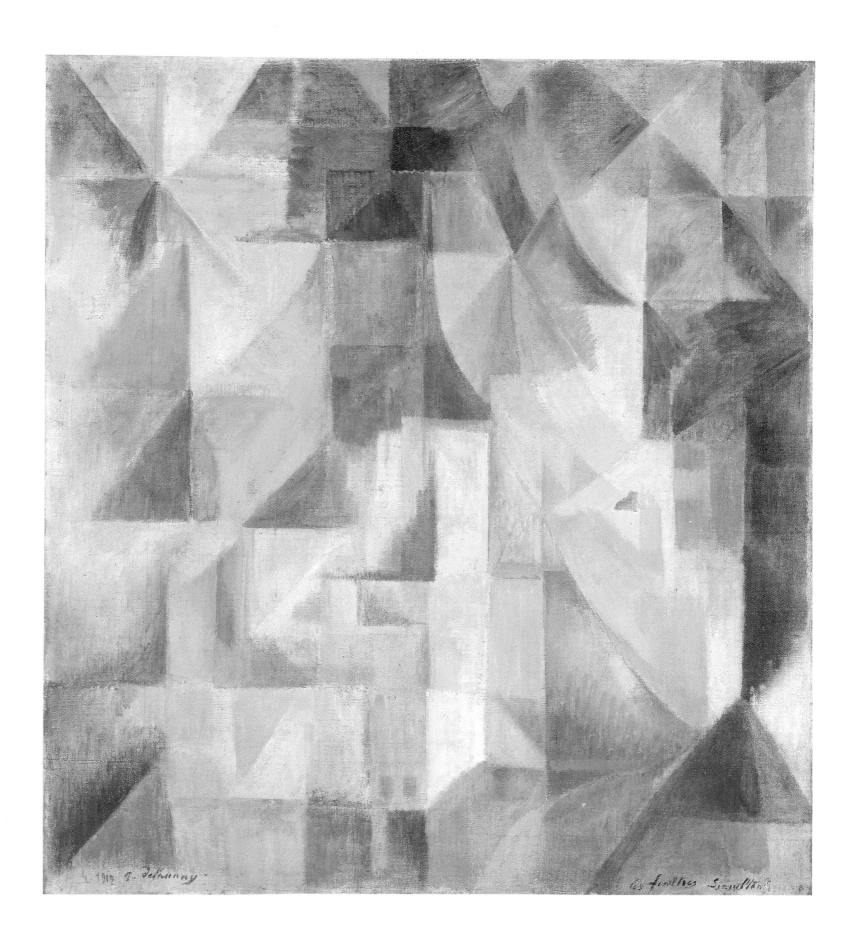

49.
Les Fenêtres simultanées (2ᵉ motif, 1ᵉʳᵉ partie)
(The Simultaneous Windows [2nd Motif, 1st Part]),
1912
Oil on canvas
55.2 x 46.3 cm (21 ⁵⁄₈ x 18 ¼ inches)
Solomon R. Guggenheim Museum, New York,
Gift, Solomon R. Guggenheim 41.464A

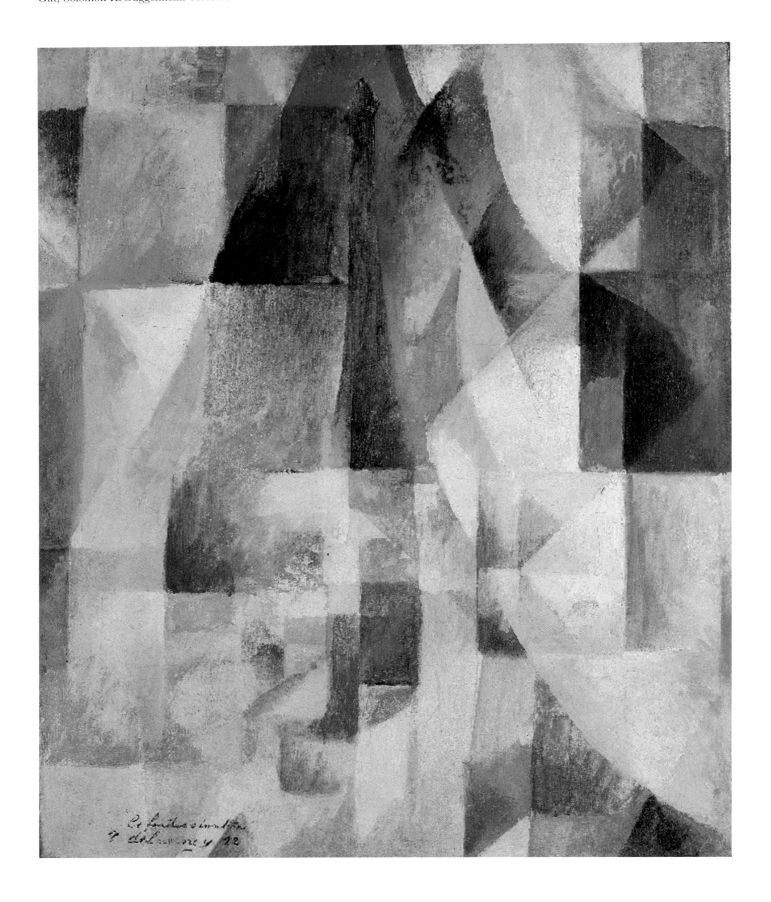

50.
Fenêtre (**Window**), 1912–13 [1912]
Oil on canvas
64.5 x 52.4 cm (25 ⅜ x 20 ⅝ inches)
Kunstsammlung Nordrhein-Westfalen,
Düsseldorf

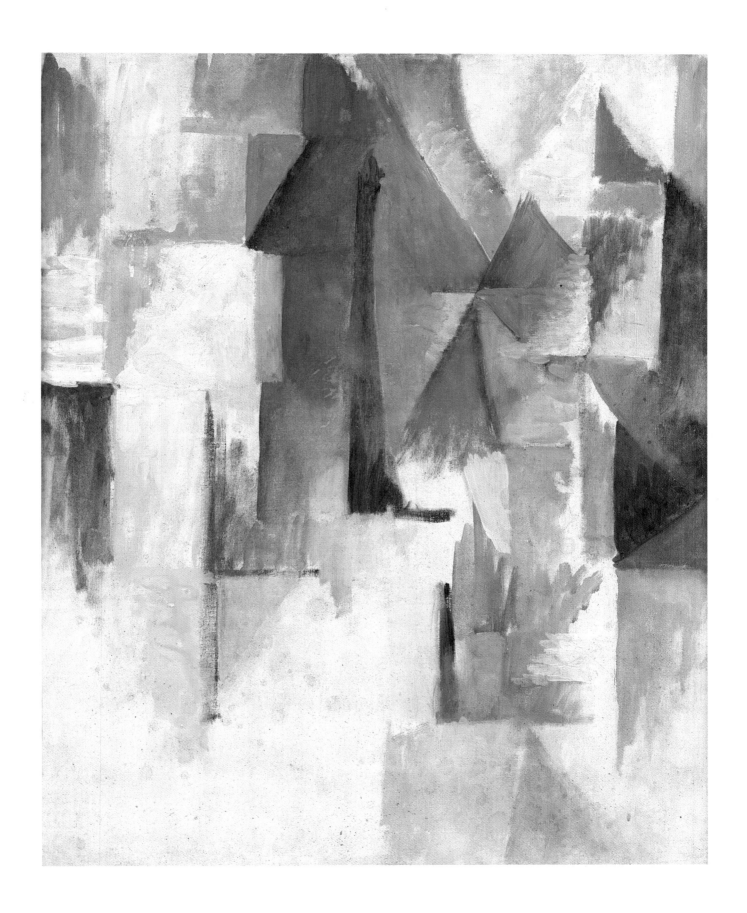

51.
**Fenêtres ouvertes simultanément
(1^{ère} partie, 3^e motif) (Windows Open
Simultaneously [1st Part, 3rd Motif]**), 1912
Oil on canvas
45.7 x 37.5 cm (18 x 14 ¾ inches)
Tate Gallery, London, Purchased 1967

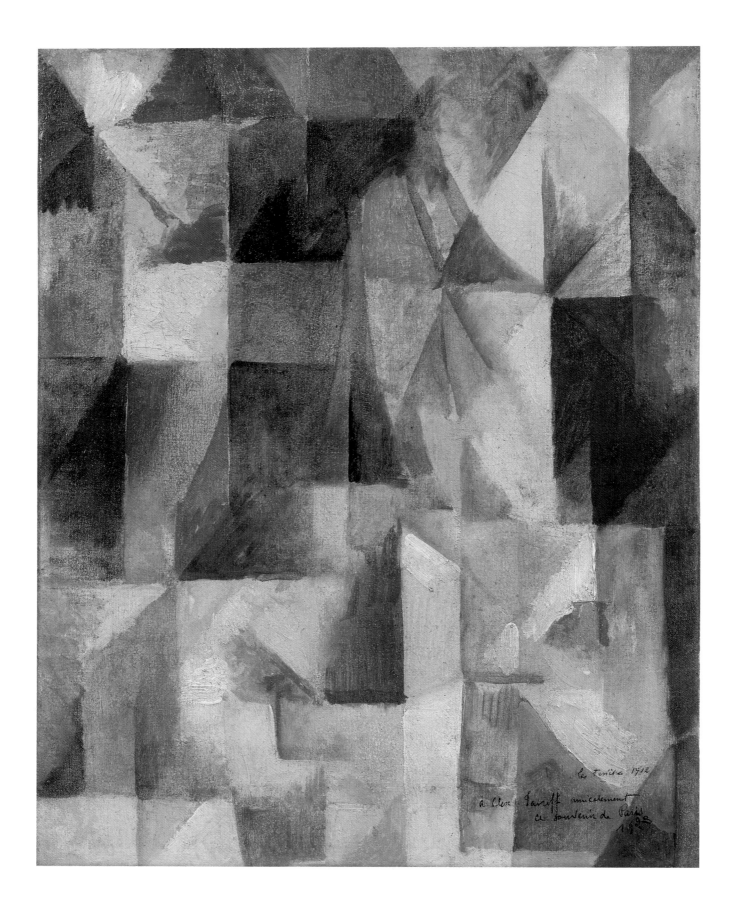

52.
La Fenêtre (The Window), 1912
Oil on canvas mounted on cardboard
45.8 x 37.5 cm (18 1/16 x 14 3/4 inches)
Musée de Grenoble

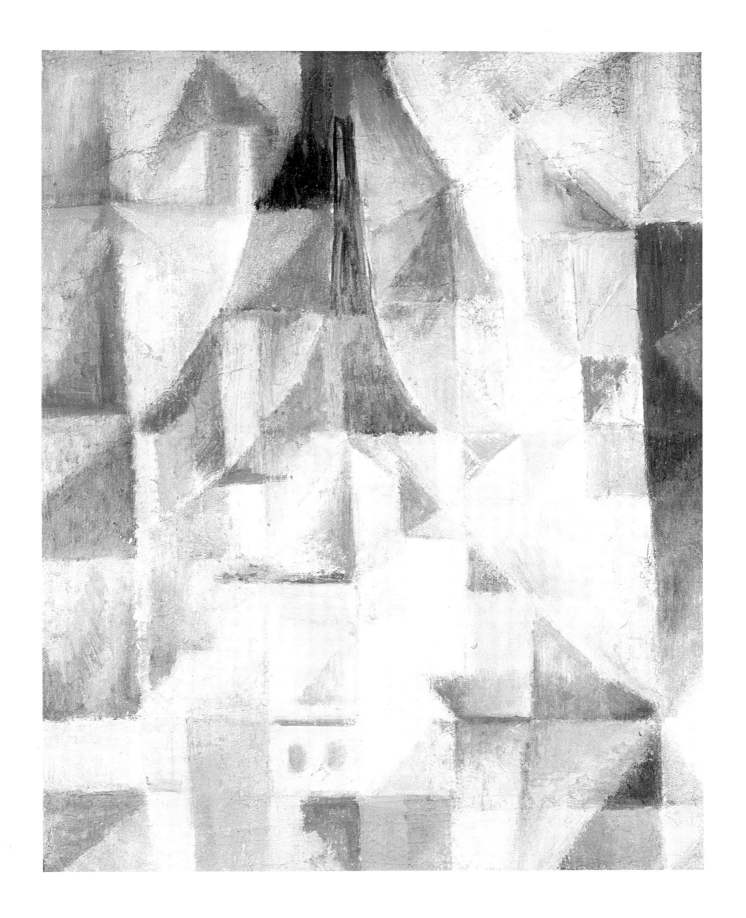

53.
Les Fenêtres (**The Windows**) (detail), 1912
Wax on canvas
79.9 x 70 cm (31 $^{7}/_{16}$ x 27 $^{9}/_{16}$ inches)
The Museum of Modern Art, New York,
The Sidney and Harriet Janis Collection

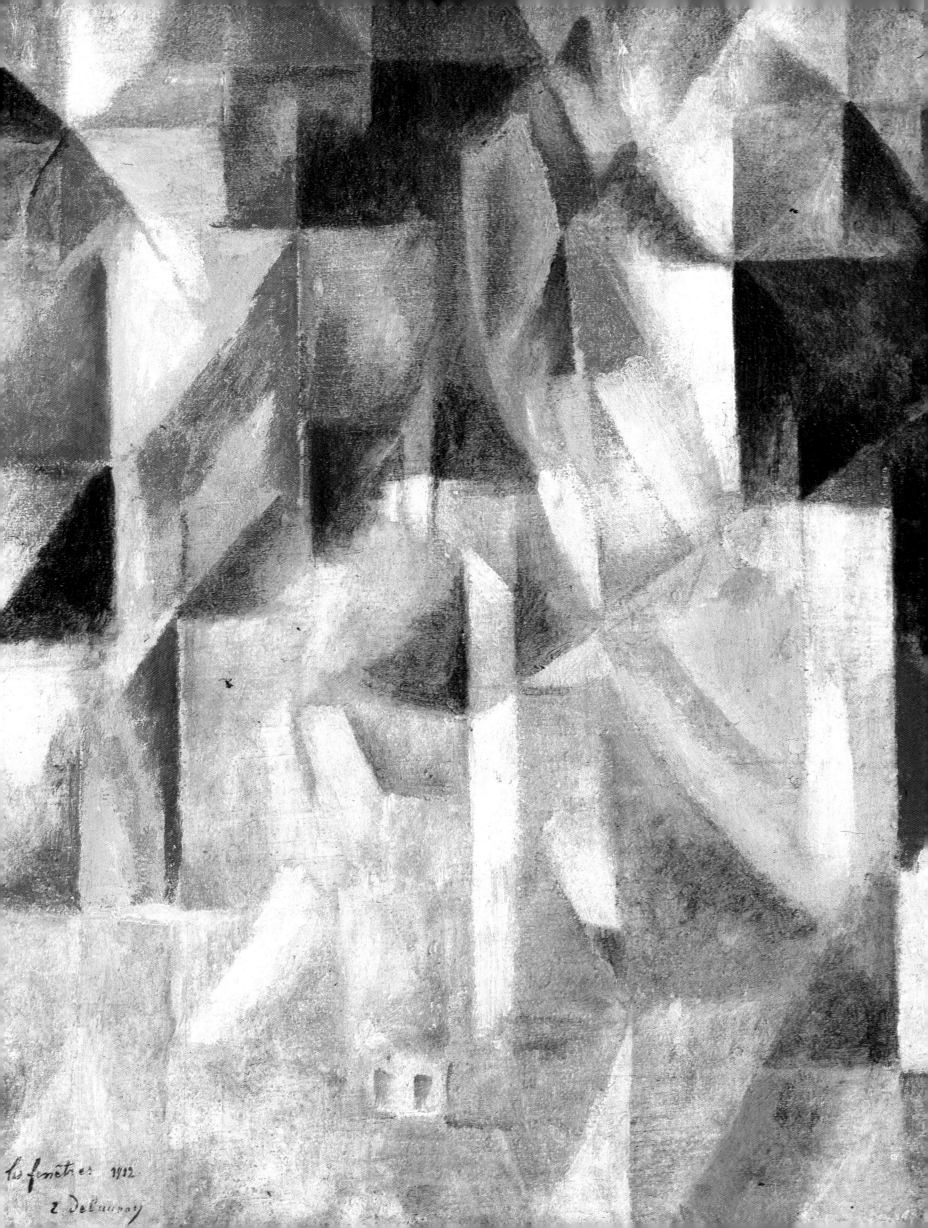

Les fenêtres 1912
R Delaunay

54.
Fenêtres en trois parties
(**Windows in Three Parts**), 1912
Oil on canvas
35.2 x 91.8 cm (13⅞ x 36⅛ inches)
Philadelphia Museum of Art,
A. E. Gallatin Collection

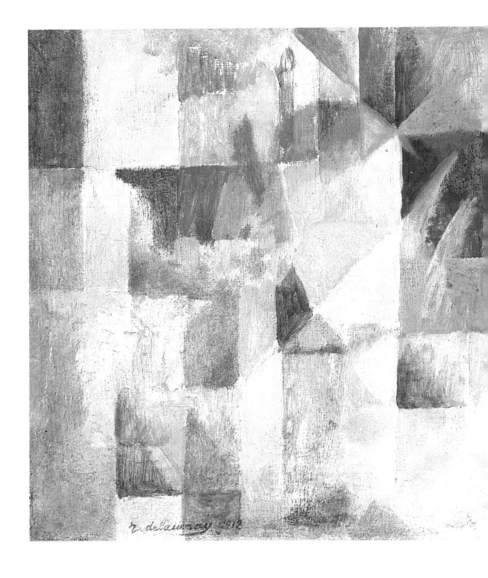

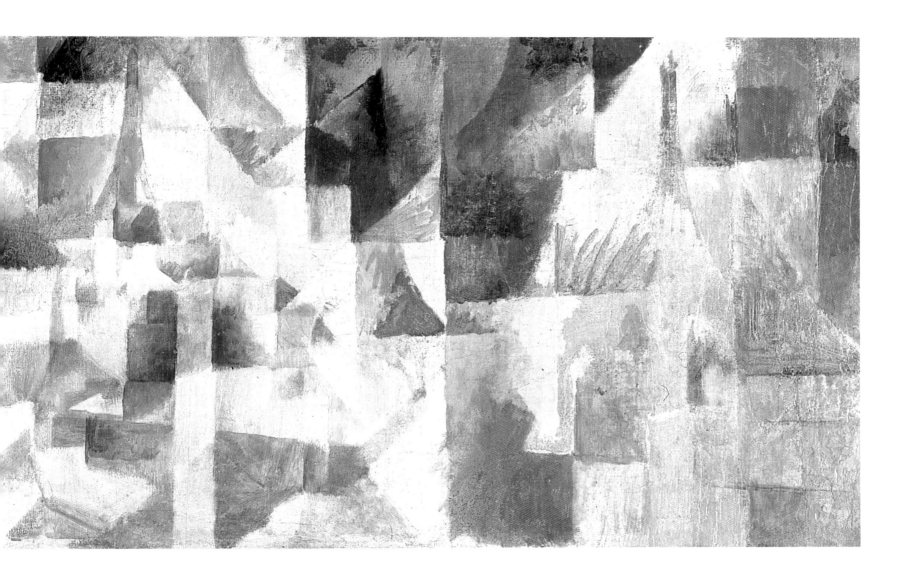

55.
**Fenêtres ouvertes simultanément
(1^{ère} partie, 3^e motif) (Windows Open
Simultaneously [1st Part, 3rd Motif])**, 1912
Oil on oval canvas
57 x 123 cm (22 ³⁄₈ x 48 ³⁄₈ inches)
Peggy Guggenheim Collection, Venice 76.2553

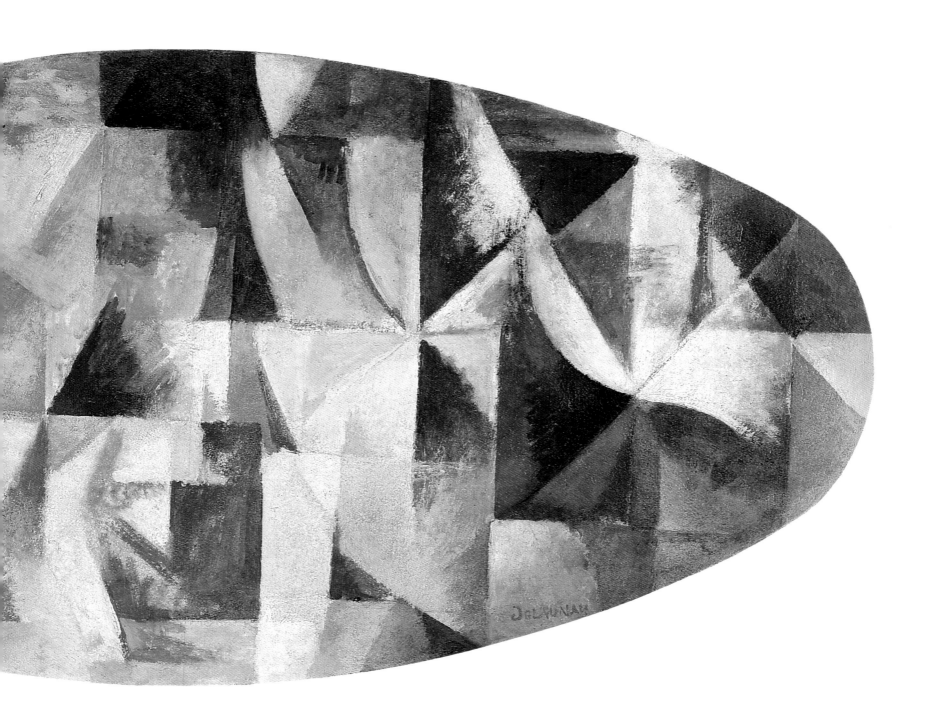

56.
Les Trois Fenêtres, la tour et la roue
(The Three Windows, the Tower and the Wheel),
1912 [1912–13]
Oil on canvas
130.2 x 195.6 cm (51¼ x 77 inches)
The Museum of Modern Art, New York,
Gift of Mr. and Ms. William Burden

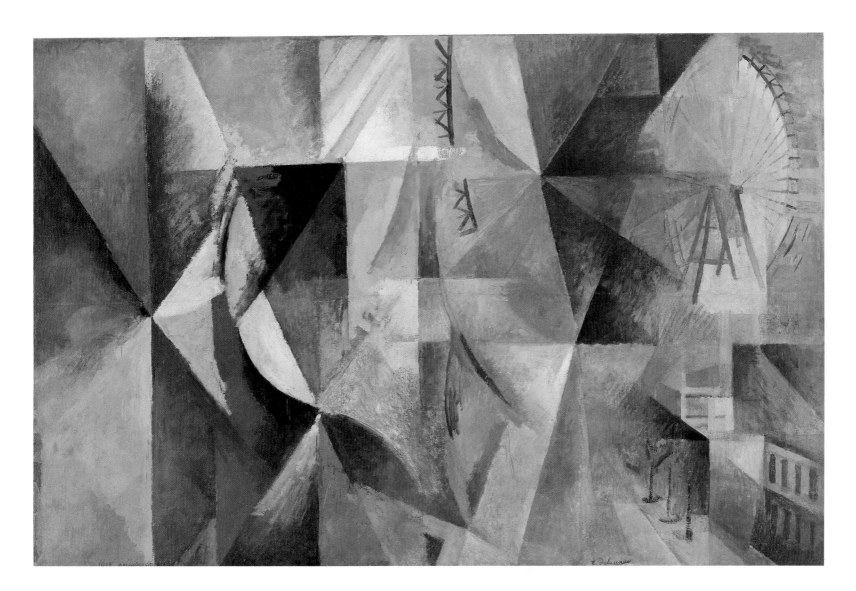

57.
Une Fenêtre. Etude pour les trois fenêtres
(**A Window. Study for the Three Windows**),
1912 [1912–13]
Oil on canvas
111 x 90 cm (43 $\frac{11}{16}$ x 35 $\frac{7}{16}$ inches)
Musée National d'Art Moderne,
Centre Georges Pompidou, Paris

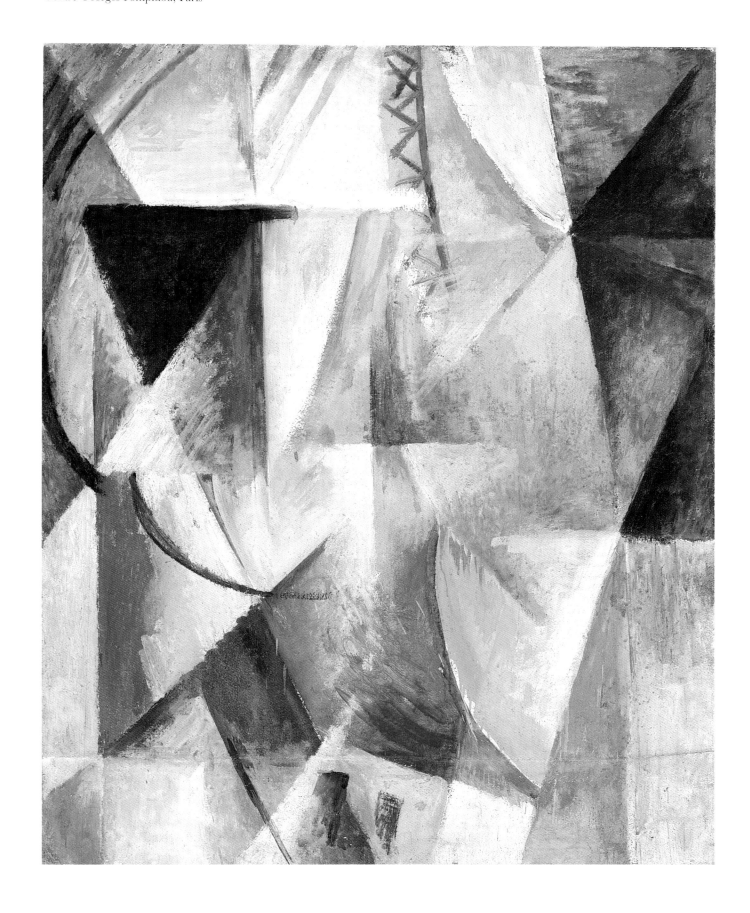

58.
Les Fenêtres sur la ville (1^{ère} partie, 1^{ers} contrastes simultanes) (The Windows on the City [1st Part, 1st Simultaneous Contrasts]), 1912
Oil on canvas
53.4 x 207 cm (21 x 81½ inches)
Museum Folkwang, Essen

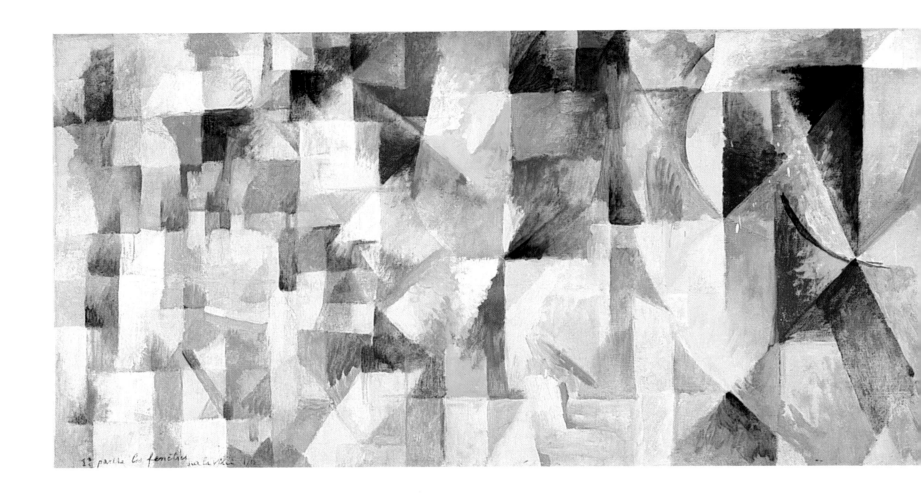

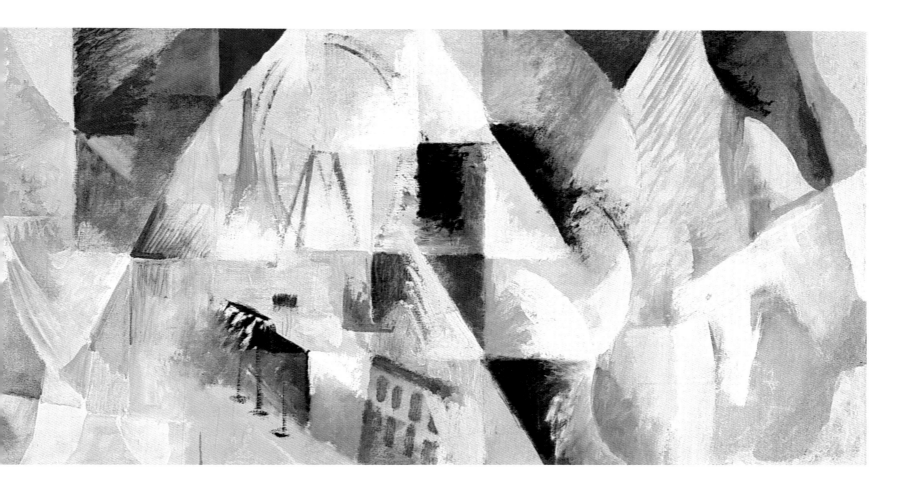

59.
Fenêtre sur la ville (Window on the City), 1914
Wax on cardboard
24.8 x 20 cm (9¾ x 7⅞ inches)
Städtische Galerie im Lenbachhaus, Munich

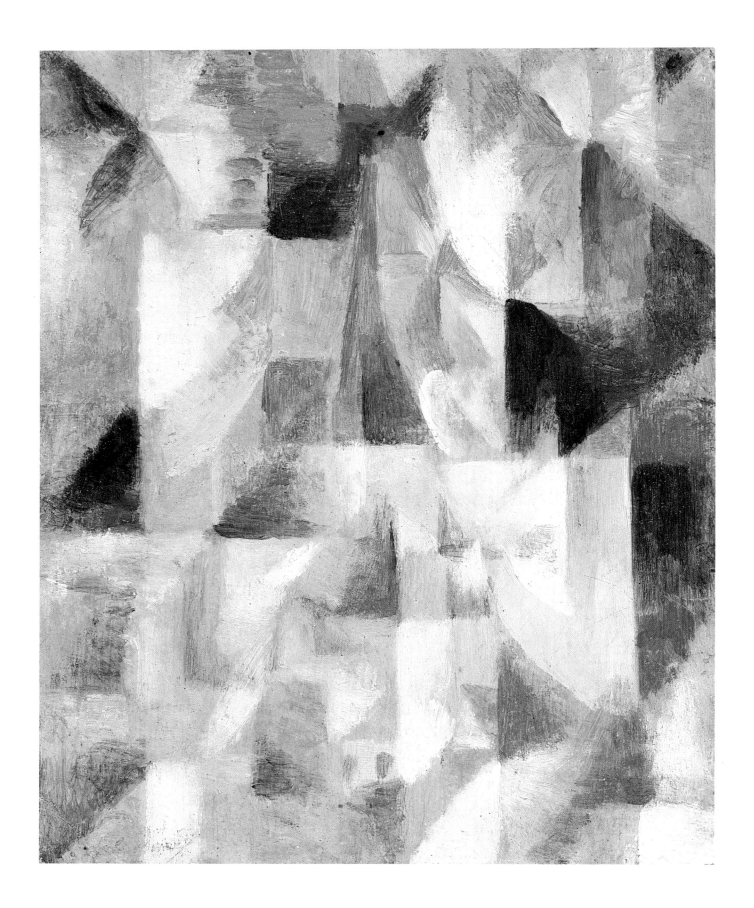

Writings

La Lumière
Robert Delaunay

L'impressionnisme, c'est la naissance de la Lumière en peinture.

La Lumière nous vient par la sensibilité.

Sans la sensibilité visuelle aucune lumière, aucun mouvement.

La lumière dans la Nature crée le mouvement des couleurs.

Le mouvement est donné par les rapports *des mesures impaires*, des contrastes des couleurs entre elles qui constitue *la Réalité*.

Cette réalité est douée de la *Profondeur* (nous voyons jusqu'aux étoiles), et devient alors la *Simultanéité rythmique*.

La simultanéité dans la lumière, c'est *l'harmonie, le rythme des couleurs* qui crée la *Vision des Hommes*.

La vision humaine est douée de la plus grande Réalité puisqu'elle nous vient directement de la contemplation de l'Univers.

L'oeil est notre sens le plus élevé, celui qui communique le plus étroitement avec notre *cerveau, la conscience*. L'idée du mouvement vital du *monde* et *son mouvement est simultanéité*.

Notre compréhension est *corrélative* à notre *perception*.

Cherchons à voir.

La perception auditive ne suffit pas pour notre connaissance de l'Univers elle n'a pas *de profondeur*.

Son mouvement est *successif*, c'est une sorte de mécanisme, sa loi est *le temps* des horloges *mécaniques* qui, comme elle, n'a aucune relation avec notre perception du *mouvement visuel dans l'Univers*.

C'est la parité des choses de la géométrie.

Sa qualité le rapproche de *l'Objet conçu géométriquement*.

L'Objet n'est pas doué *de vie, de mouvement*.

Quand il est *simulacre du mouvement*, il devient *successif, dynamique*.

Sa plus grande limite est d'un *ordre pratique*. *Véhicules*.

Le chemin de fer est *l'image* de ce successif qui se rapproche *des parallèles : la parité du Rail*.

Ainsi de l'Architecture, la Sculpture.

Le plus grand objet de la Terre est assujetti à ces mêmes lois.

Il devient simulacre de la hauteur :

La Tour Eiffel

de la largeur :

Les Villes

longueur :

Rails.

L'Art dans la *Nature est rythmique et a horreur de la contrainte.*

Si l'Art s'apparente *à l'Objet*, il devient *descriptif, divisionniste, littéraire*.

Il se rabaisse vers des *moyens d'expression* imparfaits, il se condamne de lui-même, il est sa propre négation, *il ne se dégage pas de l'Art d'imitation*

Si de même il représente *les relations visuelles* d'un objet ou *des objets entre eux* sans que la *lumière joue le rôle d'ordonnance de la représentation*,

il est conventionnel, il n'arrive pas à la *pureté plastique*, c'est une *infirmité*, il est la négation de la vie, la *sublimité de l'art de la peinture*.

Pour que l'Art atteigne la limite de sublimité, il faut qu'il se rapproche de notre *vision harmonique : la clarté*. La clarté sera couleur, proportion ; ces proportions sont composées de diverses mesures simultanées dans une action. Cette action doit être l'harmonie représentative, *le mouvement synchrome (simultanéité) de la lumière*, qui est *la seule réalité*.

Cette action synchromique sera donc le Sujet qui est l'harmonie représentative

[on the back]

La perception auditive ne suffit pas pour notre connaissance de l'Univers puisqu'elle ne reste pas dans la durée.

Sa successivité commande fatalement la parité ;

c'est une sorte de mécanisme où il ne peut y avoir de profondeur, donc de rythme.

C'est une mathématique où il n'y a pas d'espace.

Sa loi est le temps des horloges mécaniques, qui n'a en aucune façon de relation avec le mouvement de l'Univers.

C'est la parité des choses de cette sorte, c'est la condamnation au néant.

Sa qualité le rapproche de l'Objet.

L'objet n'est pas doué de la vie.

Quand l'objet est . . . , c'est le successif dynamique, mais non rythmique. Il devient simulacre du mouvement.

Sa plus grande limite est d'un ordre pratique. Véhicules. Le chemin de fer est l'image de ce successif qui se rapproche des parallèles ; les rails.

Ainsi de l'Architecture

Ce ne sont que des simulacres.

Le plus grand objet sur la Terre est sujet à ces mêmes lois ;

il deviendra le simulacre record de la hauteur, ou de la largeur, longueur, etc.

L'Art comme la nature est rythmique c'est-à-dire Eternel

S'il part d'un objet, l'Art est descriptif, se rabaisse vers des fonctions imparfaites.

Il se condamne de lui-même — il est sa propre négation. Son mode le plus représentatif est la sculpture à la cire.

Si l'Art est les relations visuelles d'un objet ou des objets entre eux, sans que la lumière joue le rôle *d'ordonnance de la représentation*, il est conventionnel, devient un langage comme un autre, est par conséquent successif. Ainsi la littérature qui n'a rien de la pureté plastique.

C'est une infirmité de l'Art Plastique, c'est la négation de la vie, la sublimité de l'Art.

L'Art vient de la fonction la plus parfaite de l'homme

l'Oeil. Les yeux sont les fenêtres de notre âme.

Il peut devenir l'harmonie vivante de la Nature

et c'est alors un élément fondamental de notre jugement vers la pureté. Voir devient la compréhension [du] bien.

Über das Licht

Robert Delaunay
Translation by Paul Klee

[*in pencil*]

L'idée du mouvement vital du monde qui
 donne le jugement de notre âme.
Notre compréhension est donc adéquate à notre vue. Il faut
 chercher à voir.
Une perception auditive ne suffit pas à notre jugement pour
 connaître l'univers, puisqu'elle ne reste pas dans la durée. Sa
 successivité amène fatalement sa mort. C'est une sorte de
 mécanisme où il ne peut y avoir de profondeur, donc de
 rythme. C'est une mathématique où il n'y a pas d'espace.
C'est la parité et de cette sorte condamnée à la mort
Sa qualité la rapproche de l'Objet, l'Objet est éternellement
 voué à la mort et sa plus grande limite est d'un ordre pratique
Ainsi de l'Architecture. Ce ne sont que des simulacres.
Le plus grand objet de la terre est voué à la même loi.

1912

Published in Robert Delaunay, *Du Cubisme à l'art abstrait, Documents inédits publiés par Pierre Francastel et suivis d'un catalogue de l'oeuvre de R. Delaunay par Guy Habasque*, Paris 1957, pp. 146–49.

Im Verlauf des Impressionismus wurde in der Malerei das Licht entdeckt, das aus der Tiefe der Empfindung erfaßte Licht als Farben-Organismus aus komplementären Werten, aus zum Paar sich ergänzenden Maßen, aus Kontrasten auf mehreren Seiten zugleich. Man gelangte so über das zufällig Naheliegende hinaus zu einer universalen Wirklichkeit von größter Tiefenwirkung (nous voyons jusqu'aux étoiles). Das Auge vermittelt nun als unser bevorzugter Sinn zwischen dem Gehirn und der durch das Gleichzeitigkeitsverhältnis von Teil und und Vereinigung charakterisierten Vitalität der Welt. Dabei müssen sich Auffassungskraft und und Wahrnehmung vereinigen. Man muß sehen wollen.

Mit dem Gehörsinn allein wären wir zu keinem so vollkommenen und universalen Wissen vorgedrungen, und ohne die Wahrnehmungsmöglichkeiten des Gesichtssinns wären wir bei einer Successiv-Bewegung stehengeblieben, sozusagen beim Takt der Uhr. Bei der Parität des Gegenstandes wären wir verblieben, beim projezierten Gegenstand ohne Tiefe.

In diesem Gegenstand lebt eine sehr beengte Bewegung, eine simple Folge von Stärkegraden. Im besten Fall kann man, bildlich gesprochen, zu einer Reihe aneinandergehängten Wagen gelangen.

Architektur und Plastik müssen sich damit begnügen. Auch die gewaltigsten Gegenstände der Erde kommen über diesen Mangel nicht hinweg, und wäre es auch der Eiffelturm oder der Schienenstrang als Sinnbilder größter Flächenausdehnung.

Solange die Kunst vom Gegenstand nicht loskommt, bleibt sie Beschreibung, Literatur, erniedrigt sie sich in der Verwendung mangelhafter Ausdrucksmittel, verdammt sie sich zur Sklaverei der Imitation. Und dies gilt auch dann, wenn sie die Lichtverhältnisse bei mehreren Gegenständen betont, ohne daß das Licht sich dabei zur darstellerischen Selbständigkeit erhebt.

Die Natur ist von einer in ihrer Vielfältigkeit nicht zu beengenden Rhythmik durchdrungen. Die Kunst ahne ihr hierin nach, um sich zu gleicher Erhabenheit zu klären, sich zu Gesichten vielfachen Zusammenklanges zu erheben, eines Zusammenklangs von Farben, die sich teilen, und in gleicher Aktion wieder zum Ganzen zusammenschliessen. Diese synchromische Aktion ist als eigentlicher und einziger Vorwurf (sujet) der Malerei zu betrachten.

Originally published in *Der Sturm* 3, nos. 144–45 (January 1913).

Light

Robert Delaunay

Impressionism is the birth of Light in painting.

Light reaches us through our perception.

Without visual perception, there is no light, no movement.

Light in Nature creates color-movement.

Movement is provided by relationships of *uneven measures*, of color contrasts among themselves that make up *Reality*.

This reality is endowed with *Depth* (we see as far as the stars) and thus becomes *rhythmic simultaneity*.

Simultaneity in light is the *harmony*, the *color rhythms* which give birth to *Man's sight*.

Human sight is endowed with the greatest Reality since it comes to us

directly from the contemplation of the Universe.

The Eye is our highest sense, the one which communicates most closely

with our *brain and consciousness*, the idea of the living movement of the world, and its movement *is simultaneity*.

Our understanding is correlative with our *perception*.

Let us seek to see.

Auditory perception is insufficient for our knowledge of the Universe.

It lacks depth.

Its movement is *successive*. It is a species of mechanism; its *principle* is the *time of mechanical* clocks which, like them, has no relation to our perception of the visual movement in the Universe.

This is the evenness of things in geometry.

Its character makes it resemble *the Object conceived geometrically*.

The *Object* is not endowed with *Life or movement*.

When it has the *appearance of movement*, it becomes *successive, dynamic*.

Its greatest limitation is of a *practical order*. Vehicles.

The railroad is the image of this successiveness which resembles parallels: *the track's evenness*.

So with Architecture, so with Sculpture.

The most powerful object on Earth is bound by these same laws.

It will become the illusion of height:

The Eiffel Tower

of breadth:

Cities

length:

Tracks.

Art in nature is *rhythmic and abhors constraint*.

If Art is attached *to the Object*, it becomes *descriptive, divisive, literary*.

It stoops to imperfect modes of expression, *it does not liberate itself from mimesis*.

If in the same way it represents *the visual relationships*

of an object or *between objects* without *light playing the role of governing the representation*.

It is conventional. It does not achieve *plastic purity*. It is a

weakness. It is life's negation and the negation of *the sublimity of the art of painting*.

For art to attain the limits of sublimity, it must approach our *harmonic vision: clarity*.

Clarity will be color, proportions; these proportions are composed of various simultaneous measures within an action.

This action must be representative harmony, *the synchromatic movement (simultaneity) of light*, which is the *only reality*.

This synchromatic action will thus be the Subject which is the representative harmony.

[*on the back*]

Auditory perception is insufficient for our knowledge of the Universe since it lacks duration.

Its successiveness fatally commands evenness;

it is a kind of mechanism where depth, and therefore rhythm, become impossible.

It is a mathematics where there is no space.

Its law is the time of mechanical clocks, where there is no relationship at all to the movement of the Universe.

It is the evenness of things of this kind that condemns them to nothingness.

Its quality resembles the Object.

The object is not endowed with life.

When the object is . . . there is the successive dynamic, but no rhythm. It becomes a similitude of movement.

Its greatest limitation is of a practical order. Vehicles.

The railroad track is the image of the successive approaching the parallel: the tracks.

Thus Architecture.

These are only appearances.

The greatest object on Earth is subject to the very same laws:

it will become a record appearance of height or breadth or length, etc.

Art is rhythmic as Nature, that is to say, eternal.

If it begins with an object, Art is descriptive, stooping to assume weak functions.

It condemns itself freely—it is its own negation. Its most representative mode is wax sculpture.

If Art is the visual relations of an object or between objects themselves, without light playing the role of *governing the representation*, it is conventional, and turns out to be a language like any other, and by consequnece, successive. Thus literature, which has no plastic purity.

It is a weakness of the sublimity of art.

Art comes from the most perfect organ of Man

The Eye. The eyes are the windows of our soul.

It can become the living harmony of Nature

and it is then a fundamental element of our judgment toward purity. To see becomes the comprehension [of the] good.

[*in pencil*]
The idea of the living movement of the world which
passes judgment upon our soul.
Our understanding is thus adequate to our sight. It is
 necessary to look in order to see.
An auditory perception is not sufficient in our judgment to
 know the universe, because it does not abide within duration.
Its successiveness leads fatally to its death.
It is a species of mechanism where there is no depth, and
 therefore no rhythm. It is a mathematics that lacks space.
It is evenness of this sort that is condemned to death
Its quality resembles the Object. The Object is eternally
committed to death and its greatest limitation is of a practical
 order.
So with Architecture. These are only appearances.
The greatest object on earth is obliged by the same law.

1912

Translation from Arthur A. Cohen, ed., *The New Art of Color: The Writings of Robert and Sonia Delaunay*, trans. David Shapiro and Cohen (New York: Viking Press, 1978), pp. 81–84.

Letter to Kandinsky

Robert Delaunay

Dear Sir:

I have seen the book about which you spoke at the house of Mme. Epstein. Unfortunately it is impossible for me to read a line of it; but I will ask her to translate it for me. It is a large task!

I have looked several more times and at length at your canvases and if I have been pleased with them it is because certain things were comprehensible to me. I have not analyzed these things: a principal reason is that I have found a more genuine interpretation, a very perceptible progress in your latest canvases over the one last year. My personal attention to your works has led me to state this above all: your latest pictures brought me right back to an inquiry I had undertaken last year at the Indépendants where I had also seen your canvases that I do not now remember.

Therefore, I find it very useful that you have sent these this year. As regards what is central to our works, I think the public must become acclimated. The effort that must be made is necessarily slow because the public flounders in old habits. On the other hand, the artist has a lot to do in the little-explored and obscure domain of color composition that is hardly traceable any earlier than the beginning of impressionism. Seurat sought the first laws. Cézanne demolished all paintings since its inception, that is to say, *chiaroscuro* adapted to a linear composition which predominates in all the known schools. . . . This inquiry into pure painting is the actual problem. I do not know any painters in Paris who are truly seeking this ideal world. The cubist group about which you speak looks only within the line, reserving a secondary and nonconstructive place for color.

I have not yet figured out how to transpose into words my investigations in this new area that has been my sole effort for a long time.

I am still waiting for a loosening up of the laws comparable to musical notes I have discovered, based on research into the transparency of color, which have forced me to find *color movement.* These things, which I believe are generally unknown, are still in an embryonic stage. I am sending you a photograph of these attempts that date back some time already and that were quite a surprise and an astonishment to my friends since they communicate with only a very few connoisseurs whose understanding is completely detached from impressionism. I remember that you have asked me, but I do not know anyone who can write about these things at the present time. However, I already have some definitive essays. Even my friend Princet has not seen them, since they were finished very recently; however, I am confident in the judgment of his sensibility and it seems to me that he will react strongly to their implications. I think that he will be able to develop these ideas in the course of work that he began several years ago and which I have already called to your attention. I will speak to you again about all that.

Also, I am no longer surprised by people who do not see: these are unintelligible realities for them at the present time. I am certain as well that it is my fault. As far as the public is concerned, the primitive stiffness of the system is not yet a lodestone to its need for pleasure. I often ask myself whether there is any need for such things! I am content with those rare connoisseurs and friends. I will speak to you some time about the subject in painting, about an exciting conversation at the home of Apollinaire, who has begun to believe in our search. This conversation coincided with your letter and underscores everything, which is still so frail but so vital . . .

I will be happy if I understand your article in the *Blaue Reiter* and I will also ask Mme. Epstein to undertake the hard work of translating your book for me.

The futurists are more successful, but perhaps they will disappear when we have found the right means, for as the French expression goes, they all throw away "the handle before the ax." As for the cubists, the leading ones deny that they are representatives of that school, feeling, perhaps, that their certainty is problematic and of short duration! . . .

April 5, 1912

Translation from Arthur A. Cohen, ed., *The New Art of Color: The Writings of Robert and Sonia Delaunay*, trans. David Shapiro and Cohen (New York: Viking Press, 1978), pp. 112–14.

Letter to Franz Marc

Robert Delaunay

Dear Friend,

Perhaps I will come, perhaps I won't. I would be very interested to see a group of your pictures. As my last card told you, I have begun two big pictures that absorb me completely and I can commit myself to nothing else on account of my work.

It is unfortunate for Germany that the publishers do not take advantage of the beautiful opportunity afforded by [Maurice] Raynal. In France we have already produced one book and there is another in the wind, but not as useful.

I was very surprised by what you wrote about the article of Guillaume Apollinaire.

You do philosophical meditations on questions of craft.

You say you love my works.

My works are the result of my exertions in the craft that lead me toward purity. Everything is intimately connected. How can one understand or even love one part of this whole, this synthesis. . . . On the one hand you tell me that I try to reconcile the mysterious laws of art, and on the other hand in your letter you write: "I know nothing but pictures, the *work* and the *effort* and the mysterious fantasy of art." I have no philosophy. How can one conceive of the techniques of refining a work or a method that dates from the Middle Ages in works of the twentieth century.

Clarity is the quality of the French race, but it is a quality that helps only French inventors. . . . I have to be satisfied with this heritage.

In Art I am the enemy of disorder. The word "art" means harmony for me. I never speak of *mathematics* and never bother with Spirit. Everything that I say is relevant to my craft and is consequently connected to results.

You say again: "Why doesn't your perception issue from light?" As if to say that without light there is no perception.

It is true that *without light the eye cannot perceive.*

"Movement of colors? What is that?"

A word from physics. Everything is movement. A pencil line is only movement. Nothing can be explained about art with words like that.

I find (and I am terribly sorry about it after reading your letter) that you have understood absolutely nothing of my views about the worker who elucidates the personal techniques of his craft alongside his works.

I am not speaking of a mechanical, but of a *harmonic* movement since it is simultaneity, which means *depth.* "We can see as far as the stars."

There is movement. My visual perception makes me aware of the depth of the universe. In the universe of simultaneity there is nothing that resembles this insight.

This unity is not divisible.

Your method of reasoning (philosophical) that you allow me to grasp in your letter is divisionist. I do not conceive of a philosophy of Art. I see only an aesthetic criticism which is adequate to *representative* means. "I am crazy about the forms of colors but I do not seek their scholastic explication."

Nevertheless, everything that you say is scholastic since you do not allow for any alternatives. You only confuse with words and abstractions. You have no clarity. What does it mean to be "crazy about drawing"? Such madness is pathological and has nothing to do with me. And I say that you are mistaken when you speak about forms. "Forms" is a prehistoric, scholastic word, found in every academic drawing manual. This kind of thing is related to geometry, which is a *professorial invention.*

I no longer like definitions of points like two plus two since I have nothing formally to do with mathematics or geometry and I am horrified by *music and noise.*

None of the finite sciences have anything to do with my passion for light. My only science is the choice of impressions that the light in the universe furnishes to my consciousness as an artisan, which I try, by imposing an *Order*, an *Art*, an appropriate representative life, to organize.

I exist only in my work and I cannot separate my means from my end.

I have an end, an artistic belief that is unique and that cannot be classified without risking becoming ponderous. I love poetry because it is higher than psychology. But I love painting more because I love light and clarity and it calms me.

This is how I would have liked to have been understood, but what does it matter after all? It is the *image* alone that is important from the popular point of view. I am devoted above all to the common cause, *to the greatest Life*, and like the man who wrote my preface . . .

His reflections lead neither to mathematical formulae nor to Cabalistic symbols. They guide him simply and naturally toward pictorial realities: colors and lines.

December 14, 1912

Translation from Arthur A. Cohen, ed., *The New Art of Color: The Writings of Robert and Sonia Delaunay*, trans. David Shapiro and Cohen (New York: Viking Press, 1978), pp. 115–17.

Letter to August Macke

Robert Delaunay

It isn't possible that at such a decisive moment you are permitting yourself to prolong a state in which your vision is endangered. I say that this moment is decisive because a complete transformation of vision and above all of the technique of representation is universally taking place. If I write you about your work, it is because I have seen you in your house surrounded by your paintings and there I have seen very clearly the crisis that you have gone through and that is confirmed by your letter.

It has to do with representation, which touches the most proximate . . . sensibility, our very depths; in short, our life. It is the same for all of us who seek to establish ourselves in the fullest sense.

I know (as you have written to me and I thank you for talking to me about it) the miserable devices that are used against those who exert the greatest effort toward this artistic movement. But you know well that these devices are very insignificant and have no possible relation to True Life, for the simple reason that we cannot hinder Life and vital movement. We cannot, because that is precisely what our enemies want the most. It is at such times that the most instinctive artists give way to desire, and it is they who for the most part make the movement. They are the almost anonymous loners who are the true representatives of tradition and of the people. Too often we do not rely on these few and we ignore them. They are also the ones whom the enemies and the blind allow to be ignored and the ones who possess the true craft, the true creators who represent life and movement.

Actually, the reality of what I am saying exists and cannot be shaken by attack nor stuffed into any corner of the Universe. For such work it is necessary simply to see and no one can prevent seeing. I make no prediction here—that is not my *métier*, and what I want to say isn't the least bit mystical. As I have said, I have seen your works and I can speak only in reference to them.

Your order of sensibility pleases me greatly and I believe that you would be able to draw upon a much more important culture if you were not plagued by needs that unhappily are stifled by archaic and antiquated techniques. These needs are of the same character as your sensibility, which pleases me. But then I find that they are constricted, immobilized in the ancient citadels of past art the old towers of silence which from time to time are restored, but that can never be revivified despite every effort.

Your true sensibility can therefore diminish from isolation and become unhealthy, no longer nourishing your vision. I do not want to envisage such a pass for you.

An indispensable thing for me is the direct observation of nature and its luminous essence. I do not exactly mean with a palette in hand (although I am not against notes taken immediately from nature—I often work from nature—what is called popularly: in front of the subject). But what I attach great importance to is observation of the movement of colors.

It is only in this way that I have found the laws of complementary contrast and the simultaneity of those colors that nourish the rhythm of my vision. There I find the representative essence—which does not arise from a system or an a priori theory. In my view, every gifted man is distinguished by his essence, his personal movement before the Universal, and it is this that I find in your works that I saw this winter at Cologne. You are not in immediate contact with nature, which is the sole source of all inspiration toward beauty. It is here that art touches its vital and critical dimension. It is here that the Spirit can grow in comparison with antagonisms, rivalries, movements; that the decisive moment is born, that a man identifies himself on the Earth. There is nothing else to do in art. I believe it is indispensable to look at oneself front and back, in the present. If, and I believe it, there is a tradition, it exists only in the sense of the most profound movement of culture. Above all, I see the sun always! Since I desire the identification of myself and others, I see everywhere the halo, the halos, the movements of colors. And I believe that this is the rhythm. To see is a movement. Vision is the true rhythm-maker. To discern the quality of rhythms is movement, and the essential quality of painting is the image [*la représentaion*], the movement of vision which functions by objectifying itself toward reality. It is the essence of art and its greatest profundity. . . . I am very much afraid of definitions, and yet we are almost forced to make them. It is not necessary, however, to be immobilized by them. I have a horror of premature manifestos. I add that the simultaneity of colors is perforce equivalent to the sense of profundity. Without it there is no movement—consequently all painting that doesn't accord with these primary necessities will be for me simply an arabesque executed in color or a geometric drawing (which is the same thing). To seek or to want movement in the arabesque is impossible.

The representative vision of art in painting is, therefore, a movement to which these conditions are indispensable, in order that it be vital and representative. It is this which defines the abrupt change between earlier and modern composition. Only the new art is visual representation, the actual movement of our inspiration in its greatest objective creation.

But I do not want to philosophize. I want to remain within the domain of sensibility which holds uniquely to craft, and above all, my friend, to bring to you a little bit of courage and friendship. Do not be angry with me, because everything I have said is only in a spirit of Life, in a movement which I have sensed passing from me to you, that I have felt for a long time already, and that your letter has only augmented. If I have succeeded in that I will be happy,

despite the difficulties in the translation of languages and the even greater difficulties of saying concrete things through the abstraction of my vocabulary as painter.

1912

Translation from Arthur A. Cohen, ed., *The New Art of Color: The Writings of Robert and Sonia Delaunay*, trans. David Shapiro and Cohen (New York: Viking Press, 1978), pp. 117–19.

Les Fenêtres

Guillaume Apollinaire

à Robert Delaunay

Du rouge au vert tout le jaune se meurt
Quand chantent les aras dans les forets natales
Abatis de pi-his
Il y a un poème à farie sur l'oiseau qui n'a qu'une aile
Nous l'enverrons en message téléphonique
Traumatisme géant
Il fait couler les yeux
Voilà une jolie jeune fille parmi les jeunes Turinaises
Le pauvre jeune homme se mouchait dans sa cravate blanche
Tu soulèveras le rideau
Et maintenant voilà que s'ouvre la fenêtre
Araignées quand les mains tissaient la lumière
Beauté Paleur d'insondables violets
Nous tenterons en vain de prendre du repos
On commencera à minuit
Quand on a le temps on a la liberté
Bigorneaux Lottes Multiples Soleils et l'Oursin du Couchant
Un vielle paire de chaussures jaunes devant la fenêtre
Tours
Les tours ce sont les rues
Puits
Puits
Ce sont les places
Puits
Arbres creux qui enlacent les Capresses vagabondes
Les Chabins chantent des airs à mourir
Aux Chabines maronnes
Et l'oie Oua-Oua trompette au nord
Où les chasseurs de ratons
Raclent les pelleteries
Etincelant diamant
Vancouver
Où le train blanc de neige et de feux nocturnes fuit l'hiver
O Paris
Du rouge au vert tout le jaune se meurt
Paris Vancouver Lyon Maintenon New-York et les Antilles
La fenêtre s'ouvre comme une orange
Le beau fruit de la lumière

1912

Originally published in Apollinaire, *Robert Delaunay*, exhibition album
(Berlin: Der Sturm, 1913), unpaginated.

Windows

Guillaume Apollinaire

to Robert Delaunay

The yellow dies down from red to green
When the aras babble in their native forest
Heaps of pilis
There is a poem to be written on the bird
 who has only one wing
We will send it as a telephone message
Giant traumatism
It makes your eyes run
There is a one pretty girl among the kids from Turin
The miserable young man wipes his nose with
 his white necktie
You will raise the curtain
And now look at the window opening
Spiders when hands wove the light
Beauty paleness impenetrable violets
They will be in midnight
When you have time you have liberty
Signoreaux Lotte serial Suns and the Sea-urchin
 of the setting sun
An old pair of yellow shoes in the presence of the window
Towers
Towers are streets
Wells
Wells
Wells are markets
Wells
Hollow trees which protect the wandering Capresses
The Octaroons sing their songs of death
To their maroon-colored wives
And in the north the goose trumpets honk honk
Where the raccoon hunters
Scrape their pelts
Sparkling diamond
Vancouver
Where the train white with snow and night fire flees the winter
O Paris
The yellow disc dies down from red to green
Paris Vancouver Hyères Maintenon New York and the Antilles
The window opens like an orange
Fine fruit of light

1912

Translation from Arthur A. Cohen, ed., *The New Art of Color: The Writings
of Robert and Sonia Delaunay*, trans. David Shapiro and Cohen (New York:
Viking Press, 1978), pp. 169–70.

La Tour parle

Louis Aragon

à Robert Delaunay

Vous du Métro
Dans le soir avec mes yeux phosphore orage
C'est moi que les collégiens de leurs mains ivres
Caressent sans savoir pourquoi
Ils lèvent leur front lourd les enfants des péniches
La balle échappe à leurs doigts gourds
Quand le fleuve en passant baigne mes pieds et chante
Voici voici la grande femelle bleue
La dame au corsage de jalousie
Elle est tendre Elle est nouvelle
Ses rires sont des incendies
Joueuse de marelle où vas-tu sauter
Vois nos mains traversées d'alcool et de sang bleu
Laisse nous respirer tes cheveux de métal
Mais accroupi dans mes jupes
Que fait près de moi ce régime de bananes
Paris paysage polaire
Mon corps de lévrier dans le vent chaud
Le sentez-vous comme il est rose
Comme il est blanc comme il est noir
Femmes léchez mes flancs d'où fuit FL FL
Le bulletin météorologique
Messieurs posez vos joues rasées
Contre mes membres adossés aux cieux
Où les oiseaux migrateurs
Nichent

1910

Manuscript reproduced in Danielle Molinari, *Robert et Sonia Delaunay* (Paris: Nouvelles Editions Françaises, 1987), p. 36.

The Tower Speaks

Louis Aragon

to Robert Delaunay

You of the Metro
With my phosphorus eyes in the evening, storm
It's me the schoolchildren caress with their drunken hands
Without knowing why
Children of the barges raise their heavy brows
The ball slips through their heavy fingers
When the river in passing wets my feet and sings
Here, here comes the great blue woman
The lady of the jealous blouse
She is tender, she is new
Fire breaks out when she laughs
Hopscotch-girl where will you jump?
See our hands shot through with alcohol and blue blood
Let us breathe your metal hair
But what's that bunch of bananas doing next to me
Crouched in my skirts?
Paris polar landscape
My greyhound-body in the warm wind
Can you smell how pink it is
How white it is, how black it is
Ladies, lick my sides from which FL FL
The weather forecast is leaking out
Gentlemen, rest your shaven cheeks
Against my limbs backed up against the heavens
Where the birds of passage
Nest

1910

Translated, from the French, by Stephen Sartarelli

Tour

Blaise Cendrars

à Robert Delaunay

1910
Castellamare
Je dînais d'une orange à l'ombre d'un oranger
Quand, tout à coup . . .
Ce n'était pas l'éruption du Vésuve
Ce n'était pas le nuage de sauterelles, une des dix plaies d'Egypte
Ni Pompéi
Ce n'était pas les cris ressuscités des mastodontes géants
Ce n'était pas la Trompette annoncée
Ni la grenouille de Pierre Brisset
Quand, tout à coup,
Feux
Chocs
Rebondissements
Etincelle des horizons simultanés
Mon sexe
O Tour Eiffel !
Je ne t'ai pas chaussée d'or
Je ne t'ai pas fait danser sur les dalles de cristal
Je ne t'ai pas vouée au Python comme une vierge de Carthage
Je ne t'ai pas revêtue du péplum de la Grèce
Je ne t'ai jamais fait divaguer dans l'enceinte des menhirs
Je ne t'ai pas nommée Tigre de David ni Bois de la Croix
Lignum Crucis
O Tour Eiffel !
Feu d'artifice géant de l'Exposition Universelle !
Sur le Gange
A Bénarès
Parmi les toupies onanistes des temples hindous
Et les cris colorés des multitudes de l'Orient
Tu te penches, gracieux Palmier !
C'est toi qui à l'époque légendaire du peuple hébreu
Confondis la langue des hommes
O Babel !
Et quelque mille ans plus tard, c'est toi qui retombais en
 langues de feu
sur les Apôtres rassemblés dans ton église
En pleine mer tu es un mât
Et au Pôle Nord
Tu resplendis avec toute la magnificence de
l'aurore boréale de ta télégraphie sans fil
Les lianes s'enchevêtrent aux eucalyptus
Et tu flottes, vieux tronc, sur le Mississipi
Quand
Ta gueule s'ouvre
Et un Caïman saisit la cuisse d'un nègre
En Europe tu es comme un gibet
(Je voudrais être la tour, pendre à la Tour Eiffel !)
Et quand le soleil se couche derrière toi
La tête de Bonnot roule sous la guillotine
Au coeur de l'Afrique c'est toi qui cours

Tower

Blaise Cendrars

to Robert Delaunay

1910
Castellamare
I was dining on an orange in the shadow of an orange-tree
When, all of a sudden . . .
It was not Vesuvius erupting
It was not a cloud of locusts, one of the ten plagues of Egypt
Nor Pompeii
It was not the resurrected cries of giant mastodons
It was not the Trumpet foretold
Nor Pierre Brisset's frog
When, all of a sudden
Fire
Blasts
Shock waves
Flash of simultaneous horizons
My phallus
O Eiffel Tower!
I haven't shod you in gold
I haven't made you dance on crystal flagstones
I haven't doomed you to the python like a virgin in Carthage
I haven't dressed you in a Grecian peplos
I've never made you wander in the circle of the monoliths
I haven't named you Tiger of David or Wood of the Cross
Lignum Crucis
O Eiffel Tower!
Great firework of the Universal Exposition!
At Benares
Along the Ganges
Among the onanistic spinning tops of Hindu temples
And the colorful cries of the multitudes of the East
You bend, o graceful palm-tree!
It was you who in the days of legend of the Hebrews
Confused men's tongues
O Babel!
And several thousand years later, it was you who came down
 in tongues of fire over the Apostles gathered in your
 Church
You're a mast upon the open sea
And at the North Pole
You shine with all the splendor of the aurora borealis of your
 wireless telegraphy
Lianas grow entangled in the eucalyptus
And you float, old trunk, along the Mississippi
When
Your jaws fly open
And a caiman chomps a Negro's thigh
In Europe you are like a gallows
(I'd like to be the tower, to hang from the Eiffel Tower!)
And when the sun goes down behind you
Bonnot's head rolls under the guillotine
In the heart of Africa that's you running

Girafe
Autruche
Boa
Equateur
Moussons
En Australie tu as toujours été tabou
Tu es la gaffe que le capitaine Cook employait pour diriger
 son bateau d'aventuriers
O sonde céleste !
Pour le Simultané Delaunay, à qui je dédie ce poème,
Tu es le pinceau qu'il trempe dans la lumière
Gong tam-tam zanzibar bête de la jungle rayons-X express
 bistouri symphonie
Tu es tout
Tour
Dieu antique
Bête moderne
Spectre solaire
Sujet de mon poème
Tour
Tour du monde
Tour en mouvement

Août 1913

Published in Danielle Molinari, *Robert et Sonia Delaunay*
(Paris: Nouvelles Editions Françaises, 1987), p. 38.

Giraffe
Ostrich
Boa
Equator
Monsoons
In Australia you've always been taboo
You're the boathook Captain Cook used to steer his boat of
 adventurers
O plumb-line of the heavens!
For Delaunay the *Simultané*, to whom I dedicate this poem.
You are the paintbrush he dips in light
Gong, tom-tom, zanzibar, jungle-beast, x-ray, express,
 bistoury, symphony
You are everything
Tower
Ancient god
Modern beast
Solar spectrum
Subject of my poem
Tower
Tower of the world
Tower in motion

August 1913

Translated, from the French, by Stephen Sartarelli

Tour Eiffel

Vicente Huidobro

à Robert Delaunay

Tour Eiffel
Guitare du ciel

 Ta télégraphie sans fil
 Attire les mots
 Comme un rosier les abeilles

Pendant la nuit
La Seine ne coule plus

 Télescope ou clairon

 TOUR EIFFEL

Et c'est une ruche de mots
Ou un encrier de miel

Au fond de l'aube
Une araignée au pattes en fil de fer
Faisait sa toile avec des nuages

 Mon petit garçon
 Pour monter à la Tour Eiffel
 On monte sur une chanson

 Do
 ré
 mi
 fa
 sol
 la
 si
 do

 Nous sommes en haut

Un oiseau chante C'est le vent
Dans les antennes De l'Europe
Télégraphiques Le vent électrique

 Là-bas

Les chapeaux s'envolent
Ils ont des ailes mais ils ne chantent pas

Jacqueline
 Fille de France
Qu'est-ce que tu vois là-haut?

Eiffel Tower

Vicente Huidobro

to Robert Delaunay

Eiffel Tower
Sky's guitar

 Words fly to
 Your wireless telegraphy
 Like bees to roses

During the night
The Seine stops flowing

 Telescope or clarion

 EIFFEL TOWER

And it's a word-hive
An inkwell of honey

At the heart of the dawn
A wire-footed spider
Spun a web of clouds

 My boy
 To climb the Eiffel Tower
 You climb a song

 Do
 ré
 mi
 fa
 sol
 la
 si
 do

 We are aloft

A bird sings It's the wind
On the telegraph Of Europe
Antennas The electric wind

 Down below

Hats fly off
They have wings but do not sing

Jacqueline
 Daughter of France
What do you see up there?

La Seine dort
Sous l'ombre de ses ponts

Je vois tourner la Terre
Et je sonne mon clairon
Vers toutes les mers

 Sur le chemin
 De ton parfum
 Toutes les abeilles et les paroles s'en vont

 Sur les quatre horizons
Qui n'a pas entendu cette chanson

JE SUIS LA REINE DE L'AUBE DES POLES
JE SUIS LA ROSE DES VENTS QUI SE FANE TOUS LES AUTOMNES
ET TOUTE PLEINE DE NEIGE
JE MEURS DE LA MORT DE CETTE ROSE
DANS MA TETE UN OISEAU CHANTE TOUTE L'ANNEE

C'est comme ça qu'un jour la Tour m'a parlé

Tour Eiffel
Volière du monde

 Chante Chante

Sonnerie de Paris

Le géant pendu au milieu du vide
Est l'affiche de France

 Le jour de la Victoire
 Tu la raconteras aux étoiles

Août 1917

Originally published in Vicente Huidobro,
Tour Eiffel (Madrid, 1918), unpaginated.

The Seine sleeps
Under the shadows of its bridges

I see the Earth turn
And sound my clarion
Toward every sea

 On the trail
 Of your perfume
 All bees and words take off

 Who upon the four horizons
Has not heard this song?

I AM QUEEN OF THE DAWN OF THE NORTH AND SOUTH POLES
I AM THE WIND-ROSE THAT WILTS EVERY AUTUMN
AND ALL FULL OF SNOW
I DIE THIS ROSE'S DEATH
A BIRD SINGS IN MY HEAD YEAR ROUND

That's what the Tower said to me one day

Eiffel Tower
Aviary of the world

 Sing Sing

Chimes of Paris

The giant hung across the void
Is France's signpost

 On Victory day
 You will tell her story to the stars

August 1917

Translated, from the French, by Stephen Sartarelli

Selected Bibliography

Writings by the Artist

"Art abstrait et peinture vraie." Ed. Pierre Francastel.
 Prisme des arts, no. 2 (1956).

*Du Cubisme à l'art abstrait, Documents inédits publiés par Pierre
 Francastel et suivis d'un catalogue de l'oeuvre de R. Delaunay par
 Guy Habasque.* Paris: S.E.V.P.E.N., 1957.

"Entre peintres: Lettre de Robert Delaunay." *L'Intransigeant*,
 Mar. 10, 1914, p. 2.

"Henri Rousseau, le douanier." *L'Amour de l'art*, no. 7
 (Nov. 1920).

"Lettre ouverte au Sturm." *Der Sturm* 4, nos. 194–95
 (Jan. 1914).

The New Art of Color: The Writings of Robert and Sonia Delaunay.
 Ed. Arthur A. Cohen. Trans. David Shapiro and Cohen.
 New York: Viking Press, 1978.

"Réponse à enquête: Chez les cubistes." *Le Bulletin de la vie
 artistique* 5, no. 21 (Nov. 1, 1924), pp. 484–85.

"Réponse à l'enquête: Faut-il renverser la Tour Eiffel?"
 La Revue mondiale, June 1, 1929, pp. 234–40.

*Robert Delaunay: Zur Malerei der reinen Farbe: Schriften von 1912 bis
 1940.* Ed. Hajo Düchting. Munich: Silke Schreiber, 1983.

"Über das Licht." Trans. Paul Klee. *Der Sturm* 3, nos. 144–45
 (Jan. 1913).

"Un Text inédit de Robert Delaunay." *Aujourd'hui* 2, no. 11
 (Jan. 1957), pp. 28–31.

Articles

Allard, Roger. "Le Salon des Indépendants." *La Rue*, Apr. 1911.

———. "Sur quelques peintres." *Les Marches du Sud-Ouest*,
 no. 2 (June 1911), pp. 57–64.

———. "Mlle. Marie Laurencin, Robert Delaunay."
 La Cote, Feb. 1912.

———. "Le Salon des Indépendants." *La Cote*, Mar. 1912.

———. "Le Salon des Indépendants." *La Revue de France*,
 Mar.–Apr. 1912.

Alley, Robert. "Robert Delaunay's Fenêtres Ouvertes
 Simultanément (1ère Partie, 3ème Motif), 1912 (Tate
 Gallery)." *Burlington Magazine* 110, no. 781 (Apr. 1960),
 p. 216.

Apollinaire, Guillaume. "Le Salon des Indépendants."
 L'Intransigeant, Apr. 21, 1911, pp. 1–2.

———. "Réalité: Peinture pure." *Les Soirées de Paris*, no. 11
 (1912).

———. "Marie Laurencin—Robert Delaunay."
 L'Intransigeant, Mar. 5, 1912, p. 2.

———. "Le Salon des Indépendants." *L'Intransigeant*,
 Mar. 19, 1912, p. 1.

———. "Les Commencements du cubisme." *Le Temps*,
 Oct. 1912.

———. "Die moderne Malerei." *Der Sturm* 3, nos. 148–49
 (Feb. 1913).

———. "Le Salon des Indépendants." *L'Intransigeant*,
 Mar. 18, 1913, p. 2.

———. "A Travers le Salon des Indépendants." *Montjoie!*,
 no. 13 (Mar. 18, 1913).

———. "Le Salon des Indépendants." *L'Intransigeant*,
 Mar. 25, 1913, p. 2.

———. "Au Salon des Indépendants." *L'Intransigeant*,
 Mar. 5, 1914, p. 2.

———. "Simultanisme—Librettisme." *Les Soirées de Paris*,
 no. 225 (June 15, 1914).

Arcangeli, Francesco. "Mostra a Parigi: Delaunay." *Paragone*,
 no. 31 (July 1952), pp. 61–62.

Ashton, Dore. "A Ceaseless Upspringing of Something New."
 In Ashton. *A Reading of Modern Art.* Cleveland: The Press of
 Case Western Reserve University, 1969.

"Ausstellung Galerie Beyeler, Basel." *Werk* 43 (July 1956),
 pp. 119–20.

Balliet, Whitney. "Profiles: Panassié, Delaunay et Cie."
 The New Yorker, Feb. 14, 1977, pp. 43–52.

Behrends, Sue. "An Investigation into the Macke—Marc—
 Delaunay Relationship." Iowa City: University of Iowa, 1974.

Bennett, B. "The City of Paris." *Museum News* (Toledo
 Museum of Art) 1, no. 2 (summer 1957), pp. 12–13.

Benson, Timothy. "Primitivism and Scientism in the Work of
 Sonia and Robert Delaunay." Iowa City: University of
 Iowa, 1976.

Bommershein, Paul. "Die Überwindung der Perspektive und
 Robert Delaunay." *Der Sturm* 3, nos. 148–49 (Feb. 1913).

Bowlt, John, E. "Orphism and Simultanism: The Russian
 Connection." *Structurist*, nos. 31–32 (1991–92), pp. 72–80.

Buckberrough, Sherry A. "The Simultaneous Content of
 Robert Delaunay's *Windows*." *Arts Magazine* 54, no. 1
 (Sept. 1979), pp. 102–11.

Busse, E. v. "Robert Delaunay's Methods of Composition."
 In Wassily Kandinsky and Franz Marc, eds. *The Blaue
 Reiter Almanac* (1912). New documentary edition, ed. Klaus
 Lankheit. New York: Da Capo Press, 1989, pp. 119–23.

Cachin, Françoise. "Futurism in Paris 1909–1913." *Art in
 America* 62, no. 2 (Mar.–Apr. 1974), pp. 38–44.

Cassou, Jean. "Robert Delaunay et la plastique murale en
 couleur." *Art et décoration* 64 (Mar. 1935), pp. 93–98.

———. "Oeuvres de jeunesse de Robert Delaunay."
 XXe siècle 2, no. 18 (Feb. 1962), pp. 99–104.

"Catalogue to the Exhibition Recent Acquisitions, 1966–67."
 Rhode Island School of Design Bulletin 54 (Dec. 1967), p. 50.

Cendrars, Blaise. "Delaunay: Le Contraste simultané."
 La Rose rouge, July 24, 1919.

———. "La Donation Delaunay au Musée du Louvre."
 XXe siècle 2, no. 23 (May 1964).

Chadwick, Whitney. "Living Simultaneously: Sonia and
 Robert Delaunay." In Chadwick and Isabelle de

Courtivron, eds. *Significant Others: Creativity and Intimate Partnership*, pp. 31–48. New York: Thames and Hudson, 1993.

Chéronnet, Louis. "Publicité moderne. Fernand Léger et Robert Delaunay." *L'Art vivant*, Dec. 1, 1926.

Chipp, Herschel B. "Orphism and Color Theory." *Art Bulletin* 40, no. 1 (Mar. 1958), pp. 55–63.

Coates, R. M. "Art Galleries: Show at the Guggenheim Museum." *The New Yorker*, Apr. 2, 1955, p. 121.

Craven, Arthur. "L'Exposition des Indépendants." *Maintenant* 3, no. 4 (Mar.–Apr. 1914), pp. 1–17.

de Chassey, Eric. "Etude de tableau: Robert Delaunay, la tour simultanée." *Beaux-Arts*, no. 141 (Jan. 1996), pp. 64–67.

Degard, Léon. "La Rétrospective Robert Delaunay à Paris." *Aujourd'hui art et architecture* 2, no. 13 (June 1957), pp. 4–9.

Degard, Léon, and Michel Seuphor. "Robert Delaunay." *L'Art d'aujourd'hui* (Oct. 1951), pp. 6–12.

"Les Delaunays." *Connaissances d'arts*, no. 399 (May 1985), p. 125.

"Delaunays 'formes circulaires' und die Philosophie Henri Bergsons: Zur Methode der Interpretation abstrakter Kunst." *Wallraf-Richartz-Jahrbuch* 48–49 (1987–88), pp. 335–64.

Delteil, Joseph. "Robert Delaunay, peintre du jour." *Les Arts plastiques*, no. 1 (Mar. 1925).

Denton, Monroe A. "Windows." *Artscribe* 28 (Mar. 1981), pp. 29–33.

De Torre, Guillermo. "Juan Gris y Robert Delaunay, reminiscencias personales." *Revista de ideas esteticas* 21, no. 84 (Oct.–Dec. 1963), pp. 295–316.

Dietrich, Barbara. "Delaunay en Alemania, en Munich." *Goya*, no. 190 (Jan.–Feb. 1986), p. 231.

di San Lazzarro, Gualtieri. "Les Delaunays." *XXe siècle*, no. 10 (Mar. 1958), pp. 72–73.

———. "La Deuxième Exposition du relief." *XXe siècle*, no. 20 (Dec. 1962).

Dorfles, Gillo. "L'arte astratta non è nata ieri." *Domus*, no. 267 (1952), pp. 42–43.

Dorival, Bernard. "La 'Fenêtre', peinture de Delaunay acquise par le Musée d'art moderne." *Revue du Louvre et des musées de France*, no. 10 (Dec. 1950), pp. 245–47.

———. "Expositions Musée national d'art moderne, retrospective Robert Delaunay." *Revue du Louvre et des musées de France* 7 (July 1957), pp. 189–91.

———. "Deux Grandes Donations au Musée national d'art moderne: La Donation Delaunay, la donation Dunoyer de Segonzac." *Revue du Louvre et des musées de France* 13, no. 6 (1963), pp. 283–88.

———. "Musée national d'art moderne: Six mois d'activité." *Revue du Louvre et des musées de France* 13, no. 6 (1963), pp. 305–06.

———. "L'Affaire Delaunay à l'Armory Show d'après des documents inédits." *Bulletin de la société de l'histoire de l'art français* (1977), pp. 323–32.

———. "Robert Delaunay et Albert Gleizes." *L'Oeil*, no. 445 (Oct. 1992), pp. 30–37.

Düchting, Hajo. "Robert Delaunay." *Weltkunst* 63, no. 13 (July 1993), pp. 1,649–51.

Duve, Thierry. "The Readymade and the Tube of Paint." *Artforum* 24, no. 9 (May 1986), pp. 110–21.

"Exhibition at the Arts Council." *Apollo* 67 (Feb. 1958), p. 60.

Fiz, Marchan. "Arqitectura y ciudad en la pintura de las vanguardias." *Goya*, no. 180 (May–June 1984), pp. 332, 334–35, 340.

Florent, Fels. "Propos d'Artiste: Robert Delaunay." *Nouvelles Littéraires*, Oct. 25, 1924.

Francastel, Pierre. "Les Delaunays." *XXe siècle*, no. 15 (Christmas 1960), pp. 64–73.

———. "Les 'Fenêtres' de Robert Delaunay." *XXe siècle*, no. 21 (May 1963), pp. 9–14.

George, W. "Lithographies de Robert Delaunay." *L'Amour de l'art*, no. 7 (1926).

Giedion-Welker, Carola. "Ausstellung, Kunsthalle Zürich." *Werk* 38, no. 10 (Oct. 1951), pp. 129–30.

Gindertael, R. V. "Robert Delaunay." *Werk* 33 (Aug. 1946), pp. 273–79.

Girardet, Sylvie, Claire Merleau-Ponty, and Anne Tardy. "La Muse de fer." *Monuments historiques de la France*, no. 132 (Apr.–May 1984), pp. 28–32.

Goll, Claire. "Der Delaunay-Stil." *Börsenkurier* (1926).

Goll, Ivan. "Le Peintre Robert Delaunay parle." *Surréalisme*, no. 1 (Oct. 1924).

Gronberg, Tag. "Working in Tandem." *Art History* 19 (June 1996), pp. 313–16.

Habasque, Guy. "Les Reliefs de Robert Delaunay." *XXe siècle*, no. 16 (May 1961), pp. 16–18.

———. "L'Oeuvre de Robert et Sonia Delaunay." *Vie des arts*, no. 41 (winter 1965–66), pp. 30–35.

Hahl, Reinhold D. "Le Soleil dans la peinture et la sculpture contemporaines." *Graphis*, no. 100 (1962), pp. 228–43.

Hamm, H. "Robert Delaunay und der kubistische Stil." *Die Kunst und das Schöne Heim* 58, no. 3 (Dec. 1959), pp. 96–99.

Hausenstein, W. "Vom Kubismus." *Der Sturm* 4, nos. 170–71 (July 1913).

Henninger, G. "Paul Klee und Robert Delaunay." *Quadrum* 3 (1957), pp. 137–41.

Hoog, Michel. "La Ville de Paris de Robert Delaunay." *Quadrum* 3 (1957).

———. "Quelques précurseurs de l'art d'aujourd'hui." *Revue du Louvre et des musées de France* 16, no. 3 (1966), pp. 165–72.

Jung-Hubsch, Thea. "Sur deux lettres inédites de Franz Marc à Robert Delaunay." *Cahiers du Musée national d'art moderne*, no. 27 (spring 1989), pp. 84–93.

Kagan, Andrew. "Robert Delaunay at the Sources of Absolute Art." *Arts Magazine* 54, no. 1 (Sept. 1979), pp. 86–87.

Klee, Paul. "Die Ausstellung des 'Modernen Bundes' im Kunsthaus Zürich." *Die Alpen* 6, no. 12 (Aug. 1912).

Krieger, Peter. "Robert Delaunay als Portraitist." *Berliner Museen* 14, no. 1 (1964), pp. 20–23.

Kuh, Katherine. "Many Sides of Cubism." *Albright-Knox Art Gallery Notes* 28, no. 2 (fall 1965), p. 6.

Kuspit, Donald. "Delaunay's Rationale for Peinture Pure, 1909–15." *Art Journal* 34, no. 2 (winter 1974–75), pp. 108–14.

———. "The Modern Fetish." *Artforum* 27, no. 2 (Oct. 1988), pp. 132–40.

Lacoste, Michel Conil. "Private Gifts Enrich the State Collections." *Studio* 167, no. 853 (May 1964), pp. 208–11.

Langner, Johannes. "Zu den Fenster-Bildern von Robert Delaunay." *Jahrbuch der Hamburger Kunstsammlungen* 7 (1962), pp. 67–82.

Lassaigne, Jacques. "L'Oeuvre de Robert Delaunay au Musée national d'art moderne." *XXe siècle*, no. 9 (June 1957), pp. 65–67.

Laude, Jean. "Du Cubisme à l'art abstrait." *Critique* 26, no. 156 (May 1960), pp. 426–51.

La Verne, George. "Delaunay: The Brief Song of Orphism." *Arts Digest* 29, no. 14 (Apr. 15, 1955), pp. 6–7.

Le Targat, François. "Robert et Sonia Delaunay." *L'Oeil*, no. 359 (June 1985), p. 72.

Loyer, Jacqueline, and Charles Perrusseaux. "Robert Delaunay, catalogue de son oeuvre lithographique." *Nouvelles de l'estampe*, no. 15 (May–June 1974), pp. 3–9.

Marchiori, Guiseppi. "Repères français de l'art abstrait." *XXe siècle*, no. 28 (June 1967), pp. 57–65.

McBride, Henry. "Now a Non Non-Objective Guggenheim." *Artnews* 52, no. 1 (Mar. 1953), pp. 26–27.

Melville, Robert. "Retrospective at the Arts Council Gallery." *Architectural Review* 123 (Apr. 1958), p. 279.

"Memento de la vie à Paris." *Montjoie!*, no. 3 (Mar. 1913).

Molinari, Danielle. "Sonia and Robert Delaunay." *Beaux-Arts*, no. 24 (May 1985), pp. 42–57.

Morris, George L. K. "Dialogues with Delaunay." *Artnews* 53, no. 9 (Jan. 1955), pp. 17–18, 64–65.

"Notable Works of Art Now on the Market." *Burlington Magazine* 108, no. 765 (Dec. 1966).

Oeri, Georgine. "Delaunay in Search of Himself." *Arts* 33, no. 6 (Mar. 1959), pp. 43–52.

Overy, Paul. "Robert and Sonia Delaunay." *Studio* 198, no. 1,011 (Dec. 1985), pp. 8–11.

Pabst, Walter. "Der 'contraste simultané' im Spiegel der Dichtung. Blaise Cendrars und seine poetischen Delaunay-Paraphrasen." In *Festschrift für Otto von Simson zum 65. Geburtstag*. Berlin: Propyläen, 1977.

Passuth, Krisztina. "Le Soleil bleu: Les Delaunays et les pays de l'est." *Cahiers du Musée national d'art moderne*, no. 16 (1985), pp. 109–17.

Pernoud, Emmanuel. "Le Trait des cubistes." *Histoire de l'art*, nos. 29–30 (May 1995), pp. 79–87.

Platte, Hans. "Robert Delaunay und Lyonel Feiniger. Zwei Bilder in der Hamburger Kunsthalle." *Jahrbuch der Hamburger Kunstsammlungen* 3 (1958), pp. 39–46.

Pohlen, Annelie. "Robert and Sonia Delaunay." *Artforum* 24, no. 1 (Oct. 1985), p. 135.

"Pour ou contre l'art abstrait." *Cahier des amis de l'art*, no. 11 (1947), p. 58.

Preston, Stuart. "Sonia et Robert Delaunay at the Musée National d'Art Moderne." *Burlington Magazine* 127, July 1985, p. 479.

Prossor, John. "An Introduction to Abstract Painting." *Apollo* 66 (Oct. 1957), pp. 75–87.

Rappaport, Ruth Ann. "Robert Delaunay and Cubism." Master's thesis, New York University, 1963.

Restany, Pierre. "Robert Delaunay." *Cimaise*, no. 6 (July–Aug. 1957), pp. 4–11.

"Retrospective at the Musée National d'Art Moderne." *Apollo* 66 (Aug. 1957), p. 29.

Robbins, Daniel. "From Cubism to Abstract Art: The Evolution of the Work of Gleizes and Delaunay." *The Baltimore Museum of Art News* 25, no. 3 (1962), pp. 9–21.

"Robert Delaunay at Accrochage Gallery, Paris." *Kunstwerk*, no. 37 (Feb. 1984), p. 32.

"Robert Delaunay at the Arts Council." *Burlington Magazine* 100, no. 660 (Mar. 1958), p. 106.

"Robert Delaunay's Eiffel Tower." *Burlington Magazine* 107, no. 747 (June 1965), p. 345.

Robertson, Eric. "Painting Windows: Robert Delaunay, Blaise Cendrars, and the Search for Simultaneity." *Modern Language Review* 90 (Oct. 1995), pp. 883–96.

Rotshuizen, Marion. "Robert Delaunay et la forme circulaire." *L'Information d'histoire de l'art* 18, no. 3 (May–June 1973), pp. 122–24.

Rotzler, Willy. "Apollinaire und seine Freunde." *Du* 3 (Mar. 1982), pp. 26–67.

Rowe, Collin, and Robert Slutzky. "Transparency: Literal and Phenomenal." *Perspecta*, no. 8 (1963), pp. 45–48.

Salmon, André. "Le Salon d'Automne." *Paris-Journal*, Nov. 1911.

———. "Le Salon." *Montjoie!* (Mar. 1914).

"Le Salon des Indépendants." *La Cote* (Mar. 1913), p. 5.

Schiff, Gert. "Robert Delaunay: Les Fenêtres, 1912." *Du* 21, no. 239 (Jan. 1961), pp. 55–56.

Schneider, Pierre. "Two Donations to the Musée d'Art Moderne." *Artnews* 63, no. 5 (May 1964), pp. 48ff.

Schurr, Gerald. "Orphic Cubism in the Louvre." *Connoisseur* 156, no. 628 (June 1964), p. 121.

Selz, Peter. "The Influence of Cubism and Orphism on the 'Blue Rider'." In *Festschrift Ulrich Middeldorf*. Berlin: Walter de Gruyter, 1968.

Seuphor, Michel. "L'Orphisme." *L'Art d'aujourd'hui*, nos. 7–8 (Mar. 1950).

———. "Sens et permanence de la peinture construite." *Quadrum*, no. 8 (1960), pp. 37–58.

Sharp, Marynell. "Artists: Man and Wife." *Art Digest* 24, no. 1 (Oct. 1949), p. 12.

"El 'Simultanisme' del Segnor i la Senyora Delaunay." *Vell i Nou*, no. 57 (Dec. 15, 1917), pp. 672–79.

Sizemore, Jean. "The Interrelationship of Robert Delaunay and Fernand Léger 1909–1913." Iowa City: University of Iowa, 1974.

Soupault, Philippe. "Robert Delaunay, peintre." *Feuilles libres*, no. 33 (Sept.–Oct. 1923), pp. 167–75.

———. "R. Delaunay." *Het Overzicht*, nos. 18–19 (Oct. 1923), pp. 99–102.

Stahn, Eva. "Robert Delaunay: Formes Circulaires." *Mitteilungen* (Kunstmuseum Bern), nos. 114–15 (Dec. 1969–Jan. 1970), pp. 1–8; no. 116 (Feb. 1970), pp. 1–6.

Stavitsky, Gail. "A. E. Gallatin and Robert Delaunay." *Notes on the History of Art* 11, nos. 3–4 (spring–summer 1992), pp. 53–58.

Steneberg, E. "Deutsche Kritiken über Delaunay, 1913–1921." *Das Kunstwerk* 15, no. 4 (Oct. 1961), p. 24.

———. "Robert Delaunay und die deutsche Malerei." *Das Kunstwerk* 15, no. 4 (Oct. 1961), pp. 3–21.

Sutton, Denys. "Robert Delaunay." *Magazine of Art* 41 (Oct. 1948), pp. 208–12.

Travis, David. "In and Out the Eiffel Tower." *Museum Studies* 13, no. 1 (1987), pp. 4–23.

Tyler, Parker. "Retrospective Exhibition of Robert Delaunay at the Guggenheim." *Artnews* 54, no. 3 (May 1955), p. 46.

Van der Waals, J. C. "Delaunay, hierofant." *Museumjournal* 3, no. 4 (1957–58), pp. 69–74.

Van Loon, H. "Where Art and Style Meet." *Maandblad voorbeeldende Kunsten* 6, no. 9 (Sept. 1929), pp. 276–81.

Venturi, Lionello. "Boccioni e Delaunay." *Commentari* 10, no. 4 (Oct.–Dec. 1959), pp. 238–42.

Veronese, Giulia. "Robert Delaunay." *Emporium* 126, no. 751 (Aug. 1951), pp. 51–56.

Waldemar, George. "Robert Delaunay et le triomphe de la couleur." *La Vie des lettres et des arts*, no. 11 (1921), pp. 331–33.

Warshawsky, W. "Orphisme, Latest of Painting Cults." *The New York Times*, Oct. 1913.

Weelen, Guy. "Los Delaunays en Espana y Portugal." *Goya*, no. 48 (1962), pp. 420–29.

Wickstrom, Mary Lawler. "Futurist and Orphist Spherical Expansions." Iowa City: University of Iowa, 1974.

Winter, Gundolf. "Durchblick oder Vision: Zur Genese des modernen Bildbegriffs am Beispiel von Robert Delaunays 'Fenster-Bildern'." *Pantheon* 42 (Jan.–Mar. 1984), pp. 34–42.

Wretholm, Eugen. "Robert Delaunay." *Konstrevy* 33 (1957), pp. 139–43.

Monographs and Books

Albrecht, Hans Joachim. *Farbe als Sprache: Robert Delaunay, Josef Albers, Richard Paul Lohse*. Cologne: DuMont Schauberg, 1974.

Apollinaire, Guillaume. *Apollinaire on Art*. Ed. Leroy C. Breunig. New York: Viking Press, 1972.

Bernier, Georges, and Monique Schneider-Manoury. *Robert et Sonia Delaunay: Naissance de l'art abstrait*. Mesnil-sur-l'Estrée: Editions Jean Claude Lattés, 1995.

Buckberrough, Sherry A. *Robert Delaunay: The Discovery of Simultaneity*. Ann Arbor: UMI Research Press, 1982.

Cassou, Jean. *Robert Delaunay, première époque, 1903–1910*. Paris: Galerie Berggruen, 1963.

Cohen, Arthur A. *The Delaunays, Apollinaire, and Cendrars: Critiques 1971–72*. New York: The Cooper Union School of Art and Architecture, 1972.

Cvach, Milos. *The Eiffel Tower: Robert Delaunay*. New York: Harry N. Abrams, 1988.

de la Tourette, F. Gilles. *Robert Delaunay*. Paris: Charles Massin, 1950.

de Montherlant, Henry. *La Relève du matin. Avec dix lithographies de Robert Delaunay*. Paris: Editions Spes, 1928.

Deltail, Robert. *Allo! Paris! Avec 20 lithographies par R. Delaunay*. Paris: Editions des Quatre Chemins, 1926.

Dorival, Bernard. *Robert Delaunay, 1885–1941*. Paris: Jacques Damase, 1975.

———. *Sonia Delaunay: Leben und Werk 1885–1979*. Munich: Raben, 1985.

Düchting, Hajo. *Robert Delaunays "Fenêtres", peinture pure et simultanée*. Munich: Minerva, 1982.

———. *Robert und Sonia Delaunay: Triumph der Farbe*. Cologne: Taschen, 1993.

Ferreira, Paolo. *Correspondance de quatre artistes portugais, Almada-Negreiros, José Pacheco, Souza-Cardoso, Eduardo Vianna, avec Robert et Sonia Delaunay*. Paris: Presses Universitaires de France, 1972.

Hoog, Michel. *Robert Delaunay*. Paris: Flammarion, 1976.

Hornbogen, Ute. *Robert Delaunay: Kleine Künstlermonographie*. Dresden: Verlag der Kunst, 1991.

Kandinsky, Wassily, and Franz Marc, eds. *Der Blaue Reiter*. Munich: R. Piper, 1912. Reprinted as Wassily Kandinsky and Franz Marc, eds., *The Blaue Reiter Almanac* (1912). New documentary edition, ed. Klaus Lankheit. New York: Da Capo Press, 1989.

Kuthy, Sandor, and Kuniko Satonobu. *Sonia and Robert Delaunay: Künstlerpaare, Künstlerfreunde—Dialogue des Artistes, Resonance*. Stuttgart: Gerd Hatje, 1991.

Molinari, Danielle. *Robert et Sonia Delaunay*. Paris: Nouvelles Editions Françaises, 1987.

Overmeyer, Gudula. *Studien zur Zeitgestalt in der Malerei des 20. Jahrhunderts: Robert Delaunay, Paul Klee*. Hildesheim: Georg Olms, 1982.

Peinture inobjective, peinture de l'énergie de la couleur: Ecrits de peintres. Paris: Jacques Spiess Gallery, 1983.

Rousseau, Pascal. *La aventura simultanea: Sonia y Robert Delaunay en Barcelona*. Barcelona: Universitat de Barcelona, 1995.

Rudenstine, Angelica Zander. *The Guggenheim Museum Collection: Paintings 1880–1945*. 2 vols. New York: Solomon R. Guggenheim Museum, 1976.

Schmalenbach, Werner. *Robert Delaunay. Eiffelturm (Museum Folkwang)*. Recklinghausen, 1965.

Schmidt, Georg. *Robert Delaunay—Zwölf Farbtafeln*. Baden-Baden: Waldemar Klein Verlag, 1964.

Spate, Virginia. *Orphism: The Evolution of Non-figurative Painting in Paris 1910–1941*. Oxford: Oxford University Press, 1979.

Les Tours Eiffel de Robert Delaunay: Poèmes inédits. Paris: Jacques Damase, 1974.

Umlauf, Joachim. *Mensch, Maschine und Natur in der frühen Avantgarde: Blaise Cendrars und Robert Delaunay*. Würzburg: Königshausen und Neumann, 1995.

Vriesen, Gustav, and Max Imdahl. *Robert Delaunay: Light and Color*. Trans. Maria Pelikan. New York: Harry N. Abrams, 1967.

Vriesen, Gustav. *Robert Delaunay: Licht und Farbe des Orphismus*. Cologne: DuMont, 1992.

Exhibition Catalogues

Marie Laurencin–Robert Delaunay. Paris: Galerie Barbazanges, 1912.

Robert Delaunay. Berlin: Der Sturm, 1913.

Exposition Robert Delaunay. Paris: Galerie Paul Guillaume, 1922.

The Early Delaunay. New York: Sidney Janis Gallery, 1949.

Robert Delaunay. Bern: Kunsthalle Bern, 1951.

Exhibition of Paintings by Robert Delaunay. Chicago: The Arts Club of Chicago, 1952.

Hommage à Robert Delaunay. Paris: Galerie Bing, 1952.

Robert Delaunay. New York: Solomon R. Guggenheim Museum, 1955.

Robert Delaunay. Liège: Musée des Beaux-Arts, 1955.

Robert Delaunay. Basel: Galerie Beyeler, 1956.

Robert Delaunay. Leverkusen: Städtisches Museum Schloß Morsbroich, 1956.

Catalogue 177: Robert Delaunay. Eindhoven: Stedelijk Museum, 1957.

Oeuvres de jeunesse de Robert et Sonia Delaunay. Paris: Galerie Bing, 1957.

Robert Delaunay. Paris: Musée National d'Art Moderne, 1957.

Robert et Sonia Delaunay. Lyons: Musée des Beaux-Arts, 1957.

Robert et Sonia Delaunay. Lyons: Musée de Lyon, 1959.

Robert and Sonia Delaunay. Turin: Galleria d'Arte Moderna, 1960.

Quelques oeuvres de Robert Delaunay et de Sonia Delaunay. Basel: Galerie d'Art Moderne, 1961.

Robert Delaunay. Hamburg: Kunstverein Hamburg, 1962.

La Peinture sous le signe de Blaise Cendrars—Première exposition: Delaunay, Léger. Paris: Galerie Louis Carré, 1965.

Robert Delaunay, 1885–1941. Paris: Galerie Louis Carré, 1965.

Robert et Sonia Delaunay. Paris: Musée National d'Art Moderne, 1967.

Color and Form 1909–1914. San Diego: San Diego Fine Arts Gallery, 1971.

The Cubist Circle. Riverside: University of California Art Gallery, 1971.

Sonia Delaunay, Robert Delaunay. Nancy: Musée des Beaux-Arts, 1972.

Sonia e Roberto Delaunay em Portugal, e os seus amigos—Eduardo Vianna, Amadeo de Souza-Cardoso, José Pacheco, Almada-Negreiros. Lisbon: Fundacão Calouste Gulbenkian, 1972.

Robert Delaunay. Brussels: Galerie Jacques Damase, 1973.

Robert Delaunay. Baden-Baden: Staatliche Kunsthalle Baden-Baden, 1976.

Robert Delaunay (1885–1941). Paris: Musée de l'Orangerie, 1976.

Delaunay, Mondrian. Basel: Galerie Beyeler, 1977.

Sonia et Robert Delaunay. Paris: Bibliothèque Nationale, 1977.

Robert Delaunay: Peintures, reliefs, aquarelles et dessins. Paris: Galerie Louis Carré, 1980.

Robert Delaunay. Blick auf die Stadt. 1910–14. Mannheim: Städtische Kunsthalle Mannheim, 1981.

Robert e Sonia Delaunay. Lisbon: Fundacão Calouste Gulbenkian, 1982.

Robert y Sonia Delaunay. Madrid: Fundación Juan March, 1982.

Robert Delaunay. Cologne: Galerie Gmurzynska, 1983.

Delaunay und Deutschland. Munich: Haus der Kunst, 1985.

Robert Delaunay, Sonia Delaunay. Paris: Musée d'Art Moderne de la Ville de Paris, 1985.

Meister des zwanzigsten Jahrhunderts. Cologne: Galerie Gmurzynska, 1987.

Paris 1930: Arte abstracto, arte concreto—Cercle et carré. Valencia: IVAM Centre Julio González, 1990.

Cubism et la Section d'Or: Reflections on the Development of the Cubist Epoch 1907–1922. Washington, D.C.: The Phillips Collection, 1991.

Malerei im Prisma: Freundeskreis Sonia und Robert Delaunay. Cologne: Galerie Gmurzynska, 1991.

Sonia und Robert Delaunay. Bern: Kunstmuseum Bern, 1992.

Die Metamorphosen der Bilder: Piet Mondrian, Carl Buchheister, Friedrich Vordemberge-Gildewart, Giorgio de Chirico, René Magritte, Edvard Munch, Emil Nolde, Alexej von Jawlensky, Pablo Picasso, Fernand Léger, Robert Delaunay. Hannover: Sprengel Museum Hannover, 1993.

Robert and Sonia Delaunay. New York: Danese Gallery; Cologne: Galerie Gmurzynska, 1997.

Lenders to the Exhibition

The Art Institute of Chicago
Courtesy of Marc Blondeau, Paris
Courtesy of Galerie Gmurzynska, Cologne
Peggy Guggenheim Collection, Venice
Solomon R. Guggenheim Museum, New York
Hamburger Kunsthalle
Kunstmuseum Basel
Kunstmuseum Winterthur
Kunstsammlung Nordrhein-Westfalen, Düsseldorf
The Minneapolis Institute of Arts
Musée National d'Art Moderne,
 Centre Georges Pompidou, Paris
Museum Folkwang, Essen
Museum of Fine Arts, Boston
The Museum of Modern Art, New York
The Morton G. Neumann Family Collection
Städtische Galerie im Lenbachhaus, Munich
Tate Gallery, London
Philadelphia Museum of Art
Anonymous lenders

Works exhibited at
Deutsche Guggenheim Berlin
cat. nos. 1–3, 8, 10, 11, 15, 19–21,
24, 27, 30, 31, 33, 40, 42, 43, 46,
49–51, 54, 55, 57–59

Works exhibited at
Solomon R. Guggenheim Museum
cat. nos.: 1, 3, 4, 8, 11, 14, 15, 18–21,
24, 27–31, 33, 36, 40, 47–51, 53–55,
57–59

The Solomon R. Guggenheim Foundation